Pen to Paper

he had given them away. When I was often afterwards surprised in comparing my drawings of his wife with his that mine were just as good as his or better & my color sketches too & that I painted a head faster & better. One night in bed the whole deceit flashed across me & it stopped me from sleeping.

Since then & it is a year ago I have known Crepon perfectly. He is not bad but weak. I would have told you maybe his history before but it would have made you think me more lonely & unhappy than I was, as I had written more of him than of my other friends. There will be no change in our relations to one another. I will be just as cordial as ever & so will he. That is we will be polite & laugh together. The heart must have nothing to do in that word cordial. I was when you told me your opinion of Crepon from his looks I would not agree with you — to agree with you but your penetration astonished me for I had been deceived myself so long. You told me Mrs Crepon was more lady like than some one of my friends I forget which one. She has a splendid head & health & was a foundation for every noble quality but her living with him & his petty lies to one another and the like is hurting her very fast. In ten years I am sure none of us would know her. I have drawn her so often I know her face well & it is changing.

pen to paper

ARTISTS' HANDWRITTEN LETTERS
FROM THE
SMITHSONIAN'S ARCHIVES
OF *AMERICAN ART*

Edited with an introduction by Mary Savig

PRINCETON ARCHITECTURAL PRESS

NEW YORK

ARCHIVES OF AMERICAN ART, SMITHSONIAN INSTITUTION

WASHINGTON, D.C.

Contents

Foreword

Since its founding in 1954, the mission of the Smithsonian's Archives of American Art has been to collect, preserve, and make available the primary materials documenting the history of the visual arts in the United States. In the past decade, digitization has transformed nearly every aspect of our work. Today, our collecting encompasses born digital materials and every year we make more and more of our collections available online for research.

And yet, the vast bulk of written material in our collections is still represented by the evidence of artists and others putting pen to paper. Whether in our Washington, DC, reading room or on computer screens, archivists and researchers piece together handwritten letters, diaries, and notes to tell the story of art in America.

Many artists in our collections make a lasting impression with their handwriting. Archivists, other staff, and frequent researchers gain an intimate familiarity with an artist's hand as they delve into personal histories. The genesis of this book occurred during a lively discussion among Archives colleagues about easily recognizable handwriting in our collections. Anyone who has worked at the Archives for any length of time is able to identify a letter by Georgia O'Keeffe, Maxfield Parrish, or Ad Reinhardt from across a room. Karen Weiss, head of digital operations at the Archives, observed that the topic was ripe for further investigation, as there are thousands of examples. The controlled, airy lettering of Rockwell Kent is especially noteworthy to me, as it evokes the precise composition of his paintings and also belies the passion conveyed in his love letters to his wife Sally. What else can we infer about artists and their lives from the examples of their handwriting we have in our collections?

Weiss's initial suggestion led to an exhibition, *The Art of Handwriting*, in the Lawrence A. Fleischman Gallery during the summer of 2013. This volume expands

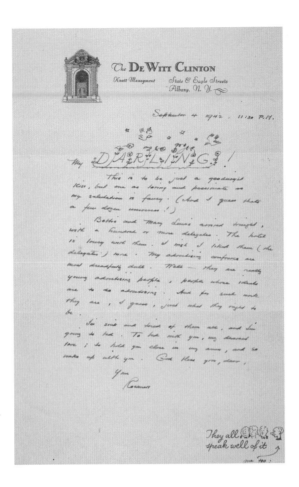

on that exhibition, demonstrating the broad scope of research on our collections as authorities on American art tell stories through handwriting. Reaching out even farther, we have made these letters and many other handwritten resources available through the Smithsonian's Transcription Center, a web-based initiative through which volunteers from around the world are transcribing them, making it possible to search every word online.

And so this book is dedicated to our longtime researchers who have spent countless hours deciphering handwriting, as well as to new audiences who are discovering our resources on our website and on the Transcription Center. Together they have helped us see many fascinating handwritten documents in our collection through new eyes, and they are opening up the Archives of American Art to the world.

Kate Haw, Director
Archives of American Art

I was in the middle of drawing when your card came! Delights — surprises, news! — I had not seen it before, but anyway it would have delighted me to have had on it the Asher touch. So —

this is to let you know we are happy, miserable — inspired, dull — lots of work — bad and good. It would be so ___ to be together —

But everything just ___? ___ smacks from ___ us too —

Philip

Philip Guston letter to Elise Asher, August 17, 1964.

8

THE ART OF HANDWRITING

Handwritten letters are performances on paper. Elegant flourishes of cursive sashay across a page, while bold strokes of calligraphy shout for attention. Free-spirited scribbled letters trip over each other, and distinctive dashes direct traffic. These lively impressions take shape in endless variations, intertwining language and art.

The expressive nature of handwriting is especially evident in personal correspondence, where its nuances evoke the presence of the author. Handwritten letters are the mainstay of any manuscript collection and also are valued for their historical content. There are hundreds of thousands of handwritten letters in the Smithsonian's Archives of American Art, dating from the eighteenth century through the present day. Each message brims with the sensibility of the writer at the moment of the interplay among mind, hand, and pen.

An artist might pen a letter just as she or he might draw a line. "I was in the middle of drawing when your card came!" writes painter Philip Guston in a 1964 letter to painter-poet Elise Asher [OPPOSITE]. A meandering doodle fills the top half of the page, suggesting that Guston has fluidly shifted from drawing to writing. He paints his words, creating hearty — if not ungainly — sentences that mirror the relaxed gestures of his abstract paintings at the time. Similarly, Surrealist painter Matta illuminates his letter to Joseph Cornell [OVERLEAF]. Gradients of color enliven several words, like *Jojo*, Cornell's nickname, and *Robert*, the name of Cornell's younger brother. These brief painterly missives are made more meaningful by the playful hand of the artist. Through the swells of ink and the furrows of line, the recipient feels the artist's meaning. Handwriting conjures mood, time, and place, offering insight about the person behind the pen. The letters in this book have been gathered to highlight the many ways in which handwriting animates paper.

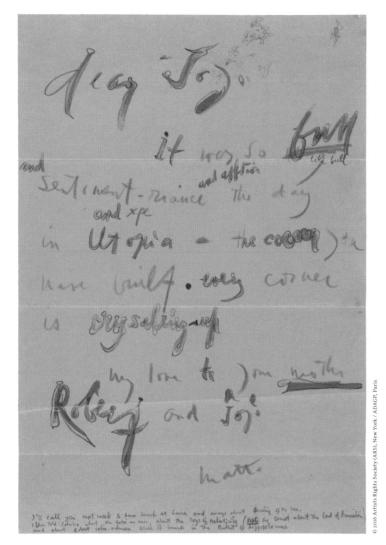

this page
Matta letter to Joseph Cornell, May 6, 1947.

opposite
Howes' model copybook, or system of penmanship, 1861, by B. G. (Benjamin George) Howes (John D. Graham papers).

So much of the historical record is handwritten. Since the colonial era, handwriting trends in the United States have come and gone, responding to changes in business, technology, education, and art. Systems of cursive, calligraphy, and hand printing can be traced to specific cultural moments and locations. In the nineteenth century, rising literacy rates, coupled with the new availability of manufactured pens and inks, generated unparalleled passion for the art of handwriting. To be sure, those who could read and write did not often include the working poor, women, or people of color. But for those with suitable social standing, penmanship became an endeavor that reflected one's intellectual acumen.[1] Writing master Platt Rogers Spencer was

most successful in popularizing ornamental writing in the United States.[2] Following Spencer's theories, numerous handwriting instructors published manuals on how to engage the mind in pursuit of flawless penmanship. An especially dexterous example can be found in the copybook used by penmanship student George W. Humphrey, who embroidered the pages with graceful letters and phrases [BELOW]. With each curlicue, Humphrey learned to articulate his taste and sophistication.

In practice, many artists mingled methods to improvise their own distinct writing systems. Their smooth scripts correlated ideal personal traits, such as artistry,

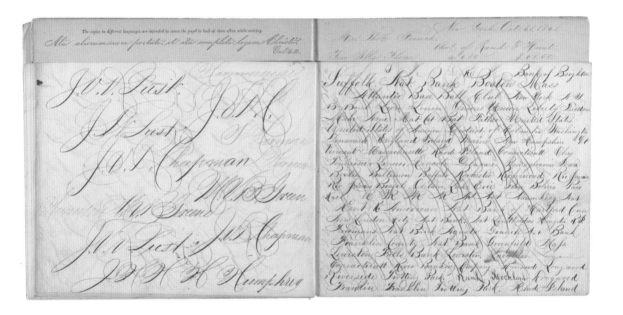

intellect, and morality, with the material mark of the hand. Along these lines, many Americans eagerly collected the autographs and writing samples of leading public figures. Charles Henry Hart, an art historian and director of the Pennsylvania Academy of the Fine Arts from 1882 to 1904, amassed a remarkable collection of letters and related ephemera of prominent American artists, including naturalist John James Audubon, sculptor John Quincy Adams Ward [OVERLEAF, LEFT], and Impressionist Edmund Tarbell [OVERLEAF, RIGHT]. These letters serve as valuable primary sources for art historians, and to autograph hobbyists they also signify the character of the writer.

Even as the penmanship trends of the nineteenth century emphasized fluid writing, they nevertheless struggled to keep pace with social and technological changes at the turn of the twentieth century. Communication underwent rapid change and more people were literate than ever before. Lovely calligraphic scripts were dismissed for their superfluity. Leading the cause was educator A. N. Palmer, who condemned earlier methods for being too artistic and philosophical. He argued for a speedier and plainer cursive system to indicate strong muscles rather than a strong mind. "There are no occult powers of the mind, which, touched by a master of will power, can be made to vibrate along the muscles of the arm like magic, guiding them safely through beautiful, but unknown forms," smirked Palmer in his *Palmer's Guide to Business Writing* (1894).[3] By the early twentieth century, many primary schools across the country had adopted his method. For generations, it represented good handwriting in most regions of the United States, at least until even leaner methods took precedent.

The Palmer hand was so universally recognized that it appealed to Pop super-star Andy Warhol [BELOW]. In a 1949 letter to Russell Lynes, managing editor of *Harper's* magazine, Warhol employs Palmer cursive. Responding to Lynes's request for biographical information, Warhol emphasizes his everyman persona: "My life couldn't fill a penny post card," he coyly writes. Warhol's contrived modesty matches his stylized penmanship. Written early in Warhol's career, the letter anticipates his fascination with popular visual culture. At the time, Warhol had already amassed a collection of celebrity autographs.

With each generation, a new handwriting method faulted its predecessor for being too unwieldy. Copybooks and child-centered curricula aimed for consistent legibility, and yet, everyone has unique handwriting. The cultural history of handwriting in the United States is replete with contradictions, exceptions, and riffs.

this page
*Andy Warhol letter
to Russell Lynes, 1949.*

opposite, left
*John Quincy Adams Ward
letter to Asher Brown
Durand, December 20,
1880.*

opposite, right
*Edmund Charles Tarbell
letter to Charles Henry
Hart, June 23, 1892
(Charles Henry Hart
autograph collection).*

Salutation to Ben. Shahn once more.

One of my children (grown) sent me as
a birthday present yesterday "Biography of a Painting",
reprint by Fogg Museum. He lives in Cambridge,
and heard the lectures.

On the morning of my birthday I read this
quietly by myself sitting under a tree, and
write to tell you that I appreciate very much what
you have done here. I understand, from a
lifetime of flashes, what you undertook to do
(close to the impossible) and write this to
thank you for a fine morning, reading and
thinking about what you said.

Yours
Dorothea Lange

28 may 57.

This book offers examples of how writing a letter can be an artistic act. A glimpse
at the handwritten letters at the Archives of American Art reveals how artists have
disrupted convention in inventive ways. With each letter, artists choose the penman-
ship style, utensils, and paper that will convey their creative inclinations. They
construct a system of writing with attention to formal properties of line and form.
With this in mind, an artist's handwriting often begs comparison with his or her work.

Dorothea Lange, for example, composed her letters like she might compose a photograph. Lange, who is best known for her iconic photographs taken during the Great Depression, padded each sentence with sizable spaces, creating an unusual sense of rhythm in her 1957 letter to social realist artist Ben Shahn [OPPOSITE]. Her handwriting appears tidy but idiosyncratic, with architectural *m*'s and the occasional emphasis given to capital letters. Lange felt that her creativity, evident in both her handwriting and documentary photography, came from within. In her 1964 oral history interview for the Archives of American Art, Lange likened her artistic originality to the individuality of handwriting: "It may sound like an immensely egotistical thing to say: I'm not aware photographically of being influenced by anyone.... Perhaps I would have done better had I been. But I haven't.... It's my own handwriting."

In 1960 painter Hans Hofmann [ABOVE] wrote an empathetic letter of condolence to curator Dorothy Canning Miller after the death of her husband, fellow curator Holger Cahill. "We feel very strongly with you," he writes. Hofmann's spindly handwriting is measured as he balances the large capital *D*'s in "Dear Dorothy" with the

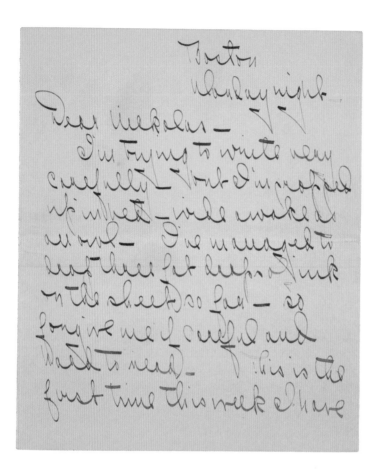

two large capital *H*'s in his signature. From start to finish, the eye follows a diagonal path across the page. The control of movement is reminiscent of his Abstract Expressionist paintings, in which he famously juxtaposed shapes and colors to suggest a sense of spatial depth on the flat surface of a canvas.

For many artists, it is easy to see how writing is performative. Martha Graham, a pioneer of modern dance, choreographed her letterforms across the page in a ca. 1923 letter to photographer Nickolas Muray [ABOVE]. "I'm trying to write very carefully," she begins in arabesque strokes of ink. Likewise, poet-dancer-potter Paulus Berensohn, who studied dance with Graham at the Juilliard School in 1951, also poured his interest in movement into calligraphy. He taught an embodied method of writing to students at the Penland School of Crafts in North Carolina, encouraging complete revisions of one letterform at a time. His technique forced students out of their established physical habits to become newly alert to the lines of their letters. As soon as one letterform was relearned, the student would move

on to another so that the handwriting — and the body — was always in transition. Berensohn's copious letters to his friend and Penland colleague Jane Brown demonstrate his inflected handwriting [BELOW, LEFT]. In a 2012 card to Brown marking the solstice, Berensohn's letterforms are a deliberate mix of sharp angles and soft curves.

For painter Louis Michel Eilshemius [BELOW, RIGHT], it was the limitation of physical movement that fostered his boisterous handwriting. A disabling car accident in 1932 confined Eilshemius to his home. A prolific writer, he devoted much of his energy to promoting his perceived contributions to society, such as his artwork, musical scores, and eccentric writings. The self-declared "Mahatma of the Art World" penned daily letters the editor of the *New York Sun* and to dealers, friends, and art world figures. His bombastic handwriting suggests his restless energy and alienation from the outside world. "I am half dead. So few visitors and I [am] neglected. Where is God," he wrote to dealer F. Valentine Dudensing around 1935.

Handwritten missives create presence in the distance between two people. Letters are material evidence of a relationship. Take, for example, a 1796 letter from portrait

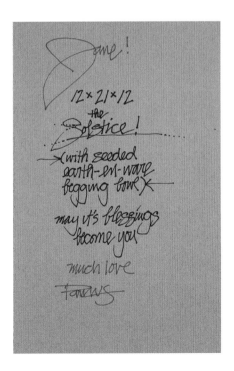

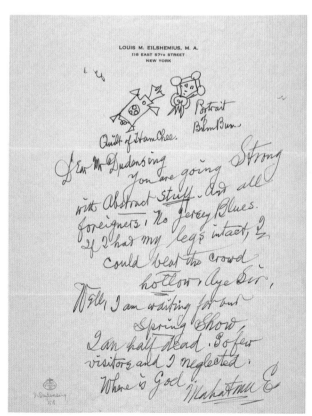

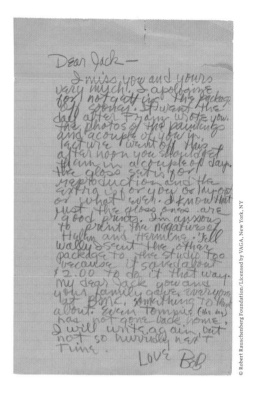

painter Lawrence Sully to his sister Elizabeth "Betsey" Middleton Smith [ABOVE, LEFT]. The lyrical ornamentation of Sully's salutation and signature relays his affection for his sibling. The body of the letter is orderly and polite, as Sully explains how a series of "untoward events has precluded" his intentions to see Betsey and return her miniature portrait. At the time, Sully was on the brink of financial ruin, and yet his refined roundhand lettering helps to hedge conflict in his family. More than 150 years later, around 1952, Robert Rauschenberg penned a more modern missive to painter Jack Tworkov [ABOVE, RIGHT]. Rauschenberg's words jumble together as he elaborates on photographs taken during their time together at Black Mountain College, where Tworkov was Rauschenberg's instructor. "I will write again, but not so hurriedly next time," he concludes. The loopy, informal lettering suggests Rauschenberg's comfort with Tworkov. In both letters, handwriting helps narrow the physical distance between sender and recipient: Sully writes with genteel deliberation, and Rauschenberg writes with restless enthusiasm.

Artists often code their feelings through handwriting. Lines can be abraded, exaggerated, or compressed to approximate the writer's emotional investment in the narrative of the letter. Chilean painter Mario Carreño emphatically wrote in all caps

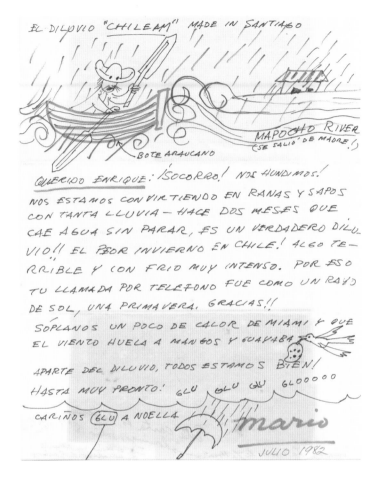

in his 1982 correspondence to Cuban-American artist Enrique Riverón [ABOVE]. The capital letters and accompanying illustrations convey Carreño's intense reaction to a destructive flood in his neighborhood in Santiago de Chile. Likewise, Abstract Expressionist Elaine de Kooning writes in sinuous lines in an undated letter to *ARTnews* editor Thomas Hess [OVERLEAF]. Some words stretch into a nearly flat line, punctured by the occasional ascending or descending lines. De Kooning felt "aggrieved" and "oppressed" by recent events involving Hess. Perhaps de Kooning's discomfort with the situation is manifest in her obfuscated handwriting.

The complexity of handwriting opens it to assumptions and interpretation. Letters contain valuable insight into the everyday lives of artists, their creative processes, and their relationships with family, friends, and colleagues. The fifty-six essayists in this book — curators, professors, graduate students, archivists, and artists — have previously pored over letters in the Archives of American Art in search of evidence

Elaine de Kooning letter to Thomas Hess, undated.

and anecdote. These letters have been cited in dissertations, quoted in exhibition catalogs, and used as source material for artwork. For this book, the writers have stepped back from the verbal content of the letter to reflect on the visual. The authors consider, in varying degrees, how the pressure of line and sense of rhythm speaks to an artist's signature style, personality, sense of place, and relationship with the recipient. And questions of biography arise: Does the handwriting confirm assumptions about the artist, or does it suggest a new understanding? These expert readings are multifaceted in interpretation, as they reveal the intricacies of mark making and art making in the history of American art.

Many authors explore how handwriting reveals some semblance of self. The wit of artists Winslow Homer and Jim Nutt and the confidence of Georgia O'Keeffe, for example, are apparent in their expressive inscriptions. Handwriting also offers clues to biographical details. Abstract Expressionist Willem de Kooning's job as a sign painter informed his curvilinear cursive, and Jackson Pollock's itinerant childhood may have shaped his inconsistent longhand. Architect Eero Saarinen experimented with handwriting to mediate his dyslexia, while Mary Cassatt's script changed with age and declining vision.

The experts also show how artists create a sense of place through handwriting. Photographer Berenice Abbott was amazed by her environs in Germany, and Harlem Renaissance painter Beauford Delaney's vigorous missives indicate his quixotic mood in Paris. Painter George Catlin wrote quickly from the plains of Oklahoma, and self-taught artist Grandma Moses's brambly cursive evokes everyday life on a farm.

Many approaches in this volume scrutinize the relationship between sender and recipient. Painter Thomas Eakins had famously handsome handwriting because his father, Benjamin Eakins, was a handwriting instructor in the nineteenth century. But Eakins wrote in a more informal hand to his dear sister, Fanny. Painter Charles Burchfield eloquently responded to "fan mail" from collector and cofounder of the Archives of American Art Lawrence A. Fleischman.

Handwriting serves as an extension of an artist's process. Several writers discuss the artists' formal objectives for their writing. Fiber artist Lenore Tawney, abstract painter Ad Reinhardt, and modernist painter Abraham Rattner, among others, studied various styles of medieval and Asian calligraphy, and artist-activist Corita Kent wanted to learn the Hebrew alphabet. Likewise, Minimalist artist Dan Flavin scrupulously practiced Spencerian script. Hanne Darboven and H. C. Westermann expressed their artistic idioms through correspondence, blurring the line between archival document and art. Each of the interpretations of handwriting in this volume offers new ways of thinking about personal correspondence.

Box 185 · Siasconset, Mass. Aug 19 1946
 Dear Webster: Nantucket may boast that
she has architectural gems to match your Taos
church — for which, and your letter, thank you —
but I can't agree, so instead I send you some-
thing in the nostalgia line: This echte photograph
ie of lotte, I mean! Not me in the civil war.
Is it from the ARIADNE auf NAXOS days, I won-
der? So you are breaking, or by this time
have broken, the back of Eliot's sonata. How pleas-
ed I am; it implies a back and a back-
bone to break. How rare! in these days when
the anatomy of the worm is body enough for
most composers. NO, I am not one bit
sorry to say — except that I shall miss seeing
you — I don't expect to be in N.Y. at all until
the 1st of Oct. But . . . it might possibly be . .
and if so, I would certainly try to arrange a
meeting with you. It might however be feasi-
ble — as far as boat time-tables go (although
J & M are having my sister, & probably
Lincoln, as guests at the time) — for me to
call on you at Woods·Hole for a few hours . or
for you to come to Nantucket (have you ever
been?) for a few hours to see us? Probably this
is impracticable but it is pleasant to dream
of. In case it be not a wildly complicated plan you
could call — J. & M. have a primitive phone
out of order at the moment: Siasconset 2134 —
from Woods·Hole & let us know. Yrs, P.

*Paul Cadmus postcard
to Webster Aitken,
August 19, 1949.*

"There should be more letter writing than there is," lamented painter Paul Cadmus in a 1988 oral history interview for the Archives of American Art. Cadmus and his interviewer, Judd Tully, predicted the demise of personal correspondence. Cadmus explains, "It's partly because Americans don't have decent handwriting anymore." Cadmus, who wrote in charming cursive, echoes the sentiments of many penmanship enthusiasts [ABOVE]. Technologies of communication, from telegrams to texting, have long threatened the written word. Today, many primary schools are dropping lessons in longhand in favor of teaching technological skills. Future

generations of readers might look at the letters in this book with untrained eyes and find themselves unable to read the letters of Isamu Noguchi or John Singer Sargent.

And yet, handwriting continues to prove its fluidity. The craft of handwriting has flourished online, especially on social media. Artists, thinkers, and makers alike are experimenting with penmanship in innovative ways. Demonstrations of calligraphy can be found on YouTube and hand-scribed cards flourish on Etsy. In the past few years, curator Hans-Ulrich Obrist has rebooted autograph collecting by posting handwritten notes — usually jotted down on Post-it Notes — by contemporary artists on Instagram, where anyone is welcome add comments. With this in mind, let's not mourn handwriting as a lost art, or even as a dying art. As snail mail fades from contemporary culture as a primary mode of communication, the vast array of handwritten letters in the Archives of American Art remains relevant and ready for new generations to discover. Let's celebrate how imaginative correspondence now exists in material and digital forms, posing new ways of thinking about art, history, and culture. In the spirit of this book, pick up your pen and write a letter today. What stories will you let your handwriting tell?

Mary Savig

Notes

1 See Tamara Plakins Thornton, *Handwriting in America: A Cultural History* (New Haven, CT: Yale University Press, 1996).

2 See Platt Rogers Spencer, *Spencerian Key to Practical Penmanship* (New York: Ivison, Phinney, Blakeman, 1866).

3 A. N. Palmer, *Palmer's Guide to Business Writing* (Cedar Rapids, IA: Western Penman Publishing, 1894).

BERENICE ABBOTT

1898–1991

*Berenice Abbott, ca. 1968–69. Photograph by
Arnold Crane.*

» *Letter to John Henry Bradley
Storrs, October 16, 1921*

In 1921 fledgling sculptor Berenice Abbott,
frustrated by the United States' increas-
ingly commercial culture, left New York
City for Paris. The move radically changed
the trajectory of her career: in Paris she
gave up sculpture, learned photography,
and eventually became one of the city's
most successful portraitists. Abbott's fascination with Germany is less
well known, which makes this letter, written from Berlin, all the more
exciting. In it Abbott gushes about Berlin's theater, music, archi-
tecture, and art. She's taken with how independent and modern the
women seem. The air, "dry-cold-fresh," feels healthy to her, healthier
than Parisian air. There is nothing overly decorative or lavish about
Abbott's handwriting in this letter, which is quickly written and to
the point. Yet the feeling of speed, the flow of her cursive, the manner
in which she writes against the grain and crowds the edge of the
page — these qualities communicate Abbott's exuberance and cer-
tainty of observation, as well as her commitment to an artist's life.

Terri Weissman
Associate Professor of Art History
University of Illinois, Urbana-Champaign

out of the Bahnhof. People have been very nice to me — only one awful nuisance is that they resent the difference of exchange to a dangerous point and can't imagine me being American without being rich. The Rhine and the Hohenzollern Bridge were superb —. Everything's different. Women look "dutchey" on the whole — at first — one really must choke laughing sometimes — they lack chic-ness but they are much more independent and "modern" than french women. Every — even workmen seem to be well dressed. I made the trip quite alone and had the time of my life inspite of many difficulties. German is much easier to speak. Could you do anything with the studio? At present Man Ray has the key — and only occasionally uses it to take photographs in. Please write me

and tell me the news of yourself — with lots of love and best regards to you both

Berenice Abbott letter to Storrs, October 16, 1921, continued.

later with it. The fact was that the circumstances in Montparnesse were deplorable. I couldn't do anything there. Germany exceeds all my expectations. This is the first place I have been thrilled with — thrilled to tears. It is a joy and I am enthusiastic beyond words. Everything seems to be developed more than anywhere. Energy — force — abounds in the air. The newer architecture excellent. Streets big and clean — shops handsome — original and all material advantages without any of the stamp of grossness a commerciality that spoils everything in U.S.A. Theaters — photography — music — years ahead. And there are signs of a most flourishing art — full swing. I am quite folle here — feel much more

IVAN ALBRIGHT

1897–1983

Ivan Albright painting That Which I Should Have Done I Did Not Do (The Door)*, 1931/41, in his studio, ca. 1940. Photograph by Helen Balfour Morrison.*

» *Letter to Earle Ludgin, August 28, 1968*

While Ivan Albright's paintings exhibit a slow, meticulous, and metaphysical approach toward representational imagery, his letters are filled with erratic, jumpy, and high-speed handwriting. Articles are often dropped, as though his hand could not keep up with his thoughts.

Albright's casual, affectionate letter to his longtime friend, collector and advertising executive Earle Ludgin, is filled with allusions to things he knew his friend would find funny (the movie he mentions is likely a profile by Lester Weinrott called *Unfinished Portrait of an Artist*, in which they both appear).

Albright's postscript foregrounds how influential Albright was in the art world, despite his fierce independence. While Albright was visiting his friend Sidney Janis's New York gallery, Arne Ekstrom had called to complain that the Art Institute of Chicago had rejected Marcel Duchamp's loan request for Albright's painting *That Which I Should Have Done I Did Not Do (The Door)* (1931–41). (Duchamp was then curating the exhibition *Doors* for Ekstrom's gallery, Cordier & Ekstrom.) Albright suggested displaying the original door that had served as the model for his painting; Duchamp, delighted, included that in the exhibition instead. Albright offers a priceless quip to Ludgin: "So I became according to Sidney Janis the grandfather of pop art — that clears that up."

Robert Cozzolino
Senior Curator and Curator of Modern Art
Pennsylvania Academy of the Fine Arts

28

Aug. 28 - 1968

Dear Earle

From a lesser movie actor
to a great one - I was in Chicago
in early Chicago and will
not be there again this fall.
I will be here until early in
October. Then Georgia -
Cordier & Ekstrom episode -

P. S. I happened to be in N.y.
at Sidney Janis. Ekstrom was
on the phone and said Duchamp
wanted my door very much for the
Cordier Ekstrom exhibition - They
had tried to borrow the painting
Door from the Art Institute & had
met a refusal - so I suggested
the original wooden door - so I
became according to Sidney

29

OSCAR BLUEMNER

» *Letter to Arthur Dove, ca. 1928*

Oscar Bluemner's penciled letter is a response to a letter of March 22, 1928, from Arthur Dove. Dove felt a strong affinity with Bluemner's exhibition of his *Suns and Moons* paintings at Alfred Stieglitz's Intimate Gallery. "The things are fine," Dove had written, "way back and way on in music and in wisdom."

The warm tone and informal format of Bluemner's return note are underscored by the fact that it is written in pencil. This soft pencil employed on slightly textured paper imparts to each line a painterly chiaroscuro that reinforces Bluemner's praise of ideas that come "from your eye and mind through the brush." The orderly script becomes looser as the ideas unfurl. The rightward flow of the letters is repeatedly countered by backward-looping curves, notably in the stems of the letter *d* and in the emphatic reverse arc of the word *I*. These calligraphic loops punctuate the pages of the letter like notes on a staff, evoking the "musical employ of paint & tones" that Bluemner sees as the most profound link between his own art and Dove's.

Two facing pages from Bluemner's heavily annotated copy of a brochure for an *Exhibition of Early Chinese Paintings & Sculptures* demonstrate the contrast between the ruggedness of hastily penciled lines (on the left) and the greater elegance and fluidity achieved when writing in ink (on the right). The acknowledgment that line itself is a medium of expression is accentuated by the energetic and varied character of the handwriting, especially in the right-hand page. The letters move rhythmically across the surface at first, then swell to a grand crescendo in a single printed line, which declares "The Line is Mind." To further emphasize this statement, each individual letter is surrounded with space. The script of the following lines shrinks and compresses to elaborate on this definition of line itself: "in all its manifestations of science, intuition, geometry, movements & shapes

Friend DOVE, Thanks for your lines.
They satisfy me more than all the trash
in the newspapers and encomiums in
the gallery, because as coming from
your eye and mind through the brush.
What we have in common, clearly, is
"Das Malerische an Sich", paint-ing
as such, as 'it', where we differ is through
philosophy. You are asketic, I am
pragmatic. And besides we agree again
on the musical version of the idea
of painting. For racial reasons. Versus
French. — What, in your recent sea
or storm painting, at Stieglitz?, I cannot
get, or submit to, is ten times exchanged
for by the musical employ of paint &
tones there evident, big enough. —
I am now no more painter. I was
painter, in order to learn. What? I
think that which I did not receive
through birth, I am at a new mile
stone — although I must keep on
painting, now like a mule — namely to
convert paint into, to convert into
paint, all that is, seems. isn't, feels,

is felt, the Sum of all, human,
all that I meet all the time, in me,
about me, — "condensed in a mustard seed"
in any intime angle of space
And I feel clearly the limitation of
myself as well as of painting so as to
do that, and of time and money to
accomplish it, and of my raving
blood that rushes me to side paths, in
many ways.
So better quit New York — fly paper to
all my feelings, I'm all mussed up and
try in vain to lick the molasses of my
tentacles — for the peaceful wilderness
like yours and your way.
Another Link.
Yes, all is vanity, as you suggest,
— perhaps; the temerity of Ur-Energie
which plays upon our heart strings
the vain winds from nowhere to
nowhere — only to make them oscillate
as color. All Hail!
Your
Bluemner

Oscar Bluemner letter to Dove, ca. 1928, continued.

of planets, character, gesture, writing, e.t.c." Significantly, Bluemner includes writing itself as one of those fundamental qualities of line, which joins "Beauty, as Rhythm," and equals "growth, life pulse, etc."

Roberta Smith Favis
Professor Emerita of Art History
Curator, Vera Bluemner Kouba Collection
Stetson University

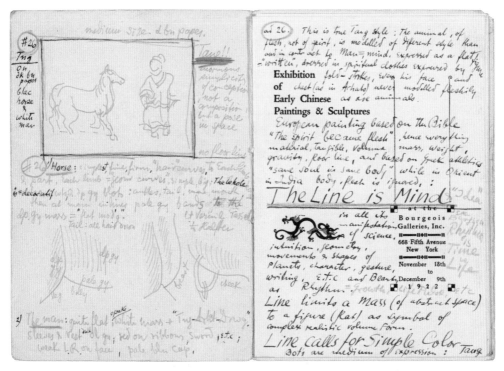

Oscar Bluemner, notes in the catalog Exhibition of Early Chinese Paintings & Sculptures, 1922, *at the Bourgeois Galleries, ca. 1922–33.*

CHARLES BURCHFIELD

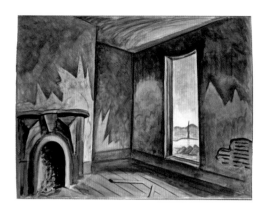

Charles Burchfield, In a Deserted House, *1918–39.*
Detroit Institute of Arts.

>> *Letter to Lawrence A.*
Fleischman, March 17, 1956

In a 1914 journal entry Charles E. Burchfield wrote: "Let the mind rule the writing not the eye...someone will decipher your hieroglyphics." In 1956, after a celebrated retrospective, Burchfield wrote in his journal that he had set to the task of "answering fan letters," which he said, "I feel I must do in each case and with great thought and care." This is one of those letters. In it, Burchfield refers to his painting *In a Deserted House* (1918–39), recently acquired by Lawrence A. Fleischman. "It always seemed strange to me," he writes, "[that] it went unsold for so long. I guess it had to wait for someone to come along who understood it." In Fleischman, Burchfield found a kindred spirit who understood his art. Fleischman would later represent the Burchfield estate for more than two decades in his Kennedy Galleries in New York City.

Tullis Johnson
Curator and Manager of Archives
Burchfield Penney Art Center

March. 17, 1956

Dear Mr. Fleischman:

Thank you for your wonderful letter of Feb. 12. It makes me feel bad that it has gone unanswered for so long, but we left here Feb. 2 for a six weeks trip to the Southwest, and could not have mail forwarded - So it was not until a few days ago I got your letter.

I don't know how to thank you for the great tribute to my work, that it contained except to tell you how highly I value it, and that I will keep it and cherish it.

I agree with you that the tide of mediocrity that seems about to engulf our modern world is indeed frightening and that the problem of keeping untainted is great. But I do believe that no matter what cultural deserts are created from time to time, there will always arise a new spirit to re-create forgotten values. That doesn't mean of course that we have to lie down and quit fighting.

ALEXANDER CALDER

1898–1976

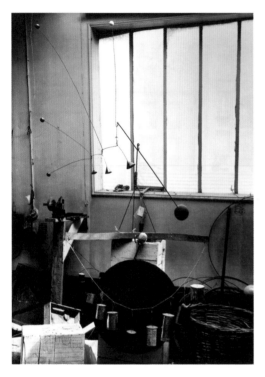

Alexander Calder's studio at 14 rue de la Colonie, Paris, 1933. Photograph by Marc Vaux.

>> *Letter to George Thomson, June 29, 1932*

By the summer of 1932 Alexander Calder figured among the most innovative of the transatlantic avant-garde. Four months prior to writing this missive to his friend George Thomson, Calder had premiered his trailblazing mobiles in a Marcel Duchamp–organized exhibition in Paris (it was Duchamp who coined the term *mobile* in 1931), with a New York City debut shortly thereafter. Penned as an afterthought, his aside about "Mister Rodin" recalls a telling experience that took place when Calder had first arrived in Paris in 1926. As he recounted in his 1966 autobiography, "George and I went to the Musée Rodin. I did not think much of the shaving cream — the marble *mousse* out of which blossoms the kiss of love. He found the kiss more important."

Calder's attitude underscores an aversion to excessive tendencies in art that became part and parcel of his intuitive practice grounded in the physicality of industrial materials and the actuality of unmediated experience. His pragmatic virtuosity is pronounced in his handwriting. With spontaneous yet deliberate pen strokes, Calder's script sweeps across the page in a manner that broadly reflects his personality — by turns responsive, direct, and swelling with energy.

Susan Braeuer Dam
Director of Research and Publications
Calder Foundation

R.F.D. #1
Pittsfield, Mass.
June 29/32

Dear George

It seems a long time since I have either written you or recieved a note from you, tho I often wonder how you are doing. A lady-freind of my pa + ma left the other day for London, and I thought of telling her to look you up but she seemed rather elderly and dull, so I decided not to. But I thought I'd write you just the same.

I had another exposition in Paris last February. This time - abstract sculptures which moved - so swaying when touched or blown, and others propelled by small electric motors. I had some 15 individual motors - so it was really quite a show.

not so much like Mister Rodin.

We came over here about May 1st to visit Louisa's mother — who has just left for Geneva, and my parents who live here in the country. We expect to leave in a month or so + come back by way of Spain

37

MARY CASSATT

Mary Cassatt, Young Women Picking Fruit, *1891. Carnegie Museum of Art.*

1844–1926

>> *Letter to John Wesley Beatty,*
September 5, 1905

>> *Letter to Homer Saint-Gaudens,*
December 28, 1922

In these two eloquent letters to successive directors of the Carnegie Institute Museum of Art, Mary Cassatt articulates her view of the art world and her place in it. By the time these letters were written, Cassatt had an international reputation as one of the original French Impressionists. Not only were her own works in great demand, particularly her paintings and pastels of women and children, but she was sought after as an advisor to young American artists and to American collectors of French realist and Impressionist art.

The first letter, written in response to an invitation to become a juror for the Carnegie Institute's annual exhibition of contemporary art, shows her belief in the independent art exhibitions promoted by the Impressionists, which dispensed with the long-standing jury system. Although she would not serve on a jury, she was serious in her offer to help the museum in any other way — after all, Pittsburgh was the city of her birth — and she exhibited in the Carnegie Internationals as well as serving on its Foreign Advisory Committee.

It was almost two decades later that the relationship between Cassatt and the Carnegie Institute reached a high point with the museum's purchase of *Young Women Picking Fruit* (1891, see illustration). In the second letter, she reminisces about her artist friends' response to this painting, which was executed in conjunction with her *Modern Woman* mural for the Chicago World's Columbian Exposition of 1893. The theme of women picking fruit was a modern version of

the story of the tree of knowledge as well as a celebration of the strides women had made in her own lifetime, but she recalled Degas's backhanded compliment: "No woman has the right to draw like that." With these feminist associations in mind, she is proud that the painting has "stood the test of time."

The handwriting in the first letter is firm and confident. In the second, almost two decades later, it is still forceful — but cramped by her failing eyesight. Impaired vision ended Cassatt's painting career in 1914 but did not lessen her spirit.

Nancy Mowll Mathews
Senior Curator Emerita
Williams College Museum of Art

after he had seen it at Durand-Ruel.
He was chary of praise. but he spoke
of the drawing of the woman arm plucking
the fruit & made a familiar gesture
indicating the knee & said No woman
has a right to draw like that.
He said the colour was like a blem
which was not my opinion, but
spoke of the picture to Berthe Morisot
who did not like it. I can but attest
that If it has some test
of true & is well drawn its place in
a museum might show the present
generation that we worked & learnt
our profession, & which cost a test"

Dec 25th 1922

Dear Mr St Gaudens

VILLA ANGELETTO
ROUTE DE NICE
GRASSE (A.·M.)

I have taken refuge here from
the gloom of Paris & I suppose you
and Mrs St Gaudens are there & I regret
I shall not have the pleasure of seeing
you. I hope your Committee have found
you some good things, but they are
a jury.

It may interest you to know
what Degas said when he saw the
picture you have just bought for your
Museum. It was painted in & 1891
in the summer, & Degas came to see me

GEORGE CATLIN

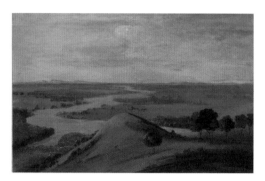

George Catlin, View of the Junction of the Red River and the False Washita, in Texas, *1834–35.* Smithsonian American Art Museum.

>> *Letter to D. S. Gregory,*
July 19 – August 21, 1834

Red River, "80 ms. [miles] above the mouth of False Washita," was no-man's-land in 1834, an area of Oklahoma occupied by few settlers and many American Indians. Artist George Catlin was traveling with a regiment of dragoons (mounted cavalry) sent to maintain peace in the territory. Their destination, a Comanche village near the Red River, would give Catlin direct contact with subjects for his *Indian Gallery*, a collection of portraits and scenic works that he was in the process of painting. From the first line, we sense that Catlin was in a hurry; he wishes to send "5 words" quickly to Dudley Gregory (brother of his wife, Clara), apparently to guarantee payment of a bill, but also to convey the "picturesque" impression of "800 mounted men on these green prairies." "You will see my sketches," he adds. Catlin's paintings were sometimes little more than sketches, deftly but hurriedly done. In the field, Catlin's brush could move as rapidly as his pencil.

William Truettner
Senior Curator
Smithsonian American Art Museum

Recd
Aug. 21

Dragoon Camp, 80. ms. above the mouth
of False Washita - on Red River.

Dear Sir,
An opportunity occurs at this moment
of dropping a few lines to friends, & amongst others I say
a word to you. I am well and in the daily
expectation of an interesting meeting
with Pawnees & Camanches, after which I shall
make the quickest track home again that I
can possibly make. This tour is of a most
fatiguing kind & I trust it may sufficiently
interesting to repay one for the trouble. The
public are expecting that I will see these
Indians or I should almost be ready to
abandon the expedition & come home.
I have had frequent letters from C.
who speaks in the warmest terms of the
kindness & friendship of the family with
whom she is staying. I enclosed a Draft
on the Sec'y - to you for 65. dols. which
I forgot to request you to enclose, when
collected, to "Clara B. Catlin Lower
Alton, Illinois" & oblige &c

800. mounted men on these green prairies
furnishes one of the most picturesque scenes I
ever saw - I would be glad that you
could see them. If you could see
my sketches home - Love to all
yours &c Geo. Catlin -

Geo. Catlin
Red River
Before July 19, 1834
Recd Aug. 21, 1834

Fort Towson
July th 19 25

D. S. Gregory Esqr
164. Broad way
New York.

FREDERIC EDWIN CHURCH

Frederic Edwin Church, ca. 1865–67. Photograph by George Gardner Rockwood.

» *Letter to Martin Johnson Heade, October 24, 1870*

Frederic Church's rhetorical flourishes are matched by the exuberance of his handwriting. His flowing cursive script and embellished capital letters convey his enjoyment as he writes to one of his favorite correspondents, fellow landscape painter Martin Johnson Heade. Heade tended to bring out the best and worst in Church, encouraging Church's delight in puns and egging on his sarcastic wit. This letter is typical of the ebullience with which Church penned his thoughts, here ranging from admonitions about the art market to a progress report on the building of his home, Olana.

The handwriting itself echoes the brushwork found in Church's oil sketches, in which the rapid back and forth of his brush delineates the contours of a landscape with lyrical flair. Church pens evocative images with consummate ease, displaying a gift for casual communication in both media.

Eleanor Harvey
Senior Curator
Smithsonian American Art Museum

...ing of the time I can spare should meet your dinner hour so much the better for me — You may expect, or not just as you please — to see a Clodhopper smiling physiognomy within a week — illuminating your doorway — Promise I can't for I have 96 31201. problems in Architecture and construction given me to solve daily —

The house grows — so do the rocks some say — The solid foundations so braced my hill that we didn't feel the popular earthquake which startled the lower world — I believe however that the earth shook only in fever and ague districts.

We are having splendid Meteoric displays —

Magnificent sunsets and Auroras — red, green, yellow, and blue — and Fish in profusion

I have actually been drawn away from my Musical Steady devotion to the new house to sketch some of the fine things hung in the sky —

Gifford is here in Hudson building a Studio atop of his Fathers House — the view from it will be splendid —

Bierstadt — I hear from his friends — proposes to remove — bag and baggage to California —

How goes the Gym. a ty? What — sizeable canvas will you take up next? by the by I am much obliged for your acting the shield between me and the Chenti fund — It is absolutely impossible for me to paint pictures for such purposes — I object to the principle of the thing and moreover — it makes me furnish

45

JOSEPH CORNELL

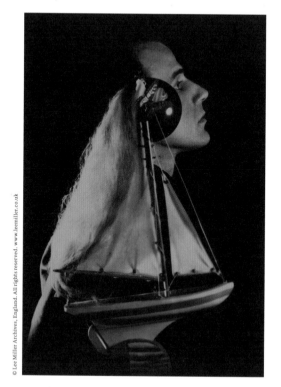

Joseph Cornell, 1933. Photograph by Lee Miller.

>> *Drafts of letter to Teeny Duchamp, October 8 and 9, 1968*

Mailed 10/9/68 8:15 am by self corner box...

Modern sculptor, collagist, and filmmaker Joseph Cornell was also a diarist and archivist. In volume and character, his diaries, correspondence, and notations on his boxes and collages testify to his love of language. Cornell devoted significant daily time to the writing process. He seldom parted with any scrap, retained multiple drafts, and often transcribed his hand-written efforts into typed versions, as if to make them more official.

Cornell was a messy writer, penciling, penning, or typing on everything from dime-store stationery to discarded envelopes, napkins, and paper bags. His phrasing reflects a stream-of-consciousness effort to capture thoughts quickly, as well as highly self-conscious editing, complete with cross outs, underlining, blotting, personalized abbreviations, rephrasing, and occasional schoolboy French. His handwriting was tight and economical, yet prone to curly flourishes, which complicates deciphering individual words and following his train of thought.

When friend and mentor Marcel Duchamp died on October 2, 1968, Cornell had already weathered the wrenching loss of his doting yet demanding mother, Helen; his younger, physically disabled brother, Robert; and a brutally murdered young woman friend, Joyce Hunter, between 1965 and 1966. Cornell possessed a heightened sensitivity to death. Sometimes, the attendant sadness incapacitated him, rendering

TO Mrs. M. Duchamp Oct 8. 68.

Such a ~~series~~ of endearing moments has been

~~It will~~ never sink in because, because he has ~~really~~ never left us. ~~so many occasions~~ The memories are ~~so endearing.~~ ~~so graphics so too~~ & enduring & ~~too~~ & graphic ~~too~~ endearing. to ~~say that the 1st.~~ ~~I recall so easily my first~~ contact ~~meeting with Marcel,~~ with Marcel, (around 1934), ~~the~~ ~~memories the delicious~~ the piquant flavor ~~sure of contact with a unique personality.~~

~~It was brief and as a stranger~~

I recall so easily an esp. cherished one, ~~the~~ first brief meeting (as a stranger), the piquant flavor of contact with a unique personality. Rare, rare qualities ~~that humble~~ me. suddenly ~~attempting expression slow my pen~~ & and humble me. attempting expression of ~~proper~~ homage. I ~~feel~~ my debt is real & great. / So many hours of the depression ~~you~~ Please accept my ~~deeper profound~~ deepest sympathies, dear Teeny, in your time of trial.

too graphic, 1st.

cherished

Brummer Gallery

The news just doesn't seem to register; the memories are too graphic, endearing & enduring. ~~An especially~~ ~~that one is a case of~~ the first meeting ~~is~~ ~~though~~ recalled much as only y'day, ~~with that is to~~ piquant flavor of contact with a unique personality. Rare, rare, qualities, stunning one's pen & humbling one attempting homage. ~~The best~~ I feel my debt is real & great.

~~Last evening I had a dream of being~~ ~~of with Marcel & conversing about Delacroix~~

Extra *for Jackie*

In a dream last evening I was conversing with Marcel, ~~about~~ ~~Delacroix~~ ~~who~~ telling him that Delacroix was staying

~~store~~ *a little* ~~I ask for time to~~

~~I do hope there may be some manner~~

All *with* love to you, dear Teeny, in the new situation

All my heartfelt love to you, ~~dear Teeny~~ and *profoundest* sympathies *deepest* to you & yours, dear Teeny, in your time & trial.

Sincerely, Joseph

48

expression impossible in any form. More often, he moved from this "enervation" to "blessed release" through writing or making art.

Cornell's papers do not include a copy of the final version of the condolence letter that he mailed to Duchamp's widow, Teeny, on October 9, 1968. Instead, several handwritten drafts trace his efforts to cope and pay his respects. Receiving the news on Thursday, October 3, created a "turbulence" that prevented him from leaving his house until the following Wednesday, when he posted the condolence letter. In the interim, he recorded three versions of a dream in which he and Duchamp discussed securing a handkerchief from their mutual hero, French painter Eugène Delacroix. Each draft provides clarifying details, including Cornell's acknowledgment of Duchamp as a conduit to understanding Romantic composer Claude Debussy, symbolist painter Odilon Redon, and the Surrealists' love of the *objet* — creating a sense of lineage and kinship that Cornell frequently expressed in his diaries. The dream's potency spills over into his two drafts of condolences, with crossed-out words and start-and-stop rephrasing evidence of the struggle to convey his thoughts.

Lynda Roscoe Hartigan
The James B. and Mary Lou Hawkes Chief Curator
Peabody Essex Museum

HANNE DARBOVEN

Large studio desk, house of Hanne Darboven, Hamburg, Germany. Photograph by Felix Krebs.

>> *Letter to Lucy R. Lippard and Charles Simonds, October 3–4, 1973*

This letter, from conceptual artist Hanne Darboven to critic and curator Lucy Lippard and artist Charles Simonds, does not convey much information in the conventional sense. Visually and conceptually complex, it exemplifies Darboven's art, as it provocatively blurs boundaries between gestural art, abstract drawing, and handwriting. It interweaves quotations from T. S. Eliot, a passing mention that she had written to mutual friends ("Sol [LeWitt] and Carl [Andre]"), and a remark about a possible visit to New York, scrawled in green. It includes wavy lines that are too regular and repetitive to be real words, dashes written out as words across the page, and philosophical phrases ("nothing never ends"). These all come across cumulatively as an expression of affection for friends, an ongoing commitment to daily labor — sitting solitarily at a worktable, filling countless pages like this one — and an expanded notion of art that subverts modernism's need for precious materials and mediums such as marble and oil paint.

Dan Adler
Associate Professor of Modern Art
Department of Visual Arts
York University, Toronto, Canada

~~~~~~~~~~~~~~~~~

Oct 3 /
Oct 4 / 1973  ambursters

i am thankful, will
so on writing writing
from ——————— dash ——— till
                dash

no thing never ends ———————
all ends up ———————————
no thing never ends ——————
and vice verse ———————
                dash

..." The dance along the artery
   The circulation of the lymph
   Are figured in the drift of stars..."
                        ELiot
..." mixing memory and desire"..
                        ELiot

dear lucy — i wrote to
sol and carl ———————
~~~~~~~~~~~~~~~~~~~~~~~
you again (air)
~~~~~~~~~~~~~~~~~~~~~~~
night follows / creates day
day follows / creates night
~~~~~~~~~~~~~~~~~
creates "it" (Call it "it")
 love and be well, hmmm
 ②

maybe — soon i will write to you again

2000 OCT NYC

i do come do

WILLEM DE KOONING

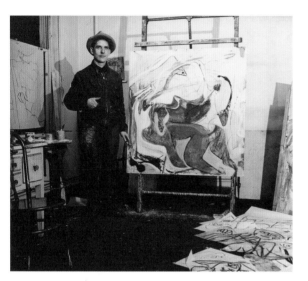

Willem de Kooning, ca. 1946. Photograph by Harry Bowden.

» *Letter to Michael Loew,
March 28, 1966*

Trained in commercial design,
Willem de Kooning was more of
a letter *painter* than *writer.* As an
undocumented immigrant in
New York, he survived by creating
signage and illustrations for adver-
tising. His commercial experience
extended to his artistic technique
— he might paint a curving and
angled form as if it were the letter
P, articulating the closed loop by tracing its rounded and straight
edges from both inside and outside the form. The process resulted in
a tapered, linear effect characteristic of the shapes that take form in
both his abstractions and his human figures. These variable angles and
loops twist and turn organically. To grasp the de Kooning aesthetic,
inspect the handwritten address on an envelope: *280 — 9th Avenue.*
The closed ovals and open curves, the acute angle of the number 2, the
ligature passing from angle to curve between *t* and *h*: all this is pure
de Kooning.

Richard Shiff
Effie Marie Cain Regents Chair in Art
University of Texas at Austin

Dear Mike,

It is nice to hear from you. Yes, . . . and it would be nice too to see you.

In a way, . . . what I had started here was to big an undertaking, (I mean in building the studio, and it take so long) if it was finished now, I could then now invite you, it would be nice, . . . but soon now anyhow, . . . I hope to see you here!

How are you? and your wife and son?

Maybe it is a nice idea to have an exhibition of Penny West's work.

de Kooning, N.y.
East Hampton, N.y.

Michael Loew
280 — 9th Avenue
New York 1, N.y.

BEAUFORD DELANEY

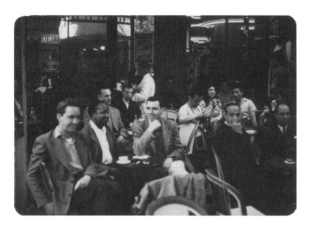

Beauford Delaney (second from left) and Lawrence Calcagno (third from left) at a cafe in Paris, 1953.

>> *Letter to Lawrence Calcagno, April 28, 1963*

"I think of you this beautiful April morning," Beauford Delaney wrote from Paris in 1963 to the painter Lawrence Calcagno. "I wish I could have coffee and conversation with you." Part of a wave of American artists who flocked to Europe after the end of the Second World War, the two had been introduced by mutual friends and remained in touch after Calcagno returned to the United States in the mid-1950s. They kept up a spirited correspondence, with Delaney sometimes writing to the younger artist daily. The letters spoke of a shared interest in philosophical ideas, painterly abstraction, religion, and men. Although Delaney and Calcagno never became lovers, they were in love with each other, expressing a remarkable clarity of affection and mutual dependence in their communications. The legibility and orderliness of Delaney's script, written in blue ballpoint pen on unlined paper, give no hint of his lifelong battle with mental illness. Calcagno (along with author James Baldwin and many others) was a life buoy who kept the artist afloat through many turbulent periods in his life, and Delaney saved and reread the letters his friend sent him, seeking in them a respite from the demons that plagued him.

Glenn Ligon
Artist
New York City

53 rue Serlingetore[?]
Paris April 28, 1963

Dear Larry:

I think of you this beautiful april morning I wish I could have coffee and conversation with you have been remembering many good moments including good people painting travel and living. While the weather is not warm its quite vital and devides itself into sunshine and rain. There is so much aitistic activity that it becomes imposiable for me to see all there is being exhibited you understand qust so much happens that one becomes very calm and see some and qust quietly withdraws because of limited energy. Paris already is full of strangers and many of them american. Its good to see so many coming over, I tell our friends of your coming exhibition in 64 they are delighted. Charley is begining to work again he is occupying himself with lithography now and so is qim legros. But I am doing gouches and oils not many but continually Its sort of been difficult for me to get under way but slowly it is happening, Have many plans but not too much occurs now worthy of mention, so will keep to the day by day which is work and visiting a few friends who also visit me and seeing shows and staying home and reading and remembering. you are always in my thoughts and I send my deepest to you and your dear friends there keep up the great work and soon you will hear from me again. Love Beauford

ARTHUR G. DOVE

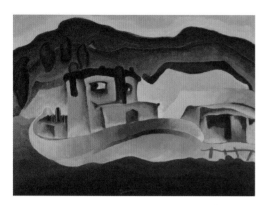

Arthur Dove, The Bessie of New York, *1932.*
Baltimore Museum of Art.

>> *Draft of a letter to Duncan Phillips, May 1933*

In May of 1933, Arthur G. Dove drafted a series of responses to collector and gallery director Duncan Phillips's proposal that he cut *The Bessie of New York* (see illustration) in half. Phillips had attempted to convince Dove he could improve the painting by eliminating the suggestion of a boat with eyes on the left. Phillips had offered to buy the revised painting, including photographs of a cropped canvas that Dove mentions at the bottom of one of the drafts.

Dove could not tell Phillips how repugnant severing a finished canvas seemed; the painter's precarious financial situation made the collector's continued patronage vital. Here, Dove's tight, controlled pencil script masks his indignation and belies the roundabout, deferential reasoning of his words. Dove composed other replies to Phillips's idea in looser script, crossing out and adding words as if to work through the delicate situation in text. Although his strokes differ markedly from the meandering organic lines acclaimed in his drawings, Dove found a way to keep both his painting and relationship with Phillips intact through the practice of handwriting. Ultimately Phillips did not purchase *The Bessie of New York* but remained an avid champion of Dove's work.

Lauren Kroiz
Assistant Professor, History of Art Department
University of California, Berkeley

Dear Mr Phillips

Your letter is the most
amazing sort of criticism that
I have ever had. When you take
the privilege of sawing my
picture in half it matters
not much to me but I should
think that you should think
better than sawing a picture
in half.

I have come to the point
of not caring whether you
are interested in buying it
or not because my love went
into the picture and if
you cut my love in half
that's your trouble—

Photographs of the paintings
were very fine but the
cutting off a portion of what
was meant to be taken away
something that you have
no right to do.

I've been very grateful to
you for what you have done
for me, and I am being
ungrateful for what you
are undoing in a case
like this—

I hope you will consider
my frankness so that I
can be still more frank
in telling you that
I think your cutting
my picture in two
was rather preposterous

MARCEL DUCHAMP

*Marcel Duchamp, 1950. Photograph by
Robert Bruce Inverarity.*

>> *Letter to Suzanne Duchamp,
January 15, 1916*

>> *Letter to Jean Crotti and
Suzanne Duchamp, August 17, 1952*

During his career Marcel Duchamp produced
various boxed collections of pictorial facsimiles
of his handwritten notes, demonstrating his
interest in the nuance of ink on paper. In a 1916
letter to his sister Suzanne, the artist first uses
the word *readymade* to designate the conceptual
transformation of everyday objects into art.
He emphasizes the term with quotation marks
and encircles *crise*, suggesting the threat to
tradition his innovation represented.

In a 1952 letter to Suzanne and her husband,
Jean Crotti, Duchamp indicates that some of his remarks are intended
for Crotti with an arrow connecting *Tu* (you) to his name. In a letter
filled with oblique references to his own body of work, Duchamp's
inclusion of a purple stamp (testifying to the "telegraphique" style
of the writing, for correspondence that is running late) provides a nod
to *The Bride Stripped Bare by Her Bachelors, Even*, which Duchamp
described as a "delay in glass."

Anne Collins Goodyear
Co-Director
Bowdoin College Museum of Art

Ici, à N. Y., j'ai acheté des objets dans le même goût et je les traite comme des "readymade", tu sais assez d'anglais pour comprendre le sens de "tout fait" que je donne à ces objets — Je les signe et je leur donne une inscription en anglais. Je te donne qques exemples:

J'ai par exemple une grande pelle à neige sur laquelle j'ai inscrit en bas: In advance of the broken arm. traduction française: En avance du bras cassé — Ne t'efforce pas trop à comprendre dans le sens romantique ou impressionniste ou cubiste. — Cela n'a aucun rapport avec;

un autre "readymade" s'appelle : Emergency in favor of twice. traduction française possible: Danger (crise) en faveur de 2 fois.

Tout ce préambule pour te dire :

Prends pour toi ce porte bouteilles. J'en fais un "Readymade" à distance. Tu inscriras en bas et à l'intérieur du cercle du bas. en petites lettres peintes avec un pinceau à l'huile en couleur blanc d'argent la phre inscription que je vais te donner ci après. et tu signeras de la même écriture comme suit :

[d'après] Marcel Duchamp.

17 août 52

Cher Jean Chère Suzanne

Tu as dû te demander ce que je faisais
après m'avoir envoyé ta longue lettre sur
l'expo Sweeney!

Tout à fait d'accord avec toi — sans
oublier que Sweeney a dû organiser
toute cette expo. en 6 semaines (avant
l'ouverture), je sais qu'il n'a pas pu
faire autre chose que de l'à peu près,
et malheureusement trop suivre son
goût (qui n'est d'ailleurs pas mauvais)

je ne rappelle que dans mes conversations
avec lui à ce sujet, je lui avais suggéré
l'idée de donner au moins un
petit panneau (tout petit) à Dada qui
est une des manifestations certaines
des 50 dernières années. — il n'en a
rien fait, naturellement.

A ce propos Janis organise une expo Dada

pour mars ou avril 1953 — il me charge
de l'organisation des idées de cette expo. — et du
coté paris parisien — je voudrais avoir
ton clown sur verre (fait à N.Y. ?)

Si tu veux l'envoyer tout de suite par
le fils de Marthe Pelletier qui part pour
N.Y. sur le Queen Mary du 3 Sept., peut
être auras tu encore le temps. En tout cas
ce n'est pas pressé — je trouve que c'est
mieux de l'envoyer par quelqu'un. ——
en fait Rose Fried pourra le ramener
en à son retour en Octobre.

Si tu penses à autre chose de la même
époque, dis le moi —

merci pour les articles de Suisse et de Carrouges
à qui je n'ai pas encore écrit.

La sœur de Katherine Dreier, Mary Dreier, m'a
donné pour toi et Gaby 2 châles espagnols très
beaux comme souvenir — je te les fais apporter
par Rose Fried (elle part le 12 Sept., te dirai le bateau
une autre fois) — Vous déciderez Gaby et toi lequel
va à qui. — Tu remercieras Mary Dreier après réception
Miss Mary Dreier 24 West 55th St. New York.

Suzanne le reste et t'il des dépôts en aquarelle Dada que tu voudrais exposer? D'une L. à Rose Fried

THOMAS EAKINS

1844–1916

Thomas Eakins, ca. 1870.
Photographer unknown.

>> *Letter to Frances Eakins,*
March 26, 1869

Thomas Eakins's father, Benjamin, made a living as
a writing master, teaching handwriting in Philadelphia
schools and drafting official documents, such as
diplomas and deeds. As a consequence, all of the Eakins
children learned to write a beautiful hand and some-
times even assisted their father with diplomas during
the busy graduation season. Eakins often used a highly
controlled and elegant style of writing in his professional
correspondence. His letters to his family, however,
were frequently less formal and show a side of the artist not often seen.
While Eakins became known for meticulously constructed pictures,
in letters like this one to his eldest sister, Frances (Fanny), his hurried
penmanship, rife with crossed-out words, reveals the artist in the
process of thinking — something he would take pains to efface from
his art. Eakins's letters show a degree of freedom that can be glimpsed
only on rare occasions in the artist's oil sketches.

Akela Reason
Associate Professor of History
University of Georgia

Dear Fanny I ~~have~~ got your ~~letter~~ last ~~Sunday~~
afternoon. I was very anxious about it ~~for~~ I
knew you would write to me to tell me
about ~~mummy~~. We are both at work at our
schools. Bill is at Yvon's & likes it very much.
& I was wondering till I got here whether
Bill & I would do better to ~~sto~~ take a studio
between us or stay ~~with~~ in Crepon's studio
~~till~~ at least till Sartain ~~came~~ back from
Italy. When we went to see Crepon he
received us not over warmly & Bill Sartain
especially coldly. Next day I was over there to
cover some canvasses & when I got nearly through
Crepon said My! how strong that paint smells
I'm afraid it will hurt the boy & give him
colics. So I took up my canvasses & carried them
back to the canvass shop. Next day I told ~~him~~
it was indifferent to us whether we staid with
him or took a studio to ourselves, so he thought
we had better take one ourselves ~~fo~~ on our account
& on that of his wife & boy. This was very sensible
& just & we are all better pleased than if we had
staid together. But there was no occasion for ~~such~~
any exhibition of coolness & he should have ~~let me~~
~~speak~~ had a little patience & let me speak my
intentions & wishes before discovering any humor or
~~should~~
~~have spoken himself~~ When I took my studio
in West St. first I asked him to ~~~~ stay
with me for company & he came up for he was
living on the ground floor & the water was streaming
always down the walls so that the doctor said they
would die if they staid there & he & his wife
& child all staid in my studio except to
sleep & I was very glad to have them there

HOWARD FINSTER

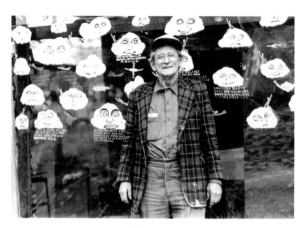

Reverend Howard Finster in Paradise Garden, Pennville, Georgia, April 1985. Photograph by Liza Kirwin.

>> *Letter to Barbara Shissler, 1981*

The Reverend Howard Finster, a Baptist preacher, banjo picker, and visionary artist from the tiny town of Pennville, Georgia, first gained national exposure with guest spots on *The Tonight Show* and *Late Night with David Letterman.*

Finster was a consummate entertainer and an old-timey Bible-belt evangelist. His handwriting, most often in block capitals, was like his preaching — purposeful, emphatic, and an integral part of his art, his "sermons in paint." In this letter to curator Barbara Shissler, he wrote about his upcoming trip to Washington, DC, for the opening of the exhibition *More than Land or Sky: Art from Appalachia* (held at what is now the Smithsonian American Art Museum). He associated the city with notable men and then filled the page with his text in block letters, curving around and suspending his illustrations in one long, run-on sentence. Finster, who rarely paused in life or in conversation, had little use for punctuation.

One wonders how William Henry Harrison ranked with the likes of the others, or why Finster considered Shakespeare in this context, but it was his unusual associations, his divine visions, that made his messages and his mission to spread The Word so compelling.

Liza Kirwin
Deputy Director
Archives of American Art, Smithsonian Institution

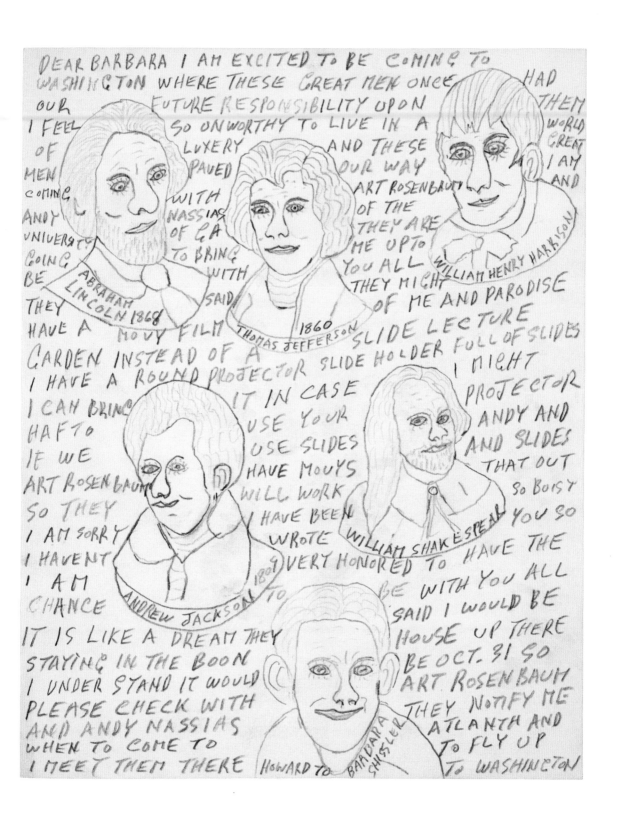

DAN FLAVIN

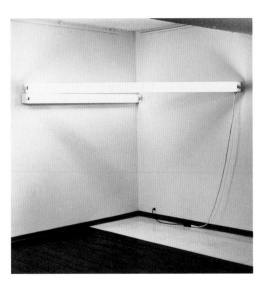

Installation view of Untitled *(1966) by Dan Flavin
in the* 10 *exhibition in Los Angeles, May 2–27, 1967.
Photograph by Virginia Dwan.*

>> *Letter to Ellen H. Johnson,
January 22, 1979*

The formality of Dan Flavin's hand-writing, which retains the look (with a personalized flourish) of the conventional cursive taught in grade school, is surprising in comparison to his radical art using electric light. Whereas his art resists associations with the handmade and has an inherently temporal quality, his letters — first inscribed in a journal, then copied in black ink on unlined paper — are carefully rendered personal accounts meant to last and presumably to record the life of the artist. By handwriting his letters and including long discourses on events in his life, Flavin seems to adopt the tradition of artists' correspondence, in which letters reveal and record the person. This old-school practice is paralleled by his interest in nineteenth-century American landscape artists such as John Frederick Kensett, whom he discusses in this letter to art historian and curator Ellen H. Johnson. Despite his progressive art, Flavin was an artist who embraced the past.

Tiffany Bell
Art historian and former project director
of the Dan Flavin catalogue raisonné

January 2, 1979
East Point

Ellen, John Paul Driscoll's catalogue of the two Kensett – Colyer albums exposition, last year, at Penn State's Museum any in the originating Babcock Galleries in Manhattan addresses the attributions of Kensetts drawings with cartoon similar to yours. He seemed to be indicating that only several certainly creditable drawings existed outside of the contents of the albums (Finally, Driscoll credited all of the Detroit Institute's "Kensetts" to Casilear.) That was another inducement of my purchase. I sensed fortunate indeed to have decided to start the collection seriously just as such prime material was available to me. By the way, my foundation friends have authorized me to purchase seven additional drawings. Our plans have expanded to a large Museum of the Hudson Highlands, most importantly dedicated to the history of my arts' along with the drawing collection of Hudson, River Valley artists. These nice folks want me to become an artist–curator of sorts. I'm flattered by the offer. I've accepted the dual responsibility. Negotiations have begun for the acquisition of a building near the river on a grand site. Within two weeks, I should know much more about the possible property purchase. If all goes reasonably well, the new museum (I'm uncomfortable with the standard sense of a museum.), should be

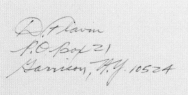

D. St. Leven
P.O. Box 21
Garrison, N.Y. 10524

Ellen Johnson
The Art Department
The University of California
at Santa Barbara
Santa Barbara, California 93106

LLYN FOULKES

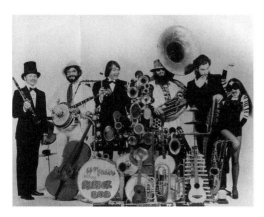

The Rubber Band, 1974. From left to right: Mike Baird, John Forsha, Llyn Foulkes, Paul Woltz, Alan McGill, and Vetza Escobar. Photograph by William Erickson.

» *Letter to Darthea Speyer, ca. 1975*

With his sloping script Llyn Foulkes addresses Darthea Speyer, who organized two solo exhibitions, in 1970 and 1975, for the artist at her gallery in Paris. The letter ends with a sketch, placing a framed painting in a western landscape. Although Foulkes during the 1970s devoted most of his canvases to his bloodied heads series (one of which, *China Town,* he mentions in this letter), his sketch harkens to his landscapes of the early 1960s. Is it an attempt to soften his comments in the letter's postscript, which underscore his need for money? The radial lines surrounding the painting single it (and its presumed author) out as quite the thing, perhaps worthy of financial reward. It might be that the painting has paused in its path toward the horizon and is wheeling from America to Paris to be sold, the dashes around it indicating its urgent speed.

The body of the letter informs Speyer that his musical ensemble, the Rubber Band, is to play at the opening of the show *Collage and Assemblage in Southern California* at the Los Angeles Institute of Contemporary Art. Foulkes concluded a subsequent letter to Speyer with a sketch featuring "THE RUBBER BAND" written in block letters receding into the landscape. Image, sound, writing — Foulkes's letters, like his paintings and his life, confuse, conflate, and play with them.

Cécile Whiting
Chancellor's Professor of Art History and Professor of Visual Studies
University of California, Irvine

for 3 weeks. Am trying to catch up. The band is playing for the opening of the assemblage show.

Write to me if there is any problem Thanks

Flynn

P.S. I haven't received money for smaller paintings sold at your gallery. I ran into someone, who bought one from you, at the opening in N.Y.

JOHN HABERLE

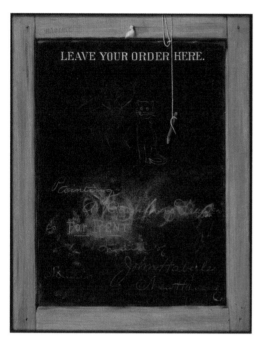

John Haberle, The Slate, *ca. 1895. Museum of Fine Arts, Boston.*

>> *Letter to Sarah "Sadie" Emack Haberle, June 20, 1895*

In this letter written to his wife from New York City, the New Haven painter John Haberle exhibits the playful sense of humor and gift for storytelling that set his trompe l'oeil still lifes apart from others painted in this idiom during the late nineteenth century. Signed with his nickname, "Happy," this affectionate note presents the artist's visit to the Central Park Zoo as a delightful adventure. The loose and loopy letters, hasty corrections, ink smudges, and repetition of the word "then" in the second-to-last line of the second page suggest the swift pace and energy with which Haberle composed his narrative, which catalogs the activities of the animals he encountered while waiting for the Metropolitan Museum of Art to open. Entering into dialogue with his "old friend" the monkey, Haberle muses on the Darwinian order of the species, reversing it to favor the "monk" (an abbreviation that playfully elevates the creature with spiritual purpose). This kind of wordplay suffuses the series of chalkboard paintings on which the artist was at work at this time, rich fields of typographical variation, of industrial letterforms contrasted with the loopy cursive we see here, with the occasional smirking animal thrown in (see *The Slate* [1895]).

Jennifer A. Greenhill
Associate Professor of Art History
University of Southern California

either but shook his tail defiantly in my face. if looked like the tail of a fat turtle - the axis deer were the only animals (+ they are spotted beauties) in the building containing the two rows of stalls. I said the only animal I meant the only in captivity. there were plenty of little mice about. the Hippopotamus's looked warm + as if they had just rec'd a coat of stove polish. there were signs about these animals that I did not see on the cages in Lion house - they read "Don't climb on the railings" a Leopard had two wooden balls in cage. they were his playthings as he was not allowed to play with children. Lazy Alligators were basking in the Sun. I thought it time to visit our old friends the Monkeys. One of them said he had heard that I was in town + expected me in. asked me how you were - told him you were taking care of our little one. He wanted to know what kind of a monkey it was - told him it was like me in every thing but looks. Well he said then it doesn't look like a monkey - just then then the rum faced keeper rushed in + asked what

MARSDEN HARTLEY

Marsden Hartley, Canuck Yankee Lumberjack at Old Orchard Beach, Maine, *1940–41. Hirshhorn Museum and Sculpture Garden.*

» *Letter to Helen and Ernest Stein, December 12, 1936*

» *Letter to Helen Stein, September 29, 1939*

Given the fact that the painter Marsden Hartley was a published poet and critic, his letters in the Archives of American Art are often disappointing because instead of eloquently expressing aesthetic ideas and feelings, he is more intent on trumpeting his own importance. His letter to Helen and Ernest Stein of December 12, 1936, is typical. He writes in a florid cursive script that looks pretty but is hard to read. Punctuation is limited to mostly dashes and an occasional period, as if his thoughts were pouring out in a passionate stream, and yet the content often seems contrived and pompous. How different this is from the rawness and expressive precision of his paintings! More unsettling is the letter's shift from talking about the drowning of the beloved Mason sons, the handsome fishermen children of the family he lived with in Nova Scotia, which left him "numb and speechless," to bragging about a favorable review of his essays by Marianne Moore.

Dear Helen & Ernest -

I am back from Canada now - and wonder how you both are - The summer for me was quite wonderful until Sep 19th - when the two superb sons of the family with whom I lived were drowned .- I have been numb and speechless since that time.

I wonder if you would be good enough to send the Kidder painting back to me at once by Parcel Post registered - as I would like to show it & it may be [?] Can it be protected and timely some tribute with fine ambitions of Kidder. I did consider able painting myself of course & am preparing material for a book on painting and painters.

a splendid piece of publicity came to me in the Nation of last Saturday written by Marianne Moore in her review of the new Caravan Book

27 Broadway
Bangor
Maine
Sep 29/39.

My dear Helen.

So nice to see your note. and I certainly wish I could say yes to your Thanksgiving idea. — at least I can certainly say yes in the spirit. but the flesh has a time selling itself across the street. so somehow it is by uncertainties. the

I have a real affection for Gloucester I swear — especially after the season — when the fancies get out. — [?] if the real men live there really. I don't know all that — I know nothing really but the awareness — and that I have — it would be fun to visit these sometimes I knew so well — out of season — for example. Ofm quiet would be nice now that everyone is gone. Provincetown — well some of them too then all the year — but I could name it —

Gloucester always has a certain something — gulls are there d'autre as Mallarmé says battle is an van and aboveness — somehow — and I must so have them un cly — + you must leave me to companshus. Beach again — God what a sense of infinity there is there — wasn't it me when [?] of summer and I meant then that time. one of the outstanding visions & that poem was an evenings well set up bathen — standing on his hunchs — with the little north of sea

But in a letter to Helen Stein alone (September 29, 1939), Hartley lets his guard down. Writing in a breathless script that runs across the page so fast it is difficult to decipher, he recalls a trip to the beach and a "well set up" male bather who was "fresh and clean and glowing." Forgetting for a moment that he was an underappreciated genius, Hartley expresses same-sex desire with a lack of self-consciousness that would have been unimaginable in his youth. In regard to the beauty of men it was not in his nature to stay numb and speechless forever.

Jonathan Weinberg
Painter and art historian

MARTIN JOHNSON HEADE

1819–1904

Martin Johnson Heade, Cattleya Orchid and Three Brazilian Hummingbirds, *1871. National Gallery of Art.*

>> *Letter to Frederic Edwin Church, April 27, May 6, June 16, 1868*

Martin Johnson Heade wrote this letter to his friend Frederic Church in several sittings while Church was traveling abroad and Heade was occupying his New York studio. Despite this residency, Heade reveals some insecurities about his place in Church's affections and priorities. Heade alternates among cajoling, needling, supplicating, and bragging to his more famous friend, regaling him with anecdotes, updating him with news, and pasting in a punning newspaper clipping. It is a self-consciously entertaining letter, with repeated, forlorn wishes for a letter in return.

Heade's handwriting similarly vacillates throughout the letter between the affectation of a relaxed, elongated script and a hunched, cramped style suggesting tension; it is irregular, with careless ink flow and hazily expanding letters. While Heade's paintings delineate every barb of a hummingbird's feather, every droplet in a crashing ocean wave, and each straw in a haystack, his script indicates no compulsion to dot his *i*'s or cross his *t*'s.

Ellery Foutch
Assistant Professor of American Studies
Middlebury College

Room 7. Studio building
N.Y. Ap. 27ᵗʰ

Mr. Church

Dear Sir:

I.d like to
know why you dont let us have a
bit of news from you occasionally.

I was able to pacify the people
for a while, but they are beginning
to stop me in the streets again, &
I want to soothe them with a little
information. I saw Mr. De Forest
a few days ago, but he had not
heard from you, "nor any other man".

The little picture that you daubed
for him is in the N.A. Exhibition.

The Ex. is rather better than usual.
I have one picture in — a storm.

I'm having a great run of sales
in Chicago, & hope it will continue.

Somebody out there wanted one of
my Salt Meadows, so I painted
one — a sun-rise — near Boston, in-
-tending to fill up the sky with clouds,
but a person who came in was so

WINSLOW HOMER

Winslow Homer, West Point, Prout's Neck, *1900.*
Clark Art Institute.

》 *Letter to Thomas B.*
Clarke, January 4, 1901

Winslow Homer possessed an arch sensibility that manifested itself in his correspondence through self-deprecating language and humorous graphic elements. In this letter to industrialist and collector Thomas B. Clarke, Homer employs wavelike flourishes of the pen as well as an extraordinary self-portrait to emphasize his claim that the painting *West Point, Prout's Neck* (1900, see illustration) was "the best" that he had painted. The cartoon not only testifies to Homer's sense of humor — it openly depicts the aging artist's bald pate — but also hints at his genius as a painter. In the little drawing Homer stands, palette in hand, before the great painting, with his right arm raised in a mysterious gesture. Is he holding a maulstick, working out some question of perspective? Tellingly, the dots on the horizon, placed where one would expect to see lights across Saco Bay, are absent in the finished painting. By erasing human presence, Homer rendered the Atlantic Ocean boundless and created a timeless narrative of wave on rock.

Thomas Denenberg
Director
Shelburne Museum

Scarboro' Me
Jan 4 1901

my dear Mr Clarke

I send today
to Mr Knoedler
the last of the
three pictures that
you are to have
on the Union League

I consider it

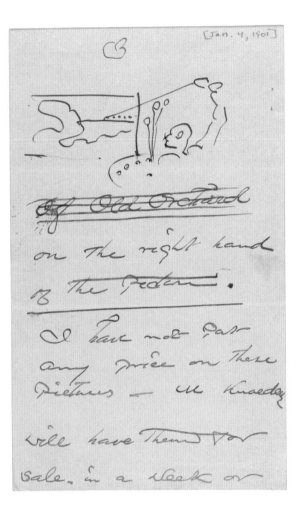

~~of~~ Old Orchard

on the right hand
of the Picture.

I have not put
any price on these
pictures — Mr Knoedler
will have them for
sale in a week or

79

HARRIET HOSMER

1830–1908

Patricia Cronin, Harriet Hosmer, Frontispiece, *from* Harriet Hosmer: Lost and Found, A Catalogue Raisonné.

>> *Letter to "Sir James,"*
August 13, after 1852

Harriet Hosmer's independence, gregarious-ness, quick wit, and keen intelligence are evident in this letter. She oscillates between flirtatious playfulness and addressing the unidentified "Sir James" as an equal, quoting Latin (*Verbum Sapienti* — a word to the wise) and finding metaphors in batteries and brakes. To make her acclaimed neoclassical sculptures, Hosmer started by modeling wet clay with her hands, then refined her designs on plaster casts and ultimately carved large blocks of marble. Sculpture was almost exclusively about the sense of touch, so it is surprising how Hosmer's hand-writing economically skims across the page.

Since neoclassicism aspired to the perfection of idealized, balanced forms, inspired by ancient Greek and Roman sculpture, it is curious to see her large, scrawling script slanting con-sistently downwards. Covering four pages, Hosmer's writing sheds light on her sense of self-worth as a woman in the world and speaks to her ambition with regard to the monumentality of her sculptures.

Patricia Cronin
Artist and Professor of Art
Brooklyn College of The City University of New York

the circumstances, to
the site in which I am
penning these lines!
Destiny and the Engineer
have named it — Union
Square !!!

Verbum Sapienti

There is one point, however,
my dear Sir James, upon
which it were well to
arrive at a speedy
understanding — You are
aware that the even tenor
of my earlier youth has
been largely perturbed by
what we might call,
astronomically speaking,
the librations of your sex.
I may add that it is not
my intention to countenance
similar librations in
the future, persuaded

as I now am, that they
would undermine not only
any ordinary constitution
but would be (sufficient to
enfeeble even a Westinghouse
brake. I have sustained
with considerable fortitude
211 of these moral
concussions but the entire
Medical Faculty concur
with me in the opinion
that the 212th might
produce, not only paralysis
of the heart, but paralogism
of the brain, and will
kindly furnish me with
a certificate to that
effect, which I shall
enclose anon in a registered
letter, along with a sonnet
to "Sympathy" which I
have already commenced
and dedicated to J. L.

RAY JOHNSON

Ray Johnson, mail art sent to John Held, April 7, 1981, announcing the Ray Johnson Dollar Bill Show *exhibit at Richard L. Feigen & Co., April 3 – May 5, 1981.*

» *Letter to Eva Lee, September 15, 1969*

Ray Johnson was the founder of the mail art network the New York Correspondance [*sic*] School (NYCS). Eva Lee, the recipient of this missive, was the owner of the Eva Lee Gallery in Great Neck, New York, only a half hour from Johnson's home in Locust Valley, Long Island. This quick note — a simple hello, printed in red marker in childlike capitals, with Johnson's signature bunny head, a lighthearted self-portrait that appears throughout his work — is a friendly invitation to join the NYCS. There is nothing pretentious about the handwriting; it is inviting, almost playful.

In an oral history interview conducted by Sevim Fesci for the Archives of American Art in 1968, Johnson stated that he was particularly interested in handwriting, especially how it would change depending on the intended reader: perhaps cursive for a more formal recipient or casual print for someone familiar. Eva Lee's note is a chummy, handwritten hello, scripted in unpresumptuous, free-spirited letters, hand-delivered to a new friend — as personal a communication as the written word will allow. One can picture Johnson's smile as he slides it under Lee's gallery door, anticipating his new friend's delighted response.

Gillian Pistell
PhD candidate in Art History
The Graduate Center, CUNY

CORITA KENT

Corita Kent, that they may have life, 1964; mailed to Ben Shahn, March 1965.

>> *Letter to Ben Shahn, ca. 1960*

"In the beginning was the word." Nowhere is this biblical statement truer than in the art of Corita Kent. The graphic, pictorial qualities of text were central to Kent's work, particularly as she drew from and manipulated the language of advertising. Sometimes known as "the Pop art nun," she made prints that twisted, fragmented, and celebrated the formal aspects of words as she commented on issues of social justice and spirituality. "It is the long, hard discipline in the school of lettering types and forms," she once commented, "that makes the playful treatment of letters a thing of grace."

Her signature handwriting (which has spawned many imitators) appears both calligraphic and casual, balancing rigor with fluidity. Kent also frequently used more clunky characters, as in her print *Enriched Bread* (based on the packaging for Wonder Bread), which gives the mass-produced product a hand-drawn, personal spin. The small red circles under the logo contain a more jagged, urgent version of her writing, to comment on hunger and poverty.

A natural designer, she thought seriously about spacing: in this correspondence to Ben Shahn, note the seemingly effortless justification of her margins. All script was of fascination to Kent: she asks Shahn to write on "some big old piece of paper" the Hebrew alphabet, or suggest a source for any "beautifully written" examples — a letter, thus, about her persistent love of letters.

Julia Bryan-Wilson
Associate Professor, History of Art Department
University of California, Berkeley

Greetings to you !

and thank you for your beautiful Christmas card.

We are still trying to figure out how it was printed but a little of the mysterious is probably very healthy.

We do want you to know too about all the special kind of delight you bring to a great number of people by all your books, book jackets and illustrations that pop into view whenever we turn around. Ounce, Dice, Trice was especially good.

I have a completely fantastic request to make of you - please don't hesitate to say no if is too fantastic. My brother and I have both begun an amateur's approach to Hebrew. He has actually begun (lives in N.Y.) I have only started carrying a book around with me. He was the one who thought of asking you to write on some big old piece of paper with a chisel edged pen or two pencils fastened together the Hebrew alphabet.

Or if you haven't time for this perhaps you could suggest a source where we could get some beautifully written ones.

We hope to see you one of these times when we are East - if we get back. We were there just before Christmas but things didn't work out that way.

May you have a wonderful year - Gratefully - Sister Mary Corita, I. H. M.

SISTER MARY PAULITA (HELEN) KERRIGAN, B.V.M.

1921–

RAINY DAY COURSE . . . Sister Mary Paulita of the Sisters of Charity from Clarke College, Dubuque, Iowa, doesn't let a little rain spoil her study of building construction. She is sketching the work at the site of a new skyscraper at 52nd Street and Avenue of the Americas. The nun is taking summer art courses at the Art Students League. The construction site has a block-long front of plexiglass to accomodate sidewalk superintendents. *Journal-American Photo by Vincent Lopez*

"Rainy Day Course," newspaper clipping enclosed in the letter.

» *Letter to Charles Alston, August 19, 1962*

Sister Mary Paulita Kerrigan, a member of the Sisters of Charity of the Blessed Virgin Mary, devoted her professional life to painting and teaching. Although she began her career as an elementary and high school teacher, she served for forty-eight years as an art professor and later as artist-in-residence at Clarke College in Dubuque, Iowa. She worked in a variety of genres ranging from liturgical art to portraiture.

In 1962 she left Iowa with another sister artist to spend the summer studying at the Art Students League of New York, sketching in the streets of Manhattan and painting in a studio. As she remarked in this thank-you letter to Charles Alston, noted painter and sculptor of the Harlem Renaissance, she enjoyed her time in the city and benefited from his criticism.

Her handwriting bears the hallmarks of the Palmer Method of penmanship: it is clear, legible, curvilinear, and efficient. The Palmer Method was a popular pedagogy, especially in Catholic parochial schools in the United States throughout the twentieth century. Through repetitive drills, children acquired a fluency in cursive. Kerrigan's slanted loops and ovals connect letters to form words with a flowing grace.

Kelly Quinn
Terra Foundation Project Manager for Online Scholarly and Educational Initiatives
Archives of American Art, Smithsonian Institution

Clarke College
Dubuque, Iowa

August 19, 1962

Dear Mr. Alston,

Now that we have reached the quiet little city of Dubuque, I have been looking back with pleasure on the wonderful summer of study at the League! I surely appreciate your excellent criticisms and help in painting.

May you have a happy and successful year.

Sincerely,

Sister Mary Paulita,
B.V.M.

LEE KRASNER

Lee Krasner, ca. 1942. Photograph by Maurice Berezov.

» *Letter to Jackson Pollock, July 21, 1956*

This newsy letter from Lee, in small, neat script written to fit one aerogram page, was penned to Jackson Pollock in midsummer 1956, during a period of trial separation. On her first trip to Europe, Krasner somewhat breathlessly chronicles the lively doings of friends in Paris and visits to Left Bank galleries and the "overwhelming" Louvre. Appending that "the painting hear [*sic*] is unbelievably bad," she probably anticipated Jackson's wry smile. This was likely the last communication Krasner ever had with Pollock, who died August 11 in a drunken car crash (his mistress survived). After we read her note that he had sent roses to her hotel and her wish that he were sharing Paris with her, her postscript "How are you Jackson?" with its expressive parentheses seems particularly poignant. Krasner would never get to the south of France or Venice. She returned home instead to bury her husband.

Ellen G. Landau
Andrew W. Mellon Professor Emerita in the Humanities
Case Western Reserve University

Sat—

Dear Jackson—

I'm staying at the Hôtel Quai Voltaire, Quai Voltaire
Paris, until Sat the 28 then going to the South of
France to visit with the Gimpel's + I hope to get
to Venice about the ~~end~~ early part of August— It
all seems like a dream— The Jenkins, Paul + Esther
were very kind, in fact I don't think I'd have
had a chance without them— Thursday nite
ended up in a Latin quarter dive, with Betty
Parsons, David who works at Sindney's Helen Franken
thaler, The Jenkins, Sidney Gist + I don't remember
who else, all dancing like mad— Went to the flea
market with John Graham yesterday— saw all the
left-bank galleries, met Druin and several other
dealers (Tapie, Stadler etc). am going to do the
right bank galleries next week — + entered the
Louvre which is just ~~an~~ across the Seine outside
my balcony which opens on it — About the "Louvre"
I can ~~say anything~~— It is overwhelming — ~~beyond~~
beyond belief— I miss you + wish you were ~~here~~
~~sharing~~ this with me— The roses were the most beautiful
deep red— Kiss Gyp + Ahab for me— It would be
~~wonderful to~~ get a note from you. Love Lee —
The painting here is unbelievably bad (How are you)
 Jackson?

JACOB LAWRENCE

Jacob Lawrence in a US Coast Guard uniform, 1944. Photograph by Arnold Newman.

>> *Letter to Edith Halpert, January 1944*

Jacob Lawrence's handwriting reflects his personality and his style of artwork: planned in advance, carefully executed, yet revealing the emotional man in its details. The Archives of American Art contains few drafts of letters; similarly, Lawrence rarely made preliminary sketches of his art.

His cursive capital *I* is curious. Its tail swings way to the left and the single letter appears to morph into his initials, *JL*. Written when he was in the Coast Guard, this poignant letter ends with the request "tell Lawrence Hello for me." Does he refer to himself? There seems to have been no other Lawrence on Halpert's staff or among mutual associates. Next he crosses out the beginning of "I intend," replacing it with "Intend." These slips suggest an ego valiantly battling the anxieties of living in a hostile and "very dead" southern town.

Realism, for Lawrence, was clearly inadequate. Instead he wanted to create powerful symbols capable of expressing the feelings of alienation generated by living where "the people are without feeling." He even imagined a book devoted to symbolic images of fascism in the South. Today, only two drawings exist from this series, *Starvation* and *Killing the Incurable and Aged*. We can only speculate that others were lost or that he abandoned the project when transferred to Boston in late February 1944.

Patricia Hills
Professor Emerita, History of Art and Architecture
Boston University

U. S. COAST GUARD TRAINING STATION
ST. AUGUSTINE, FLORIDA

Jacob Lawrence
St. M. ³⁄c (1021-097)

Dear Mrs. Halpert,

How are you? I recieved
your letter and was very glad to hear
that you had made a few sales for me.
I recieved the check from the Whitney
Museum for the picture "tomestones"
which they purchased.

Although I am working
steadily it will probably be
several months before you recieve
any work from me. I am doing
some drawings on the south. They
are being done in pen and ink. I
have not decided as yet if I will do
them in color or leave them as they
are. Although I would like to do
some paintings on the Coast
Guard, I am afraid I will not

LOUIS LOZOWICK

Louis Lozowick, ca. 1916.

>> *Letter to Adele Lozowick, July 15, 1932*

Louis Lozowick wrote this charmingly informative letter to his wife of one year, Adele, while he was staying at Triuna Island, part of Yaddo, the artists' retreat center in Saratoga Springs, New York. He must have missed her a great deal, but residents were forbidden to bring family members. The tone of the letter is light, although Lozowick describes how hard he is working.

By the early 1930s he had abandoned the jazzy, angular designs of semiabstract urban centers that he had created in the previous decade. Instead he refocused his interest in urban modernity by producing highly detailed, beautifully designed realistic lithographs that depict the development of New York's dramatic infrastructure of skyscrapers, bridges, and elevated trains, as well as respectful representations of the workers who built them.

In contrast to the angularity of these machine-age subjects, Lozowick's handwriting seems very calm and graceful. He was fluent in several languages with distinctly different alphabets, including Russian, Yiddish, French, and German, and he seems almost to draw rather than scribble his characters. The evenly spaced words and level lines also belie the intensity of the writer's passionate convictions about social justice, ideas that began to emerge more clearly in Lozowick's artworks and his political affiliations during the 1930s.

Helen Langa
Associate Professor of Art History
American University

LOUIS LOZOWICK

Here is one of my companions of the evening.

Clever little bastards (or is he?—bastard, I mean); and likes to tease. Brushes by past you just about touching you. Then whiz! Off like a bullet. I think I'll tame one and adopt it as a pet. Perhaps I ought to train a few of them for a circus. That would be novel and might even help fill the pot in these days of depression.

Which reminds me. Since next winter looks at best rather uncertain I hope to turn out enough work here so that I can take time off next winter to hustle for the wherewithal. And that's another reason why my stay here is import-

GRANDMA MOSES

Grandma Moses painting at her kitchen table, 1952. Photograph by Ifor Thomas. Grandma Moses Properties Co., New York.

» *Christmas card to Frances Greer, ca. 1950*

» *Letter to Frances and Mary Virginia Greer, December 26, 1953*

The handwriting of Grandma Moses reflects the mood and pace of her days, as well as the nature of the task at hand. Ranging from fancy to plain, Moses's execution mirrors the twin roles she played: the artist and the farmwife.

The solitary Christmas card signature is evidence that Moses could turn out a cultivated script when she took the time. The writing style in her letters to friends and family, however, defaults quickly from elegant flourishes into a pleasant and practical — grandmotherly — forward-leaning script. Legibility falls increasingly by the wayside as Moses attempts to negotiate a demanding schedule, a high volume of family news, and a limited amount of space on which to write. For Moses, writing may have been very similar to both needlework and painting: an everyday act for lovingly recording, sharing, and remembering the riches of family life.

Leslie Umberger
Curator of Folk and Self-taught Art
Smithsonian American Art Museum

EgleBridge. Dec 26. 1953. all is well
here and I trust my friends are elce where, where,
we were over with Forrest and Mary yesterday,
Had a lovely Christmass dinner,
The were 12 of us at the table, a happy lot,
you see now my Famaly have scattred out
and each goes with his wives people,
some day I will try to send you a
picture of them, that is some of them,
It has been a warm winter here,
Picked a dandelion in the yard, yesterday,
no snow here on the river as yet,
Orca is here came home from Calforna
2½ years ago with some ChinChillays,
from thir ranch, to see how they
would do in this Climate,
they have did fine, has now ove 80.
here,
mrs Cook has come here from the
ranch and will take back some of
them for sale after the first of the year,
I will miss her she is such good company,
may be you don't Know where we
are livin now, you remember
where Mary and Forrest lived,
well now they live in a new
house just across there garden,
they have sold the old house,
Geral, you remember thir oldest

even they are,
Boy, he and his wife and 2 Boys, live just acrost the oil
Kill, in a new house, and Carol and his wife and 3
little girls live in a new house just across the
road from Pearls,
and my new house is in the same field about ¼
mile from Carls, and about ¼ from the old Home
thats you Know, down across the meadow where we
picked Chicorie. Edward and his wife and four Children
and his mother and sister live in the Home stead,
I'm down here with Ona, my way, and most everof
So I can see them all Every week and down
day, Loyed and alice and thir three Boys are down
on thir same farm, mrs Cook will go back to
Calforna the 7 and in tends to come back the first
of march, they are to buy a Ranch over in
Vermont and live there, the California ranch is
up near the Donorpass, so far from Loving where,

ROBERT MOTHERWELL 1915–91

*Robert Motherwell writing in Amagansett, New York,
June 1944.*

**» *Letter to Joseph Cornell,
February 18, 1950***

Robert Motherwell discovered
his artistic voice through the
Surrealist practice of "psychic
automatism," or drawing with
no preconceived notions in order
to discover visual ideas. Psychic
automatism was, Motherwell
explained, a kind of scribbling or
doodling, although he practiced
his doodling on a grand scale. Even people who doodle on a pad while
talking on the telephone will reveal something of themselves in
the pressure of the pen or weight of a line. So it is with handwriting.

This letter to Joseph Cornell, written in 1950 as Motherwell
prepared for the first exhibition of his *Elegy to the Spanish Republic*
series, is notable for the rhythmic pattern of long, insistent vertical
lines and the compression of the letters in between. This is not
dissimilar to the vertical bars and compressed ovals that would make
up the *Elegy* series. The writing displays the confidence of an artist
coming into his own.

Tim Clifford
Artist and former Chief Researcher of the
Robert Motherwell Catalogue Raisonné Project
Dedalus Foundation

I will have to make you something
wordless, though it may originate
in something herbal, perhaps
un coup de dès — but you know
how long it takes for a complete
conception to develop, I know you
know because you are the only
complete "artist this country has,
+ it fills me with rage to
read the triviality with
which your radiant show
was reviewed. But the effect
of it on other artists has

ISAMU NOGUCHI

Isamu Noguchi, 1924. Photographer unknown. Isamu Noguchi Foundation and Garden Museum.

≫ *Letter to Andrée Ruellan, April 12, 1924*

Born in Los Angeles, Isamu Noguchi spent his formative years in Japan. It's hard to know if this freed him from the rigorous copybook practice of the day — in which students learned their letters according to strict guidelines — but Noguchi's script is airy and open in this buoyant love letter to his love in Paris. The handwriting, a loose cursive that appears more modern than the standard copperplate, is consistent with Noguchi's writing style throughout his life. What is obvious here is Noguchi's happiness and sentimentality, as an artist just beginning to develop his craft.

Presumably he wishes to be alongside his beloved, fellow artist Andrée Ruellan, in Paris, then very much the center of the art world and a place that he would visit for the first time in 1927. Noguchi and Ruellan remained friends for many years. Both artists went on to enjoy long and productive careers. Noguchi was based in New York City, with extensive travels around the world. Ruellan married fellow artist John W. Taylor in Paris, and the couple returned to the United States in 1929. Ruellan lived near the artist colony at Woodstock, New York, for the rest of her life.

Heidi B. Coleman
Archivist
The Noguchi Museum

TELEPHONE CIRCLE 2500

JOHN M GINSBURG — OWNERSHIP MANAGEMENT — HARRY B. SLADON

Hotel Harding
54TH ST., AT BROADWAY
NEW YORK CITY

Dear Andrée,

I'm so happy to
have heard from you — but
don't know what to write —
I want to speak to you to
no one else — at supper the
orchestra was playing "Why
do I love you" and you will
surely not object to one becoming
sentimentally reminiscent at
this distance 🚢 It really
exasperates me to think that
you are so far away — a
part of me seems closed to
me and I am almost another

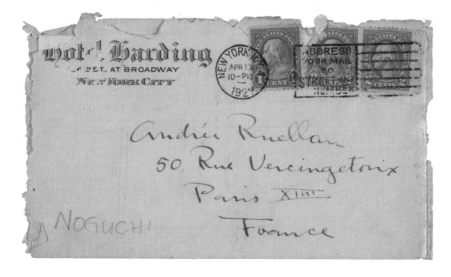

Hotel Harding
54 ST., AT BROADWAY
NEW YORK CITY

NEW YORK
APR 1?
10-PM
192?

ADDRESS
YOUR MAIL
TO
STREET AND
NUMBER

Andrée Ruellan
50 Rue Vercingetorix
Paris XIV
France

NOGUCHI

99

JIM NUTT

Jim Nutt, More More, *1986 (back view).*
Museum of Contemporary Art, Chicago.

>> *Letter to Don and Alice Baum,*
May 1, 1969

Jim Nutt's handwriting consists of an almost childlike printing, resembling that of today's young people. Educated in mid-twentieth-century public schools, however, Nutt certainly would have learned cursive. In this letter discussing a 1975 exhibition at the Museum of Contemporary Art, Chicago, Nutt's spare, modest script (featuring the odd capital letter thrown in here and there) comfortably matches his unprepossessing physical presence — he has been described by his wife, Gladys Nilsson, as appearing more like an insurance salesman than the stereotype of an artist. His handwriting is in stark contrast to the oversized, exaggerated lettering he fashioned for the texts that punctuate his raucous, brightly colored paintings of the 1960s and early '70s, or the titles that he painted on the works' reverse. The widely spaced lines and their level arrangement across the stationery suggest he is thoughtful and rational, despite the impression his over-the-top paintings may evoke. For Nutt, handwriting seems but a prosaic tool. Flourish is retained for margin drawings and deliberate misspellings that emphasize his biting wit; for instance, "Low du didshe" is a phonetic, punning spelling of Chicago art gallery owner Joe LoGiudice's last name. In essence, when emphasis is needed, Nutt draws.

Lynne Warren
Curator
Museum of Contemporary Art, Chicago

SACRAMENTO STATE COLLEGE

6000 JAY STREET · SACRAMENTO · CALIFORNIA 95819

— such folinse!

Dear Don + Alice,

ENCLOSED is ANOTHER APPRAISAL of YOUR

⟶. DID YOU TALK WITH WONDER BOY FRANKENSTIEN

OR DID he DOO IT ON his OWN. Hope (W)hiTiNG (H)alsTed

AS FORTUNATE IN geTTINg PHOTOS FROM COOPERATIVE

DAN. PEOPLE OUT here ARE NOT SURE WHAT to

MAKE OF IT. W. BOY HAS BEEN thoroughly SUCCESSFUL

IN keepiNg ▮▮▮ PEOPLE FROM thinkiNg ABOUT SHOW

by haviNg THEM THINK ABOUT him

WHATS DAT BOY
UP TO
NOW?

DAES SOMETHING TERRIBLY SIMILAR

(IN EFFECT) ABOUT FRANK— + FRANZ.

TANKS FOR YOUR NOTE ABOUT STUFF IN LOWER LEVEL.

I SENT NOTE TO KAREN ROSENBERG IMMEDIATELY

(CAN'T WAIT TO here FROM HER) · SENDING ONE TO D. ABRIAN

TO CHECK ON THAT END. WAS DISAPPOINTED TO

hear LOW DU DID SHE DID NOT BUY (he MUST BE

GEORGIA O'KEEFFE

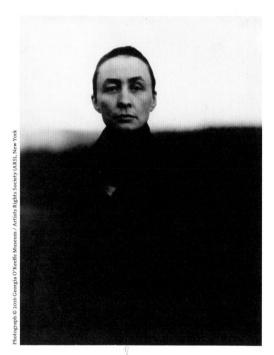

Photograph © 2016 Georgia O'Keeffe Museum / Artists Rights Society (ARS), New York

Georgia O'Keeffe, ca. 1920. Photograph by Alfred Stieglitz.

» *Letter to Cady Wells, spring 1939*

Georgia O'Keeffe's letters, like her paintings, have their own idiosyncratic style. Just as she had no concern for the rules of art, she also had no regard for correct grammatical structure. She did not use traditional paragraphs, and her spelling was frequently more phonetic than accurate. She never used commas and rarely employed periods, instead preferring squiggly lines of varying length that seem to mimic the way she spoke or thought. Sometimes these lines are horizontal, suggesting the quick insertion of a complementary idea; sometimes they are vertical, implying a new thought; and in other places they are diagonal, as if indicating a digression. But her penmanship is always bold and confident, befitting an artist who had carved a path for herself at a time when there were few other women painters to provide ready models.

Sarah Greenough
Senior Curator of Photographs
National Gallery of Art

Dear Cady:

Your check slid under my door one day last week.

I will try to collect my wits and cash the check tomorrow and give the painting to the packing man. I feel you dont really like the painting so it is difficult for me to get myself to do any thing about it.

Maybe I will try to make you another painting. If I do — and you like it better I guess you will be willing to exchange it ~

I guess we will have to let it go at that.

I would really have liked to have you take the deers head ~~~ it is for me very perfect in a delicate kind of detail that I think

CLAES OLDENBURG

Claes Oldenburg, 1969. Photograph by Jack Mitchell.

» *Letter to Ellen H. Johnson, 1971*

» *Postcard to Ellen H. Johnson, August 17, 1974*

Claes Oldenburg's long letter answers questions posed by art historian and curator Ellen H. Johnson, who was preparing a monograph on the artist. The text is printed in block letters, its style deliberate and ordered. Titling it "No typewriter," Oldenburg nevertheless captures the clarity if not the speed of typescript with his methodological control of the pencil. Oldenburg has a beloved 1927 L. C. Smith typewriter, on which he has pecked out poems and notes over the years. The typewriter and the typewriter eraser are iconic motifs in his sculpture and works on paper. His printing on the postcard to Johnson, by comparison, is much looser — a mix of capital and lowercase letters and a bit of cursive — qualities that perfectly align with his art: linear spontaneity, flair, and wit. Oldenburg embellishes his note with an "Inverted Q," another of his iconic shapes — here waving an American flag for Labor Day.

Richard H. Axsom
Curator
Madison Museum of Contemporary Art

1. It is made of odds + ends and only measures
about 3." I had a real drum set when I was about
14 + enjoyed playing it, along with jazz records. I also tried
playing piano + guitar but liked the drums best tho I hadnt
the patience or whatever to learn it very well. I eventually
sold the set.
Music was later an inspiration to modern form. I mean I
got out of the Wagner hole my Mother favored via Stra-
vinsky + Ravel — which wasnt very modern in 1954 but
modern to me. Stravinsky whom I then collected had
an influence on my attitude and style, expressed in
drawing. I also admired his discipline and read his
prose and aquired his prejudices fx liking the "out"
Tchaikovsky. Ravels detachment while producing emo-
tion fascinated me, also his parodies which were still
art in the best sense.
I was fond of blues way back and all rhythmic music.
Walter de Maria who is a good drummer seemed to take
my soft Drum set as a personal attack via magic. He and
Pat were seeing each other then and felt a bond a-
gainst me - the icy monster. All that is rumor.
Music means a lot to me + it translates for me into
art. We could discuss this.

3. It appears now, due to prohibitive transportation costs
and the complex engineering of the Ice Bag, that it will
not travel to Osaka but be built here (LA) by Gemini Ltd,
in edition of five, + perhaps shown at MOMA or during tour of
my show. The six foot model here is very promising,
it moves too. Size projected is 24 ft diam. and 11
ft high.

Dear Ellen. E467
Sitting in LA on my
terrace at Marmont
Chateau. Came here
direct from NYC.
Hope to visit Akron
day after Labor Day.
Maybe see you on
Labor Day.

Love Class.

SANTA MONICA, CALIFORNIA
Sunset overlooking the Pacific Ocean from Palisades Park.
Photo by Marino Bros.

P89988

Ellen Johnson
127 Woodhaven Dr.
OBERLIN, Ohio
44074

WALTER PACH

1883–1958

Walter Pach, ca. 1909. Photograph by Pach Brothers.

» *Letter to Arthur B. Davies, August 4, 1912*

This is a rare find: a letter from American art critic, agent, and artist Walter Pach to American artist Arthur B. Davies, the latter of whose papers remain unlocated. This seems to be the first recorded instance of Pach offering Davies his assistance with the 1913 Armory Show, beseeching him, "I do hope you will let me [be] of service if I can, when you come to Paris. I know [Henri] Matisse fairly well... and I know [Pablo] Picasso, Maurice Denis, [Ker-Xavier] Roussel and [Félix] Vallotton slightly. I could reach most everyone else I think." It was almost exclusively because of Pach that these artists, and many other Europeans, participated in this groundbreaking and divisive exhibition.

Pach's penmanship indicates, according to basic handwriting analysis, that he was well-adjusted and sociable and had an intellectual curiosity sometimes tempered with caution and skepticism — very apropos of Pach's personality. There is an academic formality to the legibility of the words, the punctuation, and the attention to detail. These measured and meticulous manners are also apparent in much of Pach's art, where forms are fully realized, images are clearly recognizable, and edges are, in general, distinctly defined.

Laurette E. McCarthy
Independent scholar and curator

any of the American papers for an article at present. But I do hope you will let me of service if I can, when you come to Paris. I know Matisse fairly well (he thought he would be away in the fall but I think the Steins might help you) and I know Picasso, Maurice Denis, Roussel and Vallotton slightly. I could reach most every-one else I think. Do let me know as soon as you come or, rather, before. I go to Germany in about ten days for a visit with my parents before their return to America. In all probability I shall be coming back myself after two or three months in Paris.

In the matter of quantity I am dis--appointed in my work here — I had meant to do such piles of pictures and find I have to go over them again and again instead of letting 'em go after one sitting as I used to. I feel I have done my best here though and — wonder of wonders — have painted one thing that is a total break from my old humdrum stuff. It had hardly changed in years. (The Autumn Salon is from Oct. 1st to Nov. 8th)

Hoping you and your family are all very well, I am Cordially yours Walter Pach.

MAXFIELD PARRISH

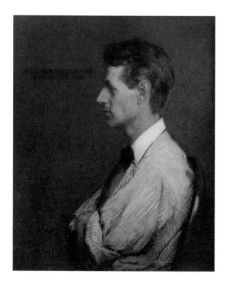

Kenyon Cox, Maxfield Parrish, *1905.*
National Academy Museum.

» *Letter to Martin Birnbaum,*
December 4, 1918

In this letter to a New York acquaintance,
Maxfield Parrish reveals in form and content
his professional discipline and personal playful-
ness. The deliberate, lyrical handwriting
suggests his lifelong urge to embellish even the
most mundane productions. Although the
letter does not feature Parrish's more elaborate,
fanciful combinations of word and caricatured
image, it still evokes a witty exaggeration
and theatricality — particularly in the bulbous
B of his correspondent's name.

By 1918 Parrish had firmly established his reputation as a multi-
talented figure with a clear sense of individuality and purpose —
to produce art, be it fine or commercial, for a mass audience. This
letter indicates in typically self-deprecating prose the type of commis-
sions Parrish embraced throughout his career. More poignantly,
it betrays a creeping weariness toward public work and the demand
for his signature "Parrish blue," contrasted with a growing desire:
"to do some things for myself."

Sylvia L. Yount
Lawrence A. Fleischman Curator in Charge of The American Wing
The Metropolitan Museum of Art

December 4th. '8.

My dear Dirnbaum:

Alas, I wish I had, but I have not a single thing for that lovely rich lady. When last in New York I fell in with a bad crowd and got all tied up with some work for the Red Cross, so I'm working day & night on some very bad things for their Christmas shindy. But— early this spring I am going to do some things for myself, and have refused all orders until next fall. Those beautiful panels are above my head getting themselves all nice and dry.

I wish people wouldn't ask for blue, for its the one thing to stop me using it. As soon as the bells were ringing up here for the end of the war I thought of you, as how you would'nt have to go. I hated to think of you in mortal combat = you would sure to have been thoughtless in bayonet work + neglect to warm it before using. I'll be down around the 10th. I think, + will stop in for a moment.

Hastily: sincerely:

Maxfield Parrish.

Catalogue of
Flaxman (inscribed)
Sent 12/5/18

GUY PÈNE DU BOIS

Guy Pène du Bois's passport, April 16, 1929.

>> *Letter to John Kraushaar, January 12, 1927*

Painter Guy Pène du Bois corresponded extensively with his dealer John Kraushaar, whose New York gallery handled his work between 1913 and 1947. His tidy hand conveys a carefully reasoned logic (at least from his perspective) in regard to his regular requests for money.

Although born in Brooklyn, his background was thoroughly French; he was named after noted writer Guy de Maupassant, a friend of his father, Henri. Between 1924 and 1930 he resided in France, and this letter was written during his sojourn abroad. His drawings and paintings are imbued with the sharp spirit of Honoré Daumier and Théophile Steinlen (with whom he studied), and his works inspired by Parisian cafes and boulevards are mirrored in the precision of his handwriting. The distinctive hand found in his letters corresponds to the signatures found on his works. Its crispness and economy of line matches the spare, fashionable elegance of the trim flappers in his paintings.

Betsy Fahlman
Professor of Art History
School of Art, Arizona State University

4 rue Duiller, Paris XIV

January 12 27

Dear John,—

I saw Galanis the other
day who asked me to tell you that
he was sending his prints on to you.
The seven pictures left on the Rochambeau
today — mine I mean. The others I
shall keep a while longer. They are
in a somewhat different vein from those
to which we are both accustomed and
I should rather be sure of them
before sending them on.

The three hundred dollars
you cabled arrived the day before
yesterday. Thanks. I do not think
that Dale and you are right about
the big pictures even from your own

JACKSON POLLOCK

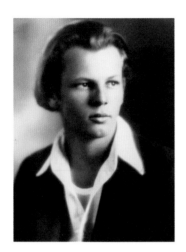

Jackson Pollock's high school portrait at Manual Arts High School in Los Angeles, 1928.

》》 *Letter to Louis Bunce, June 2, 1946*

When he penned this long, newsy letter to Louis Bunce, a friend from his Art Students League days, Jackson Pollock was thirty-four years old. His handwriting exhibits a number of distinctive qualities: notably, his capital *I* looks like the number 2, and his capital *E* is shaped like the Greek letter Σ. In the full three-page letter, several sentences are punctuated by dashes and closed with little crosses instead of periods. Arrows leading back to the subjects emphasize two parenthetical remarks. Words are often broken, and many letters are left open; this hasty execution is in line with the letter's conversational, stream-of-consciousness quality.

It's tempting to suggest that Pollock's sketchy, fluid handwriting is a reflection of his spontaneous creativity, but it's just as possible that it stems from his erratic early schooling. His family moved eight times during his childhood, so he may never have received the kind of formal penmanship training that was common in his youth.

Helen A. Harrison
Eugene V. and Clare E. Thaw Director
Pollock-Krasner House and Study Center

Dear Lou, — It was good to get your letter.
I hardly know what to advise — the housing
shortage in N.Y. (as every place is) is
terrific — don't think there is any thing
to be had — possibly a cold water flat on the
lower East side.

We are about 100 miles out on Long Island
three hours on the train. Have been here
thru the winter and we like it. We have
5 acres a house and a barn which I'm
having moved and will covert into a studio.
The work is endless — and a little depressing
at times. — but I'm glad to get away from
57th Street for a while. We are paying
$5000 for the place. Springs is about 5 mile
out of East Hampton (a very swanky Wealthy summer
place). — and there are a few artists — writers
etc. out during the summers. There are a few
places around here at about the same price.

ABRAHAM RATTNER

1893–1978

Abraham Rattner, Procession, *1944. Hirshhorn Museum and Sculpture Garden.*

>> *Letter to William Kienbusch, 1944*

Although Jewish by birth and modernist in his own art, Abraham Rattner revered the art of medieval Christianity. Born in Poughkeepsie, New York, he attended art schools in Washington and Philadelphia before going to Paris in 1920 and remaining there until forced in 1939 to resettle in New York. In France, Rattner visited many churches. The painting style he developed, with clear, brilliant colors mingled with black lines, suggests stained glass, while its swooping lines and swirling shapes also reflect his admiration for surrealism and Picasso, who was best known in the mid-1930s for "curvilinear cubism."

The handwriting Rattner developed during this period synthesizes curvilinear modernism and medieval manuscripts. In this letter, he commiserates with William Kienbusch, a younger artist whom he'd met in Paris in 1937–38, about the rigors of serving in the army in wartime. Rattner had served in World War I and wanted passionately to serve in World War II, but his age disqualified him. He became one of a number of painters who depicted Christ as a suffering Jew to comment upon the Holocaust. *Procession* (see illustration [1944]), one of Rattner's several Crucifixion scenes, shows the less sinuous, more structural lines that characterized his paintings (though not his handwriting) in the 1940s.

Piri Halasz
Art critic and art historian
New York City

116

Dear Bill:

Your kind note and Xmas card just came. It is good to hear from you and Mamjitewkj.

Anything can happen in the army. One can never say definitely the how or what, the where, the when, or the ins or outs of anything while in uniform — especially during war time. This new work you are in should be very interesting — and falls in line with your camouflage insight which ought to make you a valuable man in the new field. There is a series of two interesting articles on the map technique in Harpers Magazine of August, and September 1944 by C. Lester Walker (a free lance journalist)

Lucius Crowell — you know him I think, friend of the Poor's — and a painter — is somewhere at Ft. Belvoir doing something in the map making field. (address Pvt Lucius Crowell 2765th EBPC Ft. Belvoir, VA.) we had aperatif with him, Percila and Emmy Swan since we saw you.

Saw Annie Poor's show. candidly she has made a big jump in. conforming herself in the direction

AD REINHARDT

Ad Reinhardt in his studio, 1955. Photograph by Walter Rosenblum.

» *Postcard to Samuel J. Wagstaff, July 23, 1964*

» *Postcard to Samuel J. Wagstaff, August 12, 1965*

"In the evening, after a day's work," art critic Irving Sandler wrote, "Ad would have a few drinks and write postcards to his friends and enemies in an elegant and distinctive script." Whether letters, articles, reviews, or quotations for his cartoon-collages, Ad Reinhardt's texts were almost exclusively handwritten in careful calligraphic letters. Nowhere is the contrast between his prolific words and his reticent abstract paintings more clear than in his postcards to Wadsworth Atheneum curator Samuel Wagstaff. And yet to know Reinhardt's art is to know his writing. A connection to the alliterative puns of Reinhardt's cartoons is evident, but his postcards also mirror his fondness for series and formula (he painted only black paintings for the last fourteen years of his life, and only five-by-five-foot canvases for the last seven) and his desire to eliminate personality from his brushstroke. Just as with his iconic paintings, Reinhardt's handwriting could not be more of a signature.

Prudence Peiffer
Art historian and senior editor
Artforum magazine

DEAR SAM WAGSTAFF, I GUESS YOU MUST HAVE
THOUGHT I WAS KIDDING WHEN YOU ASKED
ME IF I SAW ANY INTERESTING ENGLISH
PAINTERS AND I ANSWERED "BRIDGET
BARDOT AND SHE'S A NICE GIRL TOO"? I
MEANT TO ANSWER "BRIDGET RILEY AND
SHE'S A NICE GIRL TOO." Ad

SAM, MONDAY I WAS IN AND OUT ALL DAY, SUN-
DAY I WAS FLOORED INTO PAINTING A CEILIN-
G, TUESDAY I GOT TRAPPED INTO A STUDIO RO-
UTINE, WEDNESDAY I RECEIVED A LETTER FR-
OM OLD LYME, THURSDAY I WENT TO A FU-
NERAL SERVICE, FRIDAY I WRITE THIS CARD
SO YOU SHOULD GET IT THEN TO TELL YOU
SORRY THAT I MISSED YOU AND WRITE THAT
I'LL BE IN TOWN ALL SUMMER LONG DURING
THE DOLDRUM-DAYS TO THE DOG-DAYS, DAYS
IN AND DAYS OUT, ABOUT THE NOVEMBER
PORTFOLIO AND CHRISTMAS BUSINESS I'M
NOT SURE, AND ABOUT OCTOBER THINGS ARE

NOT VERY DEFINITE, WHO
CAN BE CERTAIN ABOUT SE-
PTEMBER? Ad

SAM WAGSTAFF
WADSWORTH ATHENEUM
25 ATHENEUM SQ. N.
HARTFORD
CONN.

M. C. RICHARDS

>> *Letter to Francis Sumner Merritt, August 22, 1974*

Were you thinking those were the words
Those upright lines, those curves, angles, dots!
No, those are not the words, the substantial words are in the ground and sea,
They are in the air, they are in you....

M. C. Richards in her Stony Point pottery studio, 1956.
Photograph by Valenti Chasin. Getty Research Institute.

The poet and potter M. C. Richards chose these lines of Walt Whitman's to introduce a 1966 essay in *Craft Horizons* magazine on writing as a form of handcraft. This letter on hot pink paper was written some eight years later, to Francis Merritt, the founder of Haystack, a craft school in Maine. In it, Richards skips lightly from topic to topic in a series of digressions: first, a few words on a recent visit of African artisans, couched in the race politics of the time, then, short reports about her car and a dog, like jokes with no punch lines, and, toward the end, expression of concern for how the Haystack clay studio is getting along without her.

In a passage about a future program, this time on "Indians of the Americas," Richards gains momentum. The sentences gradually space out, framing a single word: *ZOWEE.* Her usual writing hand, a loosely flowing cursive, is interrupted by block letters, all in caps.

August 22, 1974

Dear Francis,

Thank you for your letter. I am
sorry to hear of Ralph Thompson's death.
He was a good man — and a memorable
proxy! Long live his memory, as you say.
He is very vivid in my mind's eye.

I loved the week with you at
Haystack — and left feeling unusually
refreshed and renewed. There's something
about blackfolks that suits me mightily.

The one moment that still hangs in
my memory like a question is the
departure of the Africans, with much
ado, swooped off by the 2 young guides
& guardians from the state department,
as if it were an honor to be black in
America! I'm still wondering how
that scene struck our black American
friends, who are more likely to be arrested
than fêted for their appearance and
ancestry, right? Ah me, the
paradoxes...

I finally got home this Monday —
took the Volvo in for inspection on
Tuesday, & it didn't pass! So now I'm
carless till it gets fixed — mostly body
work, king pins & the like. Mine didn't
win the prize — another, 1951, 270,000!
<div align="center">—over—</div>
<div align="right">miles.</div>

(I think that's what the feller said)

Raja seems glad to be home — no more collar & leash! There's lots to be done: garden & house & mail & neighbors — you know what it's like to come home after 9 weeks away in summertime! Rabbits & chipmunks making merry with the vegs., etc.

I'm wondering how Black Session II went. And already looking forward to 1976 Indians of the Americas ZOWEE.

Did Tucker ever get the pot shop cleaned up? & the Raku kiln fixed?

Take care of yourself, dear Fran — you are a treasure — and long live Haystack & the beautiful light of Maine —

much love to you & Pris,

Mary Caroline

M. C. Richards letter to Merritt, August 22, 1974, continued.

In her 1966 essay, Richards had described a materialist idea of writing: "to see the page with the artist-craftsman's spirit: volume, negative space, texture, transparency, density — how energy coagulates here, disperses there — build-ups of tension and feeling." Whitman was right, of course. Words are much more than their shapes, their curves, angles, and dots. But in that *ZOWEE*, you can read Richards's sheer love of the creative life, in a few strokes of the pen.

Glenn Adamson
Nanette L. Laitman Director
Museum of Arts and Design

EERO SAARINEN

Aline and Eero Saarinen, ca. 1954.

>> *Letter to Aline Saarinen,
April 10–11, 1953*

>> *Letter to Aline Saarinen,
1953*

Eero Saarinen didn't have one
handwriting. He had several that
he used concurrently, just as he
worked in several architectural
styles at the same time. The big
curvaceous signature "Eero"
resembles the boldly curved shapes in his Ingalls Rink at Yale, TWA
Terminal at JFK Airport, and Dulles Airport. Some letters to his second
wife, Aline, are written in capitals whose shape recalls the boxy
glass-walled buildings he designed for General Motors, Bell Labs, and
IBM. Other notes are in a small, back-sloping script. In one letter, he
prints along the edges and tucks comments into white spaces — quirky
techniques as varied as those he employed in the stony CBS Building
in New York, the crystalline University of Chicago Law School,
and the massive Morse and Stiles Colleges at Yale. Saarinen's letters
reveal his tendency to organize his thoughts in lists, his sweetness and
sense of humor, his dedication to work, and his difficulty with
spelling. (His first language was Finnish.)

One reason his handwriting was sometimes reversed is that
Saarinen had what doctors would now diagnose as dyslexia. He had
some trouble learning to read and write — especially in a second
language. He was twelve when his family moved to the United States.

ALINE

THIS WILL NOT BE WRITTEN WITH SCALPEL LIKE OBJECTIVITY IT
IS JUST GOING TO BE SMALL TALKE ———— AND THAN THE
PHONE RANG AND I HEARD YOUR VERY NICE VOICE AND ALSO
ALL THE VERY NICE THINGS YOU SAID ——— OF WICH THE VERY
NICEST WAS "I LOVE YOU SO MUCH DARLING"———— WHILE
I WAS DRAWING YOUR LETTER ON THE PLANE I HAD A FELLOW
NEXT TO ME OF THE TYPE THAT JUST GETS ON PLANES TO STRIKE
UP CONVERSATIONS — HE WANTED TO KNOW WHAT I WAS DOING
BECAUSE HE WAS CURIOUS WHICH APPARENTLY WAS SUFFICIENT EXCUSE
IN HIS MIND — I TOLD HIM IT WAS A DREAM — — AND
CONTINUED — THE THING I LIKED MOST ABOUT THE MONUMENT
WAS THAT IT WAS A BEAUTIFUL RESULT OF YOU & I BEING CLOSE
TOGETHER——— THE FUNNY THING ABOUT IT IS THAT IT PROVES
YOUR POINT IN YOUR ARTICLE SOO MUCH—THAT I TRANSLATE EVERYTHING
INTO ARCHITECTURE————YOU COULD NOW SAY "HE EVEN SEES HIS
CLOSEST FRIENDS AS STONE AND CONCRETO".———OR " HE LOOKS AT
THIS REPORTER AND"——— AND SO ON——
NOW — JUST TALKE ABOUT THINGS IN THE OFFICE THE DRAKE "BIBLE SCHOOL"
IT IS A TINY LITTLE CLASS ROOM BUILDING WITH A TINY CHAPEL — NEAR
IT IS TO BE A BIGGER CHAPEL —I THINK IT IS GOING TO BE O.K.
NOW. — IT IS LOCATED NEXT TO THE SCIENCE AND PHARMACY BUILDING
WE DID AND NOT FAR FROM DORMITORIES NOW UNDER CONSTRUCTION
—THE WHOLE THING REALLY BECOMES A CAMPUS & WHEN THESE
ARE BUILT DRAKE WILL REALLY HAVE QUITE A GOOD GROUP OF NEW
BUILDINGS. — IF PLANS ARE ACCEPTED (WEDSDAY) THAN IT WILL
LOOK LIKE THIS.

His difficulty in reading and writing may have helped him learn to think — and even communicate — visually. At his American high school, he worked as a cartoonist for the newspaper. His sense of humor came through in images, just as his ideas for architectural projects did. He thought drawing so essential to design that he rarely hired anyone who could not draw.

Jayne Merkel
Architectural historian, journalist, and author
New York City

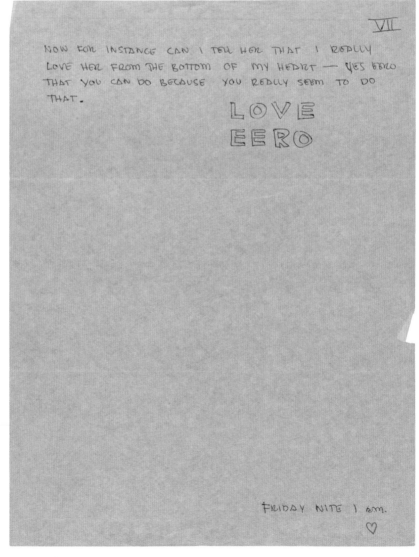

Eero Saarinen, letter to Aline Saarinen, April 10–11, 1953, continued.

Now a few words about divorce so that I don't have to waste the time on the phone with that. This will be a summary and bring you up to date.

Monday noon we will send down to the lawers a whole bunch of things.

a. Conclusive proof that G.M. will <u>not</u> go on for 3 or so more years which is his impression

b. Chart showing office and my income curve since '47 also showing tremendous effect a very favorable G.M. contract made on this curve to prove that G.M. is a unique experi situation.

c. Compilation (by Joe) of all our & other work than G.M. showing that we made a fairly low (19%) profit on all work except G M and a mighty high (?) on G M

d. My personal bookkeeping since 1948 showing that the myth that Lily has paid most household expenses is absolutely untrue — instead that I have paid thru my nose.

e. Income Tax stuff showing that I have paid 90% of Lily's taxes since '48 an amount that exceeds what she has paid in household expenses.

f. Present & projected future income.

— Armed with this he will (Ben Jayne) give his counter proposal. Which is 250 per month per child + tuitions until 18 and 200 per month + tuition thru college. + (if it works as a tax deductable - this still has to be checked 20.000. the 1st year 15 the second 10 the 3rd 6 the fourth and then it goes on with 6 until she marries. + lawyers fees. and in his pocket he has my authority to up this proposal with a direct lump sum payment of 20.000. — Meeting on this will probably be held Tuesday.

— I do not blame Lily for the high request — I would say that it was worked out by Harry & Paul Hammond — Lily understands very little about money

JOHN SINGER SARGENT

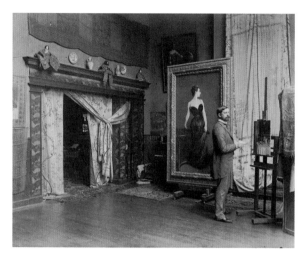

Painter John Singer Sargent in his studio in Paris with the painting Madame X, *ca. 1884.*

>> *Letter to Henry Mills Alden, January 19, 1887*

John Singer Sargent's lean, elegantly slanted handwriting matches the deliberate immediacy and seeming effortlessness of his brushwork on canvas. In this 1887 letter to *Harper's* magazine editor Henry Mills Alden, both his penmanship and his words reveal a distance from the situation at hand: the selection of a photographic portrait of the artist to illustrate the publication of a critical article by Henry James. Sargent's canny remove from the pen and written words aligns with his calculated nonchalance about the careful shaping of his image and career. He refers to himself in third person here, as if dictating the letter to another hand. In fact, at this point in his career Sargent was, as art historian Marc Simpson has proved, masterful at deliberately navigating the arenas of the international art world. His selection of a portrait for mass publication alongside what would surely be a significant critical piece by the influential James was important. James subsequently captured the artist's sophistication with the words "Perception with him is already by itself a kind of execution."

Dorothy Moss
Associate Curator of Painting and Sculpture
National Portrait Gallery, Smithsonian Institution

Jan 19th
[1887]

13, TITE STREET,
CHELSEA. S.W.

Mr John S. Sargent
sends to Mr Alden
a photograph of
himself, as requested
by Mr Henry James
for the purpose of
his article in
Harper's magazine —

Sargent

JOHN SLOAN

John Sloan, ca. 1903.

>> *Letter to Mary Fanton Roberts,
December 16, 1909*

The slanting, briskly written script of John Sloan captures in a few short but revealing sentences the twofold relationship between Sloan and Mary Fanton Roberts, who were both art world associates and friends. With his characteristic wit, Sloan compliments Roberts, critic and managing editor of *The Craftsman*, for finding his painting at the National Academy of Design's winter exhibition, where it was evidently skied, or hung near the ceiling. (He asks Roberts, "Did your foresight prompt you to tour the show with a ladder?") His joke hints at the friends' mutual annoyance at the Academy's treatment of Sloan's work. He closes the letter with an update on the whereabouts of his wife, Dolly, who suffered from alcoholism and, following their relocation to New York in 1904, periodically traveled back to Philadelphia to see her doctor.

The speed and ease with which Sloan composed his message can be seen in the evolution of the word *to*, which nearly dissolves into a figure eight by the end of the letter. The swift style of his calligraphy, as well as the candor and frankness of his language, suggests that both Sloan's note and proposed visit would be warmly received.

Jennifer Stettler Parsons
PhD candidate in Art History
University of Virginia

145 W. 23, N.Y. Dec 16 - 09 -

My dear Mrs Roberts; —

I enclose my permit
for your photographer to copy the
"Chinese Restaurant, Sixth Ave," painting,

That you found it in the
N. A. D. Exhibition - speaks well
for your eyesight - or did your
foresight prompt you to tour
the show with a ladder?

At any rate I thank you
for considering it for "The Craftsman"
article on the Ex.

Mrs. Sloan has flitted to Philadelphia
to see her medicine man - there
I join her toward the end of next week
and when x mas has passed we will
return to N.Y. and drop in on the Roberts's
during the week perhaps
With regards and compliments of the season
Yours John Sloan

ROBERT SMITHSON

Robert Smithson, Broken Circle, *ca. 1971.*
Photograph by Stedelijk Museum.

》 *Draft of a letter to Enno Develing,*
September 6, 1971

Robert Smithson drafted this letter to Enno
Develing, then research assistant at the
Gemeentemuseum in The Hague, in a carefully
formed cursive, halfway between his casual,
flowing hand and the print script of his more
significant statements or poems. The fact that
Smithson did not know how to type may account
for his changing forms of handwriting, according
to his wife, the artist Nancy Holt, who generally
acted as his typist. He made special effort in his final drafts to be
legible; sloping lines may indicate that he was copying a previous
draft. Unlike his friend Ad Reinhardt, Smithson did not attach much
importance to calligraphy. However, inspired by structuralism, he
saw landscapes in printed matter and conversely, writing — a syntax
and vocabulary — in landscapes and architecture.

Smithson was anxious to convince Develing to preserve *Broken
Circle / Spiral Hill*, an earthwork executed two months earlier in
Holland. Smithson believed that his views on art, politics, and the
economy, with Marxist overtones, would somehow motivate Develing.
Interestingly, before turning to literature and art, Develing had
worked in the international banking business. Little has changed in
the art world as described by Smithson, yet his sculpture was pre-
served and has become a major landmark. Smithson's film document-
ing the project was completed and screened for a fortieth anniversary
exhibition in 2011.

Serge Paul
Art historian, editor, and translator, Avignon, France
Holt-Smithson Foundation

Dear Enno,

I just returned from Utah.
I'm happy to hear you enjoyed
my work in Emmen. But hope they
will not destory it. It seems that
John Weber did not find time to visit
my work — that is unfortunate,
because I have so few photos of
the work. Both Reeen + Zyolstra
have yet to let me know whats
going on. So, I really appreciate
your serious concern and
interest in the project. For one
thing, the project is outside the
limits of the "museum show"; there
are a few curators who understand
this. As Jennifer Licht says, "art
is less and less about objects you
can place in a museum" yet, the ruling
classes are still intent on turning
their Picassos into capital. Museums
of Modern Art are more and more
banks for the super-rich.

SAUL STEINBERG

>> *Remarks prepared by Mr. Saul Steinberg for a luncheon given in his honor at the Smithsonian Institution on February 27, 1967*

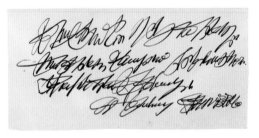

Saul Steinberg's artist statement for "Fourteen Americans," 1946.

Saul Steinberg's written remarks do not represent his handwriting, but one of his most famous art forms: an intentionally indecipherable script that he began to develop in the mid-1940s. (His real handwriting, by contrast, was a paragon of clarity.) The genesis of this fabricated paperwork lies in Steinberg's own biography, in his fraught experience in the 1930s as a Romanian-born immigrant seeking visas to flee Fascist Italy, then to enter the United States from Santo Domingo in the Dominican Republic. He used such art throughout his life to create false documents — diplomas, passports, visas, and other "certifications" whose illegibility denies bureaucracy its self-proclaimed authority.

The "letter" shown here belongs to a series of drawings Steinberg did on Smithsonian stationery while artist-in-residence in 1967. Unlike the other drawings, this one is pure fake calligraphy. Twenty years earlier, Steinberg had supplied another text with tongue in cheek. In 1946 he turned in one of his earliest examples of false handwriting as an artist's statement for the exhibition catalog *Fourteen Americans* at the Museum of Modern Art in New York City. Like his later diplomas and passports, this small "statement," as well as the Smithsonian "remarks," wittily undercut what Steinberg, who disdained such official testimonials, perceived as the pomposity of the event.

Sheila Schwartz
Research & Archives Director
The Saul Steinberg Foundation

SMITHSONIAN INSTITUTION
Washington, D.C. 20560
U.S.A.

ALFRED STIEGLITZ

Alfred Stieglitz, 1924. Photograph by
Arnold Rönnebeck.

>> *Letter to Elizabeth McCausland,*
January 22, 1932

Alfred Stieglitz was a notorious talker.
His voice was a dominating presence
in each of his art galleries. The incessant,
driving nature of his conversations
— which often devolved into lengthy
monologues — is fully embodied in his
handwriting. Stieglitz often wrote
with a broad-nib fountain pen with black
ink, filling the page with a cascade of
strong, bold marks. The sweeping arc of
a capital *T* or *B* or the stem of a lower-
case *h* stand out as rhetorical flourishes,
the equivalent of a raised eyebrow or
an emphatic hand gesture. Lowercase letters run together in a seamless
blur, driven along by the insistent, horizontal current of a *t*'s cross-
stroke. Yet it is the dashes — which Stieglitz used with great frequency
— that speak most eloquently. On the page, they flow together with
the *t* cross-strokes, forming a continuous rhythm. As we read, we
hear Stieglitz refusing to take a breath — refusing to place a period —
always rambling on.

Kristina Wilson
Associate Professor of Art History
Clark University

Jan 22/32

My dear Elizabeth McCausland: I have
just wired you-- Had to. Your work
— Marin article — the O'Keeffe rotogra-
vure — so perfect. And I wanted you
to know at once my feeling —
And how badly I needed what you
gave me — just this morning Your
work in the Republican — its spirit —
the work of an artist — real integrity
in these days of ever increasing
sloppiness & lack of all that's
really fine — Together with your gift —
for gift it is — comes a letter from
Brett — Taos snowbound — a
grand letter clean as the snow —
enclosing a few of Laurence's last

HENRY OSSAWA TANNER

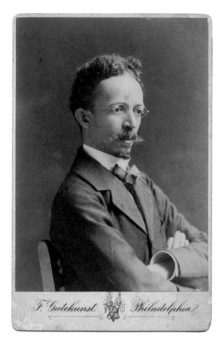

Henry Ossawa Tanner, 1907. Photograph by Frederick Gutekunst.

>> *Draft of a letter to Eunice Tietjens, May 25, 1914*

Henry Ossawa Tanner wrote this letter in response to an article that Eunice Tietjens was readying for publication. Writing at the height of Tanner's career, when the artist was living comfortably in France, Tietjens contended that Tanner's success came in spite of a number of personal hurdles, including ongoing racial prejudice. In his emphatic handwritten response, Tanner took issue with the author's uncomplicated assumption about his racial identity.

This is an uncharacteristic letter for the normally reserved and circumspect Tanner. Note how many words he underlines or puts in quotes. Every inch is filled with Tanner's passionate response to his own rhetorical question, written near the bottom of page one: "Now am I a Negro?" The construction of this letter, with its flowing script and multiple strikethroughs, attests to the anger Tanner felt at the prejudice he faced as an African American and the eloquence with which he combated being pigeonholed as a "Negro" artist.

Anna O. Marley
Curator of Historical American Art
Pennsylvania Academy of the Fine Arts

to end their torture I gave them away—

Please don't imagine, that any of this criticism of American mayapples in the least. to you or yours — It absolutely does not, there are many others also— But the last paragraph made me want to tell you what I think of myself— that I am glad I am what I am, for the same reason than a Swede hates to be called a Norwegian, a Scotchman to be called + Dane, to be called a Swede, a Scotchman to be called an Englishman &c &c— He is no better than the other, but, sometimes he thinks he is, as my chickens thought the earth was made for chickens +not for tinkers— Of course I shall not write Mr Lane but, should the article be accepted & you would recommend that you

Dear Mrs Tietjens—

Your good note very appreciative article to hand I have read it + except it is more than I deserve. It is exceptionally good. What you say, is what I am trying to do- in a smaller way, doing, (I hope)

The only thing I take exception to, is the inference given in your last paragraph — + while I know it is the dictum in the States, it is not any more true for that reason—

You say "In his personal life Mr T. has had many things to contend with. Ill health, poverty, race prejudice, always strong against a negro"— Now am I a Negro? Does not the 3/4 of English blood in my veins which when it flowed "in pure" Anglo-Saxon veins which has done in the past, effective

LENORE TAWNEY

Lenore Tawney, 1966. Photo by Clayton J. Price. Lenore G. Tawney Foundation.

» *Postcard to Maryette Charlton, February 15, 1969*

» *Letter to Maryette Charlton, January 27, 1970*

Lenore Tawney is celebrated for her groundbreaking contributions to fiber art and her work in collage. The handwritten word was fundamental to both her everyday life and her work. Tawney was an inveterate traveler and frequent correspondent who sent hundreds of beautiful, often enigmatic postcard collages to friends. A regular diarist, she filled journals with fine script. "Words and letters can be compacted to a dense knot or drawn out to great length....They could be plaited [or] twisted," she reflected, suggesting a parallel between a line of text and a line of thread. Her own delicate handwriting was a perfect example.

Tawney's script often embellished her collages and occasionally became their primary subject. Not meant for literal reading, these words — turned upside down or written line on top of line — conveyed a more ambiguous, mysterious communication. For Tawney, painted markings could also function as written language. "I want to make a dark cloud," she wrote. "On the threads I will paint — like rain — gold....In a way this gold will be like script, a field of script, holy writing."

In this postcard and letter, Tawney reflects on the same event: a visit in Kyoto with a Zen master who presented her with "a square of calligraphy, with fine characters."

Kathleen Nugent Mangan
Executive Director
Lenore G. Tawney Foundation

Dear Charlton,

A year ago I was in Kyoto. From my notebook:

The day before I had visited Kobori al Ryoko-in, an incredibly beautiful ancient Japanese building with tiny old gardens. He gave me a small pottery jar + a square of calligraphy, with five characters.

The first - meaning "nothingness"
The second - meaning "event" or "making happen"
The third meaning "this or that"
The fourth, a double character, meaning "noble man"

"Doing nothing, one is a noble man"
or
"Not changing anything, one is a noble man"

Then Kobori spoke of the being of the
plum blossom in its vase, of the tea kettle,
of the tea bowls, of the fire, of the big
pottery piece, of ourselves.
I was suddenly aware of these things
as being, + of myself as the same.
Kobori said, the plum blossom _is_ a
flower, but inside it, it does not know
that it is a flower. It simply _is_.
The same with us. When we are drawing
a line, it is a part of our being. Only
after it is done, can someone look at
it + say, It is a line.

LT

CY TWOMBLY

Installation view of Discourse on Commodus *by Cy Twombly at the Leo Castelli Gallery, March 1964.*

» *Letter to Leo Castelli, ca. 1963*

The content of this letter is typical of the practical, business-minded correspondence abstract painter Cy Twombly shared with his New York gallerist Leo Castelli. Here, Twombly makes reference to nine vertically oriented paintings he has just completed in Rome, identifiable as the series *Discourse on Commodus*, which he first exhibited at the Leo Castelli Gallery in March of 1964.

Pencil drawings of vertical rectangles — like the one in blue ink in the middle of this letter — appear frequently in Twombly's drawings and paintings of the 1950s and '60s. Though occasionally Twombly uses such rectangles to depict windows or three-dimensional boxes in his paintings, here, the rectangle clearly refers to the outline of the canvas. Perhaps where it appears in his paintings, the vertically oriented rectangle might likewise represent for Twombly an imagined or hypothetical painting surface sketched in miniature.

White, unlined paper permits Twombly's cursive to spread or contract as his improvised message dictates. This tendency echoes the improvisational character of line in his paintings, where he often employs a more sprawling, frantic version of this same cursive handwriting, but to poetic and gesturally expressive ends.

D. J. McKetta
PhD candidate in Art History
University of Texas at Austin

Dear Leo, Have your
series finished —
9 in all and 1 separate
piece if you need it.
They are shaped this
way ▢ & can go 2
on the facing wall
3 on each side & 1
on the small inner
wall making the
total 9 —
I am really terribly
happy over them &
I think that you will
be pleased by them.
Now they must have
some time to dry —
Will have them stretched

MAX WEBER

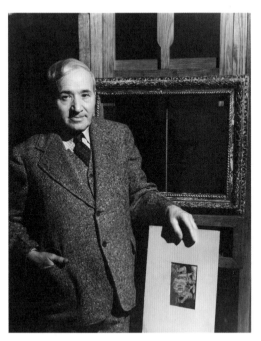

*Max Weber, ca. 1940. Photograph by
Alfredo Valente.*

» *Letter to Forbes Watson,
April 2, 1941*

Max Weber wrote in a bold, legible script,
favoring black ink and fountain pens
with broad nibs. His elegant and forceful
handwriting — so different from the
printed signature on his early paintings
— is indicative of the strength of his
character and the power of his art. In his
letters his hand rarely falters, although
this may be because he wrote drafts, many
of which he kept, such as this one. The
editing of his letters shows a concern
for precision that was also characteristic
of his art. His distinctive handwriting
contains personal flourishes, such as a
scroll on a capital T or his later use of three vertical lines for the capital
M of his first name. Surprisingly there are very few drawings among
the hundreds of letters that he wrote, as if words and pictures were
separate entities. In addition to English, Weber was also literate
in Yiddish, and he practiced his Yiddish script in his later years so
that he would not forget it.

Percy North
Instructor in the Liberal Studies program
Georgetown University

April 2. 1941

Dear Forbes:

Enclosed you will please find the article I promised to write before I left Washington. I hope you will find it printable. If you do, please do not hesitate to change ^or leave out^ a word or phrase as you see fit, for you know that writing is just a little side issue with me. The art of writing is immense and that is why I shrink ^and freeze up^ when called upon to do so.

And if you think the article is apt to ~~arouse harsh criticism and~~ create ill feeling ~~and antagonism~~, please do not hesitate to discard it. I will understand perfectly. It is an honest expression of my feeling about the Gallery. ~~In case~~ ^Should^ you find it "fit to print," and if it does ^subsequently^ raise a little dust ^subsequently^, I know you will intervene in my behalf by persuading the authorities not to deport me ^yet^.

With kindest regards to Mrs. Watson from Frances and the Children, Sam

If the article is published two or three of the titles might accompany the text

H. C. WESTERMANN

>> *Letter to Clayton and Betty Bailey,*
November 17, 1963

A gift masquerading as an apology, H. C. Westermann's missive
to Clayton and Betty Bailey conflates creativity and correspondence.
Narratively, it conveys his regret for drinking their supply of beer.
Artistically, it showcases his fondness for found imagery, expressive
line, verbal/visual punning, and vernacular speech. All are deployed
to express his "THANKS!!" for a recent visit with the Baileys in St.
Louis. Whereas the rubber stamps reiterate the convenience of air mail
delivery, the drawings and text personalize the communication. Hatch
lines trailing the capital *I* (like those behind the airplanes) connote
speed while lending mass and pace to the three-dimensionality of the
letter, suggesting the bodily presence of the artist himself moving
through space. The smiling orb in the upper right corner indicates
that the note was written on a Sunday. Or consider the salutation after
the obligatory "Dear." "Ya" is a colloquialism given visual weight
by its blocky appearance, thus differentiating it from the surrounding
words rendered in the artist's typical style of handwriting. Then
there's the closing and signature. Written in a clunky cursive derived
from the Palmer Method he had learned in elementary school, they
evoke the formality of a trained hand without any pretense of refine-
ment. Therein resides an entire aesthetic sensibility.

David McCarthy
Professor of Art History
Rhodes College

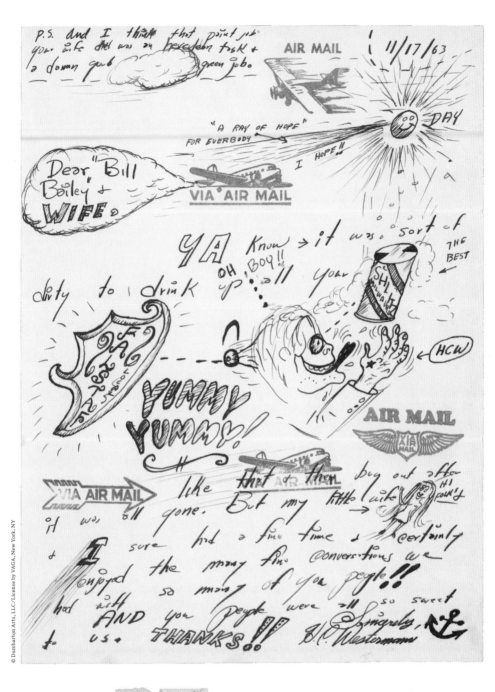

EDWARD WESTON

Untitled (Portrait of Edward Weston), *1940.*
Photograph by Brett Weston. The Brett Weston
Archive.

>> *Letter to Holger Cahill,*
March 5, 1936

Edward Weston, a trailblazer of modernism in American photography, wrote this letter in 1936, when he was at the height of his creative prowess, comfortable in his style and on the cusp of being awarded the first Guggenheim Fellowship ever given to a photographer. His writing contains little of the self-consciousness of his early days as an artist and none of the shaky, tentative execution of his late years with Parkinson's disease. He writes here with a confident, fluid line that is clearly legible but idiosyncratic. Its simple elegance and emphasis on lyrical curves mirror his work of the period, which displays a modernism of organic structure, graceful shape, and emotional content. And like his intuitive approach to judging negative exposure, Weston's penmanship here unfolds with an improvisational flair and betrays a well-proportioned ego ready to take on the world.

Brett Abbott
Keough Family Curator of Photography and Head of Collections
High Museum of Art

3 - 5 - '36
446 Mesa Rd
Santa Monica
Calif

Dear Mr. Cahill -

The idea, or ideal, back of the WPa art project is of such great importance that I hesitate to comment. At the time of the PWaP, which gave me the first opportunity of my life to do work that I wished to do and get paid for it, I intended to write Mr. Bruce. But again the subject was so big, had such extensive connotations that I kept postponing.

That a democracy should at last recognize the cultural value, even necessity of the artist to

JAMES McNEILL WHISTLER

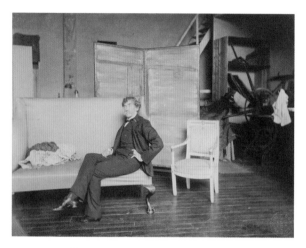

James McNeill Whistler in his studio at 86 rue Notre Dame des Champs, 1890s. Photograph by M. Dormac. Freer Gallery of Art / Arthur M. Sackler Archives.

》 *Letter to Charles Bowen Bigelow, October 5, 1891*

》 *Letter to Frederick H. Allen, June 6, 1893*

The expatriate American artist James McNeill Whistler famously proclaimed that art should be an effortless expression of aesthetic principles, betraying no sign of mental effort or physical labor. His handwriting appears — at least at first glance — to be similarly unstudied: the hasty translation of a series of brilliant thoughts relayed in line after line of quick, delicate strokes, punctuated with an abundance of dashes, underlinings, and exclamation marks.

These two letters, written in the early 1890s, are, however, hardly offhand. They were part of a campaign Whistler undertook to discredit a pirated edition of *The Gentle Art of Making Enemies*, an artful selection of some of his earlier pronouncements on art and art criticism. Although the letters to artist Charles Bowen Bigelow and art critic Frederick Allen lack his signature butterfly (the monogram with which he "branded" his works from the 1870s onward, when he abandoned a conventional signature altogether), they nevertheless embody both sides of Whistler's personality: the spontaneous conjurer of beauty and the calculating — and often ruthless — self-promoter. The handwriting is light, fresh, and dashing, a seemingly breathless expression that aims, nevertheless, at total control.

Pray offer my apologies to Mr. Allen for the trouble I am giving him, and accept my best thanks for your kind courtesy —

Very faithfully Yours

Jr McNeill Whistler

Oct. 5. 1891.

Dear Mr Bigelow — You tell me that your friend Mr Ford. Allen, of New York, upon the representation of Sheridan Ford, sent over the sum of one hundred pounds, to be paid by him to me — as an inducement to close with him, accepting his proposal to lecture, paint, and generally "tour" in America, under the management of a Syndicate in which Mr Allen was interested —

153

You were good enough to say that you
would convey to Mr Allen my answer
to his enquiry as to whether I had ever received
the hundred pounds in question — I therefore
beg that you will kindly write and inform him
that I never received from the man Ford any sum
on any occasion whatever —

The Sheridan Ford proposals were so
preposterous that my Solicitor, Mr George Lewis, to whom
I had referred him, about him about his business, and
advised me to have nothing whatever to do with him —
& there the matter ended!

I never knew, until you told me, of
the Ford's obtaining money under this false
pretence; — and now I beg Mr. Allen to be
good enough to forward a simple declaration
of the fact to me — This is all important, as
on the 26th of this month, Sheridan Ford is
cited before the court of Antwerp (Police Correctionnelle)
on a charge of Piracy — and I am subpoenaed
to appear as a witness —

As it will be such a man share in the matter
of time, please ask Mr. Allen to send his statement
directed to me, "aux soins de
(Avocat)
Maitre A. Maeterlinck.
No 1. Rue des Dominicaines. Anvers. Belgique.

James McNeill Whistler letter to Bigelow, October 5, 1891, continued.

Despite his claim that art should appeal to the eye alone — dismissing the explanatory efforts of critics as little more than "clap-trap" — Whistler was a prolific writer. In addition to his publications and letters to editors, he wrote more than ten thousand letters to family, friends, and foes over the course of some five decades.

Lee Glazer
Associate Curator of American Art
Freer Gallery of Art and Arthur M. Sackler Gallery,
Smithsonian Institution

GRANT WOOD

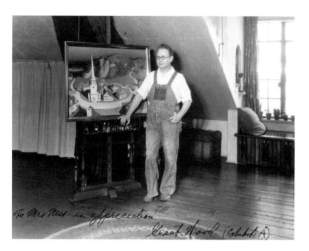

Grant Wood in his studio, 1931. Photograph by John W. Barry.

>> *Letter to Zenobia Ness,*
October 28, 1930

Writing to Zenobia Ness, director of the art program at the Iowa State Fair, Grant Wood is so exuberant that he forgoes a salutation. "Hurray!" he exclaims in large red-pencil letters, surrounded with a hand-drawn frame. And then in black ink, he continues: "Two paintings of mine in the American show — 'Stone City' and 'American Gothic'!" He uses the red pencil to double underline the fact that the jury for the Chicago Art Institute's annual exhibition of contemporary art has accepted not one but *two* of his paintings. Nearly forty years old at the time, Wood was unknown outside of his home state of Iowa, and this was a breakthrough, catapulting him to national fame. *American Gothic* won a medal and was purchased by the Friends of American Art for the permanent collection of the Art Institute of Chicago. Reproduced in newspapers across the country, *American Gothic* became Wood's ticket out of Iowa and into mainstream American history.

Wanda M. Corn
Robert and Ruth Halperin Professor Emerita in Art History
Stanford University

Cedar Rapids Ia Oct 28— 1930

Hurray!

Two paintings of
mine in the American
Show — "Stone City" and
"American Gothic"!
Two is the maximum
and only a few make it
each year
I am having photos
of the two made in
the Art Institute and will
get them when I go in
next week. Intend to have

Transcriptions

These verbatim transcriptions preserve the exact spelling and punctuation of the original letters. The format of the letters, however, has been standardized according to the modified block style for greater clarity.

FOREWORD

» **Rockwell Kent (1882–1971), page 7**
letter to Sally Kent, September 4, 1942
1 p.; 24 × 16 cm; Rockwell Kent papers

September 4 1942—11:30 P.M.

My DARLING!

This is to be just a goodnight kiss, but one as loving and passionate as my salutation is fancy. (And I guess that's a few dozen universes)!

Bobbie and Mary Lewis arrived tonight, with a hundred or more delegates. The hotel is lousy with them. I wish I liked them (the delegates) more. My advertising confrères are most dreadfully dull. Well—they are really young advertising people, people whose ideals are to do advertising. And for such work they are, I guess, just what they ought to be.

I'm sick and tired of them all, and I'm going to bed. To bed with you, my dearest love; to hold you close in my arms, and so wake up with you. God bless you, dear,

Your
Rockwell

INTRODUCTION

» **Philip Guston (1913–80), page 8**
letter to Elise Asher, August 17, 1964
2 pp.; 28 × 22 cm; Elise Asher papers
Reproduced with permission of Musa Mayer

I was in the middle of drawing when your card came! Delights—surprises, news! I had not seen it before, but any way it would have delighted me to have had on it the Asher touch. So—this is to let you know we are happy, miserable—inspired, dull—lots of work—bad and good. It would be so [drawing of blooming flower] to be together—

Isn't everything just [drawing of a smiling face] ?

xxx
smacks from us too—
Philip <u>and</u> musa

———

Musa is Musa McKim Guston (1908–92), Guston's wife and a painter and poet.

» **Matta (1911–2002), page 10**
letter to Joseph Cornell, May 6, 1947
1 p.; 27 × 19 cm; Joseph Cornell papers
© 2016 Artists Rights Society (ARS), New York / ADAGP, Paris

Dear Jojo
It was so <u>full</u> like bull and sentiment-riance and afftion the day and xpe in Utopia—the cocoon you have built. every corner is crysaling-up

My love to your <u>mother</u> Robert and Jojo
Matta.

I'll call you next week to have lunch at Lane's and arrange about $ending of the box. I have told Patricia about the Baba' on sun, about the toys of relativity (<u>kept</u> my secret about the Lord

of Princeton) and about Robert extra-ordinaire sense of humor in the Ballet of Hippopotamus.

———

Robert is Joseph Cornell's brother (1910–65); Patricia is Patricia Kane Matta (1923–72), Matta's first wife.

» **John Quincy Adams Ward (1830–1910), page 12**
letter to Asher Brown Durand, December 20, 1880
1 p.; 20 × 12 cm; Charles Henry Hart autograph collection

9 West 49th St
Dec. 20th/80

My dear Durand
I was delighted to find at the Century your kind note and the beautiful "Ariadne" as a work of art and "a Memento of good old times" I shall cherish it most lovingly

What a superb engraving it really is!

The date of its publication when I was only "a four year old" makes me realize what a long and splendid artistic career your honored Father has had

May happiness always attend him.

Very sincerely yours
J.Q.A. Ward

———

Century is Century Association, a private club in New York City; Asher Durand's father, John Durand, was a watchmaker and silversmith.

» **Edmund Charles Tarbell (1862–1938), page 12**
letter to Charles Henry Hart, June 23, 1892
1 p.; 18 × 12 cm; Charles Henry Hart autograph collection

Birkin June 23, 1892

Chas Henry Hart Esq
Chairman Committee in Exhibition,

Dear Sir
Your letter of the 18th informing me of my election as one of the Hanging Committee for your 63rd Annual Exhibition just received.

It gives me much pleasure to accept the position and to hope I may be able to fill it satisfactorily.

Very sincerely yours
Edmund Tarbell

» **Andy Warhol (1928–87), page 13**
letter to Russell Lynes, 1949
1 p.; 28 × 21 cm; Harper's Magazine records kept by managing editor Russell Lynes

[drawing of a head and speech bubble]

Hello mr lynes

thank you very much

biographical information

my life couldn't fill a penny post card

i was born in pittsburgh in 1928 (like everybody else—in a steel mill)

i graduated from carnegie tech

now i'm in NY city moving from one roach infested apartment to another.

Andy Warhol

» **Dorothea Lange (1895–1965), page 14**
letter to Ben Shahn, May 28, 1957
1 p.; 28 × 22 cm; Ben Shahn papers

Salutations to Ben Shahn once more.

One of my children (grown) sent me as a birthday present yesterday "Biography of a Painting", reprint by Fogg Museum. She lives in Cambridge, and heard the lecture.

On the morning of my birthday I read this quietly to myself sitting under a tree, and write to tell you how I appreciate very much what you have done here. I understand, from a lifetime of flashes, what you undertook to do (close to impossible) and write this to thank you for a fine morning, reading and thinking about what you said.

Yours
Dorothea Lange

28 May '57

———

On November 20, 1956, Shahn presented the lecture "Biography of a Painting" at the Fogg Museum, Harvard University. The museum published the lecture later that year.

» Hans Hofmann (1880-1966), page 15

letter to Dorothy Canning Miller, July 24, 1960
1 p.; 28 × 22 cm; Holger Cahill papers

Reproduced with permission of the Renate, Hans and Maria Hofmann Trust

Provincetown / Mass
July 24. 1960.

Mrs. Dorothy Miller Cahill.

Dear Dorothy
We feel both so very sad about the passing of your husband. It is as if we have known him forever and this will be always so.

We feel very strongly with you.

Very Sincerely
yours
Hans and Maria Hofmann

» Martha Graham (1894-1991), page 16

letter to Nickolas Muray, ca. 1923
6 pp.; 19 × 16 cm; Nickolas Muray papers

Boston
Monday night

Dear Nickolas—
I'm trying to write very carefully—but I'm propped up in bed—wide awake as an owl—I've managed to drop three fat drops of ink on the sheet so far—so forgive me if careful and hard to read—This is the first time this week I have felt enough like myself to write—But yesterday—being Sunday—I spent at a Dental Surgeons—when I had planned to go to Mr. Wescott's—I can't tell you how miserably disappointed I was—But that dentist must make it possible for me to go this week—Are you coming?

Please—I'm lonesome—You know you promised and yet I'm afraid you forget—Please try—to come I mean—Boston is a strange place—The poor Follies are panting under an excess of clothing—Kama's garden might be a lingerie salon—Dreadful—So far I have escaped—being—ac-cording to the executives—"art"—Shades of the great!

Someday—I hope I shall be in a position to speak fully to the "youth" of Boston whose morals—chastity—are so carefully guarded—as to vanish

under excessive cultivation—It is almost impossible to come home alone—and—nearly home—with both person and temper undisturbed —

I think I love Rachel Saul I only talked with her a few minutes—but she is so dear—you know they came for me Saturday night—and I could not go—It was well I didn't—as I was a little delirious Sunday—

Please—are you coming—I do so want you to come—

I must go to sleep or try—I have an anxious parent—but I do not want to sleep—I have a eager mood—Look at this writing—I'm sleeping in a quaint little peaceful sort of bed—and I'm not peaceful—

Tell me—are you still as mentally well—as when I saw you last—you know how truly I want that to belong to you—I miss your friendship—closeness—

Will you send me Leja's address—please—and is she well?

Give my love to Ben Pinchot—I am putting both my Theatre and hotel addresses to this letter—I'm hoping you can come.

I am going to the country Saturday night surely—I hope you will be there —I'm here so happy in just meeting Mr. Wescott—I truly love him—

Please—
My love always—
Martha
Graham [written in a different hand]

Shubert Theatre—
and
Hotel Belleone—Beacon Street

———

As a performer in the Greenwich Village Follies in 1923, Graham starred in the The Garden of Kama, *a romantic scene choreographed by Michio Ito; Leja is Leja Gorska (1897-1988), Muray's second wife; Ben Pinchot (1890-1986) was a photographer.*

» **Paulus Berensohn (b. 1933), page 17**
greeting card to Jane Brown, December 21, 2012
1 p.; 21.5 × 14 cm; William and Jane Comfort Brown
papers

Jane!

12 × 21 × 12
the
Solstice!

→(with seeded
earth–en–ware
begging bowl)←

may it's blessings
become you

much love
Paulus

» **Louis Michel Eilshemius (1865–1941), page 17**
letter to F. Valentine Dudensing, ca. 1935
1 p.; 28 × 22 cm; Valentine Gallery records

[drawing labeled "Quilt of Ham Chee"]

[drawing labeled "Portrait of Bum Bum"]

Dear Mr. Dudensing
You are going Strong with Abstract Stuff. And all
foreigners. No Jersey Blues. If I had my legs intact,
I could beat the crowd hollow. Aye Sir.

Well, I am writing for our Spring Show. I am half
dead. So few visitors and I neglected. Where is
God.

Mahatma E.

» **Lawrence Sully (1769–1804), page 18**
letter to Elizabeth "Betsey" Middleton Smith,
March 10, 1796
1 p.; 20 × 16 cm; Charles Henry Hart autograph
collection

Lawrence Sully
Miniature Painter

Richmond March 10th 1796.

Dear Sister
In long expectation of seeing you in Charleston
has been the cause of my silence; a series of
untoward events has precluded my intentions but
still hope to see you this Spring. Sally would not

have delayed keeping her correspondance with
you, but from a long & severe illness of which
she has but lately recover'd from, but hopes
soon to see you in person, am sorry I could not
comply with Mr Smith's wishes in sending your
Miniature as I lent it to Newburn who refuses to
give it me again, if I come to Charleston Mr Smith
shall not be in want of it to whom you will most
kindly remember me, my wife joins me in Love &
Friendship to you both.

as ever Dear Betsey

Your afft Brother
L Sully

————

Sally is Sarah Annis Sully (1779–1867), Lawrence
Sully's wife.

» **Robert Rauschenberg (1925–2008), page 18**
letter to Jack Tworkov, ca. 1952
1 p.; 34 × 22 cm; Jack Tworkov papers

Dear Jack—

I miss you and yours very much! I apologize for
not getting the package off sooner. It went the day
after Franz wrote you. the photos of the paintings
and a couple of you in lecture went off this after-
noon you should get them in a couple of days. the
gloss set is for reproduction and the extra is for
you or lay-out or what ever. I know that just the
gloss ones are good prints. I'm anxious to print
the negatives of Helen and Hermine. Tell Wally I
sent the other package to the studio too because
it saved about $2.00 to do it that way. My dear
Jack you and your family gave everyone at B.M.C.
something to think about. Even Tommie (the dog)
has not gone back home, I will write again, but not
so hurridly next Time.

Love Bob

————

Franz is Abstract Expressionist Franz Kline (1910–
62); Helen and Hermine are Tworkov's daughters;
Wally is Rachel Wolodofsky Tworkov (1916–91),
Tworkov's wife. B.M.C. is Black Mountain College
in Black Mountain, North Carolina.

» **Mario Carreño (1913–99), page 19**
letter to Enrique Riverón, July 18, 1982
1 p.; 27 × 22 cm; Enrique Riverón papers

[drawing of a man paddling in floodwaters labeled "bote araucano" and "Mapocho River (Se Salió de Madre!)"]

Querido Enrique: ¡Socorro! Nos Hundimos! Nos estamos con virtiendo en ranas y sapos con tanta lluvia— Hace dos meses que cae agua sin parar, Es un verdadero diluvio!! El peor invierno en Chile! Algo terrible y con frio muy intenso. Por eso tu llamada por telefono fue como un rayo de sol, una primavera. Gracias!!

Sóplanos un poco de calor de Miami y que el viento huela a mangos y guayaba. [drawing of a bird]

Aparte del diluvio, todos estamos bien!

Hasta muy pronto! Glu Glu Glu Glooooo

[drawing of an umbrella and rain]

Cariños Glu a Noella

Mario

Julio 1982

» **Elaine de Kooning (1918–89), page 20**
letter to Thomas Hess, undated
2 pp.; 23 × 16 cm; Thomas Hess papers

Dear T.

Many thanks for the ravishing flowers although I can't imagine why you sent these since you seemed increasingly aggrieved Fri. afternoon, over my unawareness of the passage of time, over Eliot Hoffman's way of dealing with my problems (which, as far as I'm concerned has been swift and impeccable—so I found your outburst against him quite unwarranted and over my confusing New Rochelle with Portchester (interchangeable commuter parts to me—and the fact is you lived in N. R. before I ever heard of

2

Bob Mallory whom I certainly don't associate with N.R. having never seen him in that environment, as for your first grievance, if I have to watch the clock for any reason, I tend to look for the nearest exit—

Sorry to sound so aggrieved [insertion: Or oppressed] myself—but that's the way I feel—

Love

E.

―――――

Bob Mallory is sculptor Robert Mallory (1917–97).

» **Paul Cadmus (1904–99), page 22**
postcard to Webster Aitken, August 19, 1949
1 p.; 14 × 9 cm; Paul Cadmus letters to Webster Aitken

Box 185 · Siasconset, Mass. Aug 19 1949

Dear Webster: Nantucket may boast that she has architectural gems to match your Taos church— for which, and your letter, thank you—but I can't agree, so instead I send you something in the nostalgia line: This echte photograph-ie of Lotte, I mean! Not me in the civil war. Is it from the ARIADNE AUF NAXOS days, I won-der?

So you are breaking, or by this time have broken, the back of Eliot's sonata. How pleas-ed I am; it implies a back and a back-bone to break. How rare! In these days when the anatomy of the worm is body enough for most composers.

NO, I am not one bit sorry to say—except that I shall miss seeing you—I don't expect to be in N. Y. at all until the 1st of Oct. BUT…it might possibly be…and if so, I would certainly try to arrange a meeting with you.

It might however be feasi-ble—as far as boat time-tables go (although J & M are having my sis-ter, & probably Lincoln, as guests at the time)—for me to call on you at Woods-Hole for a few hours, or for you to come to Nantucket (have you ever been?) for a few hours to see us? Probably this is impracticable but it is pleasant to dream of. In case it be not [insertion: a] wildly complicated [insertion: plan] you could call—J. & M. Have a primitive phone out of order at the moment: Siasconset 2134—from Woods-Hole & let us know.

Yrs, P.

―――――

Lotte is opera singer Charlotte "Lotte" Lehmann (1888–1976), who sang the title role in Ariadne auf Naxos, *an opera by Richard Strauss. The front of the postcard features Lehman's portrait.*

» Berenice Abbott, page 25

letter to John Henry Bradley Storrs, October 16, 1921

4 pp.; 19 × 18 cm; John Henry Bradley Storrs papers

Courtesy of The Estate of Berenice Abbott

Berenice Abbott c/o American Express—
55 Charlottenstrasse
Berlin
Octobre 16—

Dear Storrs—
Always surprises. The last time I write you a letter of despair—the next you find me in Berlin. But it was very sudden—my good luck—my desire—for quite a while. I had one day a sudden flash of intuition about Germany. It came like an inspiration. I was in terrible straits at the time—thought I might sell my studio but found that it could not be exchanged. Someone, however loned me enuf to get to Berlin and rather than simply loose the studio I payed the up to January. Something may be done later with it. The fact was that the circumstances in Monparnasse were deplorable. I couldn't do anything there. Germany exceeds all my expectations. This is the first place I have been thrilled with—thrilled to tears. It is a joy and I am enthusiastic beyond words. Everything seems to be developed more than any where. Energy—force—abounds in the air. The newer architecture excellent. Streets big and clean—shops handsome—original and all material advantages without any of the stamp of grossness or commerciality that spoils everything in U.S.A. Theaters—photography—music—years ahead. And there are signs of a most flourishing art—full swing. I am quite folle here—feel much more energetic. I expect to teach rag time dances here and have little doubt but that I can do it. I shall begin very business like to advertise and then wait for the customers! The place is clearly more healthy than Paris—dry—cold—fresh. One does not see a fifth or a hundredth of the number of Americans here. I caught a terrible cold coming up on the train and can't speak aloud. My spirits are high nevertheless—Stopped off at Cologne on the way and found it to be the most wonderful—old city. There's a cathedral there that is the finest

I have ever seen—the first one that ever moved me emotionally. It was very unexpected—just when one comes out of the Bahnhof. People have been very nice to me—only one awful nuisance is that they resent the difference of exchange to a dangerous pint and can't imagine one being American without being rich. The Rhine and the Hohenzollern Bridge were superb—. Everything's different. Women look "dutchy"—on the whole—at first—one really must choke laughing some-times—They lack chicness but they are much more independent and "modern" than french women. Every—even workmen seem to be well dressed. I made the trip quite alone and had the time of my life in spite of many difficulties. German is much easier to speak. Could you do any think with the studio? At present Man Ray has the key—and only occasionally uses it to take photographs in. Please write me and tell me the news of yourself. With lots and lots of regard & affection —always your friend Berenice

» Ivan Albright, page 29

letter to Earle Ludgin, August 28, 1968

1 p.; 27 × 19 cm.; Earle and Mary Ludgin papers

Aug 28, 1968

Dear Earle
From a lesser movie actor to a great one, I was in Chicago in early Chicago and will not be there again this fall. I will be here until well in October. Then Georgia—Cordier & Ekstrom episode—

P. S. I happened to be NY. at Sidney Janis. Ekstrom was on the phone and said Duchamp wanted my door very much for the Cordier Ekstrom exhibition—They had tried to borrow the painting Door from the Art Institute I had met a refusal—so I suggested the original wooden door—so I became according to Sidney the grandfather of pop art—That clears that up—

Sorry about the film. Come out here & see us—

Sending this by carrier moose, have mother & child in willow patch by barn. sending child so letter wont get lost—

love
Ivan

letter to Arthur Dove, ca. 1928
2 pp.; 27 × 19 cm; Arthur and Helen Torr Dove
papers

Friend Dove,
Thanks for your lines. They satisfy me more
than all the trash in the newspapers and enco-
miums in the gallery, because as coming from
your eye and mind through the brush. What we
have in common, clearly, is "Das Malarische au
Sich", paint-ing as such, as 'it', where we differ is
through philosophy. You are asketic, I am prag-
matic. And besides we agree again on the musical
version of the idea of painting. For racial reasons.
Versus French.—What, in your recent sea or storm
painting, at Stieglitz', I cannot get, or submit to,
is ten times exchanged for by the musical employ
of paint & tones there evident, big enough.—

I am now no more painter. I was painter, in
order to learn. What? I think that which I did
not receive through birth. I am at a new mile
stone—although I must keep on painting, now like
a mule—mainly to convert paint into, to convert
into paint, all that is, seems, isn't, feels is felt, the
sum of all, human, all that I meet all the time, in
me, about me, —"condensed in a mustard seed"
in any intrine angle of space. And I feel clearly the
limitation of myself as well as of painting so as
to do that, and of time and money to accomplish
it, and of my raving blood that rushes me to side
paths, in many ways.

To better quit New York—fly paper to all my feel-
ings, I'm all mussed up and try in vain to lick the
molasses of my tentacles—for the peaceful wil-
derness like yours and your way. Another Link.

Yes, all is vanity, as you suggest, —perhaps; the
temerity of Ur-Energie which plays upon our
heart strings the vain winds from nowhere to
nowhere—only to make them oscillate as color.

All Hail!

Your
Bluemner

letter to Lawrence A. Fleischman, March 17, 1956
3 pp.; 22 × 15 cm; Lawrence and Barbara
Fleischman papers

March 17, 1956

Dear Mr. Fleischman:
Thank you for your won-derful letter of Feb. 12.
It makes me feel bad that it has gone unanswered
for so long, but we left here Feb. 2 for a six weeks
trip to the Southwest, and could not have mail
for-warded—So it was not until a few days a-go I
got your letter.

I don't know how to thank you for the great trib-
ute to my work that it contained except to tell you
how highly I value it, and that I will keep it and
cherish it.

I agree with you that the tide of mediocrity
that seems almost to engulf our modern world
is indeed frightening and that the problem of
keeping untainted is great. But I do believe that
no matter what cultural deserts are created
from time to time, there will always arise a new
spirit to re-create forgotten values. That doesn't
mean of course that we have to lie down and quit
fighting.

-2-

People like yourselves, who are keenly a-ware
of the danger, do more than you perhaps
think to neutralize the devastating effects of
mass-thinking.

I was very pleased to learn that you had acquired
"In a Deserted House" and "Night-hawks at
Twilight". The former I think one of the best of
the period, and it always seemed strange to me it
went unsold for so long. I guess it had to wait for
someone to come along who understood it. For
many it was too bleak, but that wasn't its message
at all. "Nighthawks" needs no comment I guess;
I love to see them frolicking in the vanguard of a
storm—I think they must use the swirling eddies
of wind as we do sliding places. How I en-vy
them—if there were anything at all to the theory
of evolution (which I doubt very much) man would
long ago have developed wings. And I love the
eeriness of a woods at nightfall.

I wanted wings so often, on our trip—going through the desert, some odd-shaped mountain-peak in the distance called so strongly

-3-

for a closer look. I guess the answer would be a helicopter. I am anxious in the time when helicopters will come down in price and can be handled easily by an ordinary driver. I feel sure that time will come, and that I will run one before I die. It's one of the things I think I simply <u>must</u> do or my sojourn on this earth will not be complete.

We enjoyed our trip, got to visit our various children and grandchildren along the way (as far as Los Angeles) and saw many strange and fantastic natural wonders—But—it is grand to be back in my own country, (which is buried in a beautiful fall of snow)—and I can hardly wait until I can get out in my favorite woods, set up my easel, and go to work—the long abstinence from it, enforced by my stay in the hospital and the Retrospective, has caused my brain to seethe with ideas—a good result!

We do hope you can find your way to Gardenville in the near future—Thanks again for your letter—

Cordially yours
Charles Burchfield.

» **Alexander Calder, page 37**
letter to George Thomson, June 29, 1932
2 pp.; 28 × 22 cm; Alexander Calder letters and photographs

R.F.D #1
Pittsfield, Mass.
June 29/32

Dear George
It seems a long time since I have either written you or recieved a note from you. Tho I often wonder how you are doing. A lady-friend of my pa & ma left the other day for London, and I thought of telling her to look you up but she seemed rather elderly and dull, so I decided not to. But I thought I'd write you just the same.

I had another exposition in Paris last February.

This time—abstract sculptures which moved—so swaying when touched or blown, and others propelled by small electric motors. I had some 15 individual motors—so it was really quite a show. not so much like Mister Rodin.

We came over here about May 1st to visit Louisa's mother—who has just left for Geneva, and my parents who live here in the country. We expect to leave in a month or so & come back by way of Spain

2/

visiting Miro (remember him) near Barcelona. You said my cards always roused your envy of my wanderings—and so I feel uncomfortable about writing you. But I am quite fond of you and feel that an occassional note is not amiss. We hope you'll be able sometime to get over to Paris and spend a week with us. Please let us know if ever you should have the chance

The address is
14 rue de la Colonie
Paris 13eme

Very cordially from us both
Sandy Calder

————

Louisa is Louisa James Calder (1905–96), Calder's wife.

» **Mary Cassatt, page 39**
letter to John Wesley Beatty, September 5, 1905
4 pp.; 18 × 27 cm; Carnegie Institute, Museum of Art records

Sept. 5th

Dear Mr. Beatty
I have long been wanting to write to you, & have hardly known how. It is so long ago that I had the pleasure of meeting you in Paris that you may have forgotten the conversations we had at that time. I then tried to explain to you my ideas, principles I ought to say, in regard to jury's of artists, I have never served because I could never reconcile it to my conscience to be the means of shutting the door in the face of a fellow painter. I think the jury system may lead, & in the case of the Exhibitions at the Carnegie Institute no doubt does lead to a high average, but in art which we

want is the certainty that the one spark of original genius shall not be extinguished, that is better than average excellence, that is what will survive, what it is essential to foster—'The 'Indepéndents" in Paris was originally started by our Group, it was the idea of our exhibitions & since taken up by others, no jury's & most of the artists of original talent have made their debut there in the last decade, they would never have had a chance in the official Salons. Ours is an enslaved profession, fancy a writer not being able to have an article published unless passed by a jury of authors, not to say rivals—

Pardon this long explanation, but the subject excites me, it seems to me a very serious question in our profession, these are my reasons for never having served on the jury of the Institute, if I could be of the least service in any other way I would most gladly. I would consider nothing a trouble to serve the Institute of which you are so devoted a Director. As to sending pictures, this year I have none, they have been sold in Paris and I could not ask the owners to send them so far as it would seem to them.

With my sincere regrets and my renewed excuses, believe me, my dear Mr. Beatty

Most sincerely yours
Mary Cassatt

» Mary Cassatt, pages 40–41
letter to Homer Saint-Gaudens, December 28, 1922
3 pp.; 19 × 14 cm; Carnegie Institute, Museum of Art records

Dec 28th 1922

Dear Mr St Gaudens
I have taken refuge here from the gloom of Paris & I suppose you and Mrs St Gaudens are there & I regret I shall not have the pleasure of seeing you. I hope your Committee have found you some good things, but they are a Jury.

It may interest you to know what Degas said when he saw the picture you have just bought for your Museum. It was painted in & 1891 in the summer, & Degas came to see me after he had seen it at Durand-Ruels. He was chary of praise, but he spoke of the drawing of the woman arm plucking

the fruit & made a familiar gesture indicating the line & said no woman has a right to draw like that. He said the color was like a Whistler which was not my opinion, he had spoken of the picture to Berthe Morisot who did not like it. I can understand that. If it has stood the test of time & is well drawn its place in a Museum might show the present generation that we worked & learnt our profession, & which isnt a bad thing—I hope you had a pleasant time in Rome.

My best wishes to you & Mrs St Gaudens for the coming year may it bring you all this troubled world can give of good.

Sincerely yours
Mary Cassatt

———

Durand-Ruels is the gallery of Paul Durand-Ruel (1831–1922), a French art dealer who represented many Impressionist painters.

» George Catlin, page 43
letter to D. S. Gregory, July 19–August 21, 1834
2 pp.; 25 × 20 cm; George Catlin papers

Rev'd Aug. 21

Dragoon Camp 80. ms. above the mouth of False Washita—on Red River

Dear Sir,
An opportunity occurs at this moment of dropping a few lines to friends & amongst others I say 5 words to you. I am well and in the daily expectation of me in witnessing an interesting meeting with Pawnees & Comanches, after which I shall make the quickest march home again that I can possibly make. This tour is of a most fatiguing kind & I trust it may sufficiently interesting to repay me for the trouble. The public are expecting that I will see these Indians or I should almost be ready to abandon the expedition & come home. I have had frequent letters from Clara who speaks in the warmest terms of the kindness & friendship of the family with whom she is staying. I enclosed a Draft on the [Secy?]—to you for 65 dols. which I forgot to request you to enclose when collected, to "Clara B. Catlin Lower Alton, Illinois" & oblige & [illegible] 800 mounted men on these green prairies furnishes one of the most picturesque scenes I

ever saw. I would be glad that you could see them. You will see my sketches however.

Love to all Yours &c.
Geo. Catlin—

———

*Clara is Clara Bartlett Gregory (1807–1945),
Catlin's wife.*

» **Frederic Edwin Church, page 45**
*letter to Martin Johnson Heade, October 24, 1870
4 pp.; 21 × 27 cm; Martin Johnson Heade papers*

Hudson Oct. 24th/70

My dear Mr. Heade
That Petit Grand Manan picture is not at all suitable for exhibition. On no account let it go to Chicago or anywhere else to be exhibited. I dont mean by this that I am ashamed of it, but I have my own view as to which of my pictures I want exhibited and—'twixt you and I—I prefer generally to keep out of—Public places. I feel so much confidence in your gun that I consider the game dinner questioned fixed. I am contemplating a visit to New York to select registers (hot air) for my Castle and if the time I can spare should meet your dinner hours so much the better for me. You may expect, or not just as you please, to see a clodhoppers smiling phiz—within a week—illuminating your doorway. Promise I cant for I have 9631201. problems in Architecture and construction given me to solve daily—

The house grows—so do the rocks some say. The solid foundations so braced my will that we didn't feel the popular earthquake which startled the lower world. I believe however that the earth shook only in fever and ague districts. We are having splendid meteoric displays, magnificent sunsets and Auroras—red, green, yellow, and blue—and such—in profusion I have actually been drawn away from my usual steady devotion to the new house to sketch some of the fine things being in the sky.

Gifford is here in Hudson building a studio atop of his fathers house. The view from it will be splendid. Bierstadt, I hear from his friends, proposes to remove—bag and baggage to California. How goes the Jim-a-ky? What sizable canvas will you

take up next? I am much obliged [insertion: to you] for ~~your~~ acting the shield between me and the charity fund. It is absolutely impossible for me to paint pictures for such purposes, I object to the principle of the thing and moreover it makes me feverish to think of the amount of studio work, I have engaged to do this season.

The system Artist's have adopted of making auction sales of pictures on every occasion does a vast deal towards making their works appear of little value in the eyes of the public. The "Jerusalem" has been seasoning for months, I painted upon it to-~~do~~-day The first time for two weeks. Where do you buy your writing paper? Your letter appeared to be written on a later style of papyrus than we clodhoppers have had access to.

yours sincerely
Frederic E. Church

———

*Gifford is landscape painter Sanford Robinson
Gifford (1823–80); Bierstadt is landscape painter
Albert Bierstadt (1830–1902).*

» **Joseph Cornell, pages 47–48**
*drafts of a letter to Teeny Duchamp, October 8
and 9, 1968
4 pp.; 27 × 20 cm; Joseph Cornell papers*

To Mrs. M. Duchamp

Oct 8. 68.

Such a surging[insertion: e] of endearing moments has been

It will [insertion: never] sink in because [insertion: of] ~~he~~ course he has never [insertion: really] left us. ~~So many accept~~ No ¶ The memories are ~~so endearing. So graphic, so too~~ & enduring ~~& too & graphic too~~ [insertion: too graphic] + too endearing. 1 [circled]. ~~permit its cherished contact. I recall so easily my first meeting with Marcel, (around 1934), the moments the delicious the piquant flavor [illegible] of contact with a unique personality.~~

~~It was brief and as a stranger~~

Brummer Gallery

I recall so easily an esp. cherished one, ~~the~~ first brief meeting (as a stranger), the piquant flavor

of contact with a unique personality. Rare, rare qualities ~~that humble one. Suddenly attempting expression~~ slowing my pen & and humbling me attempting Expression of ~~proper~~ homage. I feel my debt is real & great. ~~so many hours of the depression years~~ Please accept my ~~deepest profoundest~~ deepest sympathies, dear Teeny, in your time of trial.

Oct. 8. 68

~~Jackie~~

Not sent in letter on other side

Last evening ~~on the couch before [illegible]~~ I had a vivid dream about Delacroix being alive & ~~& interp Marcel about him and all~~ sounding out Marcel as to the poss. of obtaining one of ~~Del his~~ his handkerchiefs. But this meagerly betokens a great mystique, ~~I feel a D. to [[Rodin ?]] to Duchamp.~~ with respect to: HOMMAGE

Last evening I had this vivid dream of Delexcroix, and of con-versing with Marcel abt him.

10/9/68

The news just doesn't seem to register ~~the~~ the memories are too graphic, endearing & enduring. ~~An especially cher. one is recalled of~~ the first meeting ~~is thought~~ recalled [insertion: fresh] as only y'day, ~~and the~~ with its piquant flavor of contact with a unique personality. Rare [insertion: rar qualities, shaming ~~my~~ one's pen & humbling ~~me~~ one attempting homage. ~~The debt~~ I feel my debt is real & great.

~~Last evening I had a dream of being of with Marcel & conversing about Delacroix~~

Extra

In a dream last evening I was conversing with Marcel, ~~about Delacroix who~~ telling him that Delacroix was staying. [sentence is circled]

for Jackie

~~Please I ask for ^a little time to to~~

~~I do hope there may be some moment~~

All my [insertion: h felt] love to you, dear Teeny, in this new situation.

All my heartfelt love ~~to you, dear Teeny~~ and profoundest [insertion: deepest] sympathies to you & yours, dear Teeny, in your time of trial.

Sincerely, Joseph

~~Should I find myself equal to it at a later date.~~

~~It shall not be for want of effort surely in time to come, "noblesse oblige".~~

» **Hanne Darboven, page 51**
letter to Lucy R. Lippard and Charles Simonds, October 3–4, 1973
3 pp.; 30 × 21 cm; Lucy R. Lippard papers
© 2016 Artists Rights Society (ARS), New York / VG Bild-Kunst, Bonn

am burgberg Oct 3/
 Oct 4/1973

dear lucy, dear charles, dear ethan

dear 1, 2, 3, one two three

thank you lucy soooo much fror writing for me, i recived ART FORUM "today"

lucy,
lucy, writing writing i do (live) am burgberg

NYC is my "home"

seasons follows / creates seasons

dash

night follows / creates day
day follows / creates night and vise verse—

dash

—repeat plus repeat—

+

but: how else: my answer "today" // "today" // "today"

1

Oct 3/
Oct 4/1973 am burgberg

i am thankful, will go on writing writing
from—sill

dash

nothing never ends—;
all ends up—;
nothing never ends—:
and vice verse—;

dash

"The dance along the artery The circulation of the

lymph. Are figured in the drift of stars…"
Eliot

"mixing memory and desire"
Eliot

dear lucy—i wrote to Sol and Carl—;

free again // air

night follows / creates day
day follows / creats night

creates "it" Call it "it"

love and be well, hanne

2

i will write to you again—soon, mayby

i do come to NYC soon

3 + 10 + 7 + 3 = 23 →

[illegible] → 23

4 + 10 + 7 + 3 = 24 →

[illegible] → 24

3 + 10 + 7 + 3 = 23 →

"Alas, this world is real, 10 → 20

23

4 + 10 + 7 + 3 = 24 →

i, Alas, am Borges "…[illegible] 10 20

241

Sranstatation

i will be as quiet as pencil and paper as writing is
→

→ writing

3

———————

Ethan is Ethan Ryman (b. 1964), Lippard's son; Sol is artist Sol LeWitt (1928–2007); Carl is artist Carl Andre (b. 1945).

» **Willem de Kooning, page 53**
letter to Michael Loew, March 28, 1966
1 p.; 26 × 21 cm; Michael Loew papers

All quotations by Willem de Kooning © 2016 Estate of Lisa de Kooning

Dear Mike,
It is nice to hear from you. Yes,…and it would be nice too to see you. In a way,…what I had

started here was to big an undertaking, (I mean in building the studio,……and it take so long,)….
if it was finished now, I could then now invite you, it would be nice,…but soon now anyhow,..I hope to see you here!

How are you? and you wife and son?

Meabe it is a nice idea to have an exhibition of Penny West's work.

2

So many of our friends are gone. Add my name,. Yes! Your son must be growing up? My daughter is 10 years already. Give my love to them, and you too.

Love Bill

» **Beauford Delaney, page 55**
letter to Lawrence Calcagno, April 28, 1963
1 p.; 28 × 22 cm; Lawrence Calcagno papers

53 rue Vercingetorix
Paris April 28th, 1963

Dear Larry:
I think of you this beautiful April morning I wish I could have coffee and conversation with you have been remembering many good moments including good people painting travel and living. While the weather is not warm it's quite vital and divides itself into sunshine and rain. There is so much artistic ac-tivity that it becomes impossible for me to see all there is being exhibited you under-stand just so much happens that one becomes very calm and see some and just quietly with-draws because of limited energy. Paris already is full of strangers and many of them American. It's good to see so many com-ing over, I tell our friends of your coming exhibition in 64 they are delighted. Charley is beginning to work again he is accompanying him-self with lithography now and so is Jim Legros. But I am doing gouches and oils not many but continuously. It's sort of been difficult for me to get underway but slowly it is happening. Have many plans but not too much occurs now worthy of mention, so will keep to the day by day which is work and visiting a few friends who also visit me and seeing shows and staying home and reading and remembering. You are always in my thoughts and I send my deep-est

to you and your dear friends there keep up the great work and soon you will hear from me again.

Love Beauford

———

Jim Legros is painter James K. LeGros (b. 1929); Charley is painter Charles Boggs.

» **Arthur G. Dove, page 57**
draft of a letter to Duncan Phillips, May 1933
4 pp.; 28 × 22 cm; Arthur Dove papers

Dear Mr Phillips
Your letter is the most amazing sort of criticism that I have ever had. When you take the privilege of sawing my picture in half it matters not much to me but I should think that you should think better than sawing a picture in half.

I have come to the point of not caring whether you are interested in buying it or not because my love went into the picture and if you cut my love in half that is your trouble. Photographs of the paintings

II

were very fine but ~~the~~ cutting off a portion of what has meant to be takes away something that you have no right to do.

I've been very grateful to you for what you have done for me, and I am being ungrateful for what you are undoing in a case like this.

I hope you will consider my frankness so that I can be still more frank in telling you that I think your cutting my picture in two was rather preposterous.

III

I would be glad to have any thing done that would lend toward the furtherance of the living of modern painting. But I do not see how that can be without a certain cooperation that means giving towards spirit which ~~is~~ should be enjoyed by all those who are concerned really in the love of making fine things.

I don't understand your letter when you try to cut my picture in half

I think that's rather stupid. Your ease in disposing of part of my painting creates a difference from a horizontal to a vertical. I'm glad that I don't have

to go through that any more—I am beginning to feel with—for instance—Brett's disclaim—about Lawrence that I am "beyond danger."

» **Marcel Duchamp, page 59**
letter to Suzanne Duchamp, January 15, 1916
2 pp.; 26 × 21 cm; Jean Crotti papers

15 Janvier environ

Ma chère Suzanne
Merci énormément pour t'occuper de toutes mes affaires

—Mais pourquoi n'avais tu pas pris ~~cette~~ mon atelier pour habiter. J'y pense juste maintenant— Mais je pense que peut être ça ne t'irait pas. En tout cas, le bail finit 15 Juillet et si tu reprenais, ne le fais qu'en proposant à mon proprio de louer 3 mois par 3 mois, comme cela se passe ordi- nairement; il acceptera sûrement. Peut être père ne serait pas mécontent de regagner un terme si c'est possible que tu quittes La Condamine pour 15 avril. _____But I don't know anything about your intentions and je ne veux que te suggérer quelquechose._____

Maintenant si tu es montée cz moi tu as vu dans l'atelier une roue de bicyclette et un <u>porte bou- teilles</u>. J'avais acheté cela comme une sculpture toute faite. Et j'ai une intention à propos de ce dit porte bouteilles: Ecoute.

Ici, à N.Y., j'ai acheté des objets dans le même goût et je les traite comme des "readymade" tu sais assez d'anglais pour comprendre le sens de "<u>tout fait</u>" que je donne à ces objets—Je les signe et je leur donne une inscription en anglais. Je te donne qques exemples: J'ai par exemple une grande pelle à neige sur laquelle j'ai inscrit en bas: <u>In advance of the broken arm</u>. traduction française: <u>En avance du bras cassé</u>. Ne t'escrime pas trop à comprendre dans le sens romantique ou impres- sionnisté ou cubiste.

—Cela n'a aucun rapport avec;

un autre "readymade" s'appelle: <u>Emergency in favor of twice</u>. traduction française possible: <u>Danger crise en faveur de 2 fois</u>.

Tout ce préambule pour te dire:

Prends pour toi ce porte bouteilles. J'en fais "un Readymade" à distance. Tu inscriras en bas et à l'interieur du cercle du bas en petites lettres peintes avec un pinceau à l'huile en couleur blanc d'argent la ~~phr~~ inscription que je vais te donner ci aprèse et tu signeras de la même écriture comme suit:

[d'après] Marcel Duchamp.

» Marcel Duchamp, pages 60-61
letter to Jean Crotti and Suzanne Duchamp,
August 17, 1952
6 pp.; 25 × 20 cm; Jean Crotti papers

17 Aout 52

Cher Jean Chère Suzanne

[arrow pointing from "Tu" to "Jean"]

Tu as dû te demander ce que je faisais après m'avoir envoyé ta longue lettre sur l'expo Sweeney!

Tout a fait d'accord avec toi—sans oublier que ~~d~~ a dû organiser toute cette expo. en 6 semaines (avant l'ouverture), je sais qu'il n'a pas pu faire autre chose que de l'à peu près, et malheureusement trop suivre son goût (qui n'est d'ailleurs pas mauvais)

je me rappelle que dans mes conversations avec lui à ce sujet, je lui avais suggéré l'idée de donner au moins un petit panneau (tout petit) à Dada qui est ~~d¹~~ une des manifestations certaines des 50 dernières années—il n'en a rien fait, naturellement.

A ce propos Jam's organise une expo Dada pour Mars ou Avril 1953—il me charge de l'organisation des idées de cette expo.—et du coté ~~pan~~ parisien je voudrais avoir ton clown sur verre (fait à N.Y.?)

Si tu veux l'envoyer tout de suite par le fils de Marthe Pelletier qui part pour N.Y. sur le Queen Mary du 3 Sept., peut être auras tu encore le temps. En tout cas ce n'est pas pressé—je trouve que c'est mieux de l'envoyer par quelqu'un.——Au fait Rose Fried pourra le ramener ~~ar~~ à son retour en Octobre.

Si tu penses à autre chose de la même époque, dis le moi___

Merci pour les articles de Suisse et de Cassouges à qui je n'ai pas encore écrit.

La Soeur de Katherine Dreier, Mary Dreier, m'a donné pour toi et Gaby 2 châles espagnols très beaux comme souvenir—je te les fais apporter par Rose Fried (elle part le 12 Sept., te dirai le bateau une autre fois)—Vous déciderez Gaby et toi lequel va à qui.—Tu remercieras Mary Dreier après réception

Miss Mary Dreier 24 West 55th St. New York.

Suzanne te reste ~~il~~ t'il des dessins en aquarelle Dada que tu voudrais exposer? Donne les à Rose Fried]

Tu me demandes mon opinion sur ton oeuvre, mon cher Jean—C'est bien long à dire en quelques mots—et surtout pour moi qui n'ai aucune croyance—genre religieux–dans l'activité artistique comme valeur sociale.

Les artistes de tous temps sont comme des joueurs de Monte Carlo et la loterie aveugle fait sortir les uns et ruine les autres—Dans mon esprit ni les gagnants ni les perdants ne valent la peine qu'on s'occupe d'eux—C'est une bonne affaire personnelle pour le gagnant et une mauvaise pour le perdant.

Je ne crois pas à la pein ture en soi—Tout tableau est fait non pas par le peintre mais par ceux qui le regardent et ~~a~~ lui accordent leurs faveurs; en d'autres termes il n'existe pas de peintre qui se connaisse lui même ou sache ce qu'il fait—il n'y a aucun signe extérieur qui explique pourquoi un Fra Angelico et un Leonardo sont également "reconnus."

Tout se passe au petit bonheur la chance—Les artistes qui, durant leur vie, ont su faire valoir leur camelotte sont d'excellents commis—voyageurs mais rien n'est garanti pour l'immortalité de leur oeuvre—Et même la postérité est une belle salope qui escamote les uns, fait renaitre les autres (Le Greco), quitte d'ailleurs à changer encore d'avis tous les 50 ans.

Ce long préambule pour te conseiller de ne pas juger ton oeuvre car tu es le dernier à la voir (avec de vrais yeux)—Ce que tu y vois n'est pas ce qui

en fait le mérite ou le démérite—tous les mots qui serviront à l'expliquer ou à la louer sont de fausses traductions de ce qui se passe par delà les sensations.

Tu es comme nous tous, obnubilé par une accumulation de principes ou anti-principes qui généralement embrouillent ton esprit par leur terminologie et, sans le savoir, tu es le prisonnier d'une éducation que tu crois libérée_____

Dans ton cas particulier tu es certainement la victime de l'"Ecole de Paris", cette bonne blague qui dure depuis 60 ans (les élèves se décernant les prix eux mêmes, en argent)

A mon avis il n'y a de salut que dans un ésotérisme—or, depuis 60 ans nous assistons à l'exposition publique de nos couilles et et bandaisons multiples—L'epicier de Lyon parle en termes entendus et achète de la peinture moderne____

Les musées américains veulent à tout prix enseigner l'art moderne aux jeunes étudiants qui croient à la "formule chimique"____

Tout cela n'engendre que vulgarisation et disparition complète du parfum original.

Ceci n'infirme pas ce que je disais plus haut, car je crois au parfum originel mais comme tout parfum il s'évapore très vite (quelques semaines, quelques années maximum); ce qui reste est une noix séchée classée par les historiens dans le chapitre "histoire de l'art"____

Donc si je te dis que tes tableaux n'ont rien de commune avec ce qu'on voit généralement classé et accepté, que tu as toujours su produire des choses entièrement tiennes, comme je le pense vraiment, cela ne veut pas dire que tu aies droit à t'asseoir à côté de Michel-Ange.

De plus, cette originalité est suicidale,

dans ce sens qu'elle t'éloigne d'une "clientèle" habituée aux "copies de copistes", ce que souvent on appelle la "tradition".

Une autre chose, ta technique n'est pas la technique "attendue"—Elle est ta technique personnelle empruntée à personne—par là encore, la clientèle n'est pas attirée.

Evidemment si tu avais appliqué ton système de Monte Carlo à ta peinture, toutes ces difficultés

se seraient changées en victoires tu aurais même pu créer une école nouvelle de technique et d'originalité.

Je ne te parlerai pas de ta sincérité parce que ça est le bien commun le plus courant et le moins valable—tous les menteurs, tous les bandits sont sincères. L'insincérité n'existe pas—Les malins sont sincères et réussissent par leur malice mais tout leur être est fait de sincérité malicieuse.

En 2 mots fais moins de self-analyse et travaille avec plaisir dans te soucier des opinions, la tienne et celle des autres.

Affectueus Marcel

» **Thomas Eakins, page 63**
letter to Frances Eakins, March 26, 1869
4 pp.; 21 × 13 cm; Thomas Eakins letters

Paris. Good Friday March 26/69.

Dear Fanny I ~~have~~ got your letter last Sunday afternoon. I was very anxious about it for I knew you would write to me to tell me about mommy. We are both at work at our schools. Bill is at Yvon's & likes it very much. I̶ I was wondering till I got here whether Bill & I would do better to ~~sta~~ take a studio between us or stay ~~with~~ in Crepon's studio ~~till~~ at least till [illegible] ~~eame~~ back from Italy. When we went to see Crepon he received us not over warmly & Bill Sartain especially coldly. Next day I wentover there to cover some canvasses & when I got nearly through Crepon said My! how strong that paint smells I'm afraid it will hurt the boy & give him colics. So I took up my canvasses & carried them back to the canvass shop. Next day I told him it was indifferent to us whether we staid with him or took a studio to ourselves, so he thought we had better take one ourselves ~~for~~ on our account & on that of his wife & boy. This was very sensible & just & we are all better pleased than if we had staid together. But there was no occasion for ~~such~~ any exhibition of coolness & he should have ~~let me speak~~ had a little patience & let me speak my intentions & wishes before discovering any humor or should have spoken himself. When I took my studio in West St. first I asked him to ~~eome in~~ stay with me for company & he came up for he was living on the

ground floor & the water was streaming always down the walls so that the doctor said they would die if they staid there & he & his wife & child all staid in my studio except to sleep & I was very glad to have them there for company ~~and she~~ I like to see a child playing about. ~~when he~~ I was paying 850 fr a year. He looked about for a new studio & apartments & found this big studio with its two little rooms & kitchen to it for 800 fr. ~~but as he feared did not like machikes~~ & to save the expense he asked me to ~~take~~ give up my studio & come in with him & so I would pay but half—400 fr. & have no trouble about sweeping or keeping clean. This was very advantageous to me & I did it, & would have ~~sade~~ saved 450 fr. a year. New he has had constant work & made enough money to keep the big studio easily for his wife & child ~~who re~~ and so he is glad to get shut of us. As soon as he was sure we were going he got more polite than ever I saw him & got chairs for me to stand on to get at casts and brushed them off for me. I think he felt mean, for he still kept talking about things which were decided on & how his boy might step in our paints & so on. Bill & I went all over yesterday afternoon hunting studios & when most despairing of our days' work ~~passed~~ found just what we wanted. It is not near so big as Crepons' but as we wont have much furniture to fill it up it will be big enough. It is in the big new St of Rennes no far from the Church of Saint Germain des Pres. It is just the right place ~~between residence~~ for our hotel Bills School, my school, the dinner place Harry Moore's studio etc etc & everything lies in a ~~circumfer~~ comparative small circumference around it. I would give you the address so you could send my letters there only ~~I have~~ the place is not not numbered yet.

Crepon is a weak man & He is falling back always, for he lives all by him self & ~~has so~~ being weak was improved by contact when he was with the French students who are above him as a class. He was the schoolmate of such men as Tony Robert Fleury & Bonnat & Lafebvre Deslonyng.

Crepon once deceived me very much. He had some studies hanging up ~~in his ro~~ & he said he had done them. They were grand in color, better than Gerome ever could do in some of their qualities, though of course far behind in others. Now

Crepon was very good in giving me advice & he did it as well as he knew how ~~but he did~~ & he told me how he had done these things in the way he imagined they had been done, & of course I paid great attention to advice in my innocence which I would have only paid a just attention to if I had known he was ignorant. I possibly staid in Paris longer than he at first thought ~~but~~ When these fellows came back from Italy the studies went away & when I asked after them he he had given them away. ~~When~~ I was often afterwards surprised in comparing my drawings of his wife with his that mine were just as good as his or better & my color sketches too & that I painted a head faster & better. One night in bed the whole deceit flashed across me & it stopped me from sleeping.

Since then ~~I~~ it is a year ago I have known Crepon perfectly. He is not bad but weak. I would have told you maybe his history before but it would have made you think me more lonely or unhappy than I was, as I had written more of him than of my other friends. There will be no change in our relations to one another. I will be just as cordial as ever & so will he. That is we will be polite and laugh together. The heart must have nothing to do in that word cordial. ~~I was~~ when you told me your opinion of Crepon from his looks I would not ~~agree with~~ let on to agree with you but your penetration astonished me for I had been deceived myself so long. You told me Mrs Crepon was more lady like than some one of my friends I forget which one. She has a splendid head & health & was a foundation for every noble quality but ~~their~~ her living with him their petty lies to one another and the like is hurting her very fast. In ten years I am sure ~~yo~~ none of us would know her. I have drawn her so often I know her face well & it is changing.

I am sorry to have written you such a mean letter but it is what I happen to be most thinking of. It is very cold & damp yet & possibly that is what set me to thinking of it again. Bill & I both have colds fortunately light ones & the little water I put in my wine or something else gave me a week's belly ache which I am now got rid of

———

Bill is artist William Sartain (1843–1924), a friend of Eakins's from Philadelphia and travel

companion in Paris; Yvon is French painter and
instructor Adolphe Yvon (1817–93); Crepon is
French painter Lucién Crepon (1828–87); Tony
Robert Fleury is French painter and instructor
Tony Robert-Fleury (1827–1912); and Bonnat is
French painter Léon Bonnat (1833–1922).

» **Howard Finster, page 65**
letter to Barbara Shissler, 1981
1 p.; 25.5 × 20 cm; Barbara Shissler Nosanow
materials relating to Howard Finster

Dear Barbara

[text wraps around drawings of Abraham Lincoln,
Thomas Jefferson, William Henry Harrison,
Andrew Jackson, William Shakespeare, and
Howard Finster]

I am excited to be coming to Washington where
these great men once had our future responsibil-
ity upon them I feel so unworthy to live in a world
of luxery and these great men paved our way I am
coming with Art Rosenbaum and Andy Nassias of
the University of GA They are going to bring me
up to be with you all they said they might have a
movy film of me and Parodise Garden instead of a
slide lecture I have a round projector slideholder
full of slides I can bring it in case I might haf to
use your projector if we use any slides Andy and
Art Rosenbaum have movys and slides so they
will work that out I am sorry I have been so buisy
I haven't wrote you so I am very honored to have
the chance to be with you all It is like a dream
they said I would be staying in the Boon House up
there I understand it would be Oct. 31 so please
check with Art Rosenbaum and Andy Nassias
They notify me when to come to Atlanta and I
meet them there to fly up to Washington Art was
by the other day and recorded me singing and
playing my banjo and gettair. He is planning on
taking me up when he goes if nothing happens we
will be right in on your people in Washington We
will have a great time It will be exciting believe
me I have been in 2 universitys in California
one in Denver Colorado I was in university in
Philadelphia Miami University and La Grange and
university at Atlanta and University of GA and 2
universitys in North Carolina and all of them was
a great hit and we really had fun and fellowship I

will soon be going to Nashvill Tennessee for about
a week in a big art show so it will be the same
there with you al it will be great I am now working
on the garden on a walk about 3 hundred feet long
for a walk to my new gallery

HOWARD FINSTER
1981

———

*Finster's traveling companions were painter Art
Rosenbaum (b. 1938) and ceramist Andy Nasisse (b.
1946), both in the art department of the University
of Georgia, Athens.*

» **Dan Flavin, page 67**
letter to Ellen H. Johnson, January 22, 1979
2 pp.; 28 × 22 cm; Ellen Hulda Johnson papers
Reproduced with permission of The Dan Flavin Estate

January 22, 1979
East Point

Ellen, John Paul Driscoll's catalogue of the two
Kensett-Colyer albums exposition, last year,
at Penn State's Museum and in the originating
Babcock Galleries in Manhattan addresses the
attributions of Kensett's drawings with caution
similar to yours. He seemed to be indicating
that only several certainly creditable drawings
existed outside of the contents of the albums.
(Finally, Driscoll credited all of the Detroit
Institute's "Kensetts" to Casilear.) That was
another inducement of my purchases. I sensed
fortunate indeed to have decided to start the
collection seriously just as such prime material
was available to me. By the way, my foundation
friends have authorized me to purchase seven
additional drawings. Our plans have expanded
to a large Museum of the Hudson Highlands,
most importantly dedicated to the history of my
arts along with the drawing collection of Hudson
River Valley artists. These nice folks want me to
become an artist-curator of sorts. I'm flattered
by the offer. I've accepted the dual responsibility.
Negotiations have begun for the acquisition of
a building near the river on a grand site. Within
two weeks, I should know much more about the
possible property purchase. If all goes reason-
ably well, the non-museum (I'm uncomfortable
with the standard sense of a museum.), should be

ready in a few years. And perhaps, you would be so kind as to lend some of your Kensetts to us for our triumphant gala opening. By the way, I found a reference for you about your group of drawings. They are sketches for engraved illustrations for George Curtis's "Lotus Eating: A Summer Book" of 1852. Driscoll dates those sketches 1851. Here is my combined list of purchases or, soon to be purchased drawings: "Windsor Castle" (184?) (Driscoll catalogue number 7), "Stolzenfels" (August 3, 1845) (no. 11), "The Bay of Baiae (?) with Ischia" (1847) (uncatalogued), "Camel's Hump beyond Lake Champlain" (August 25, 1848) (no. 39), "The Great Gorge of the Hudson Highlands from Newburgh" (1848–1849) (uncatalogued), "Catskill Mountains" (1848–1849) (no. 42), "Trees, Franconia Notch" (October 20, 1850) (no. 44), "~~Niagara~~ Trees, Franconia Notch (?)" (1850) (no. 48), "Niagara Falls" (circa 1852) (no. 55), "Rocks and Trees near Niagara Falls" (circa 1852) (no. 56) and "Rocks and Trees near Niagara Falls (?)" (circa 1852) (no. ~~56~~ 57). I will look for your book, "Modern Art and the Object" mit footnote-worthies. Thank you. Dan F.

By the way, I'm supposed to reciprocate for Don Judd in his Marfa, Texas buildings complex. I hope that I won't find "dry gulch", 'way the hell down there.

» **Llyn Foulkes, page 69**
letter to Darthea Speyer, ca. 1975
2 pp.; 28 × 22 cm; Galerie Darthea Speyer records

Dear Darthea—I had Miami send the "Chinatown" painting to me. I need it for the opening of an assemblage show here at LICA. I will pull it out of the show and send it to you before the middle of april (along with other new works). Sorry that Jane Livingston took some of the smaller pieces but I had promised them to her last year. I am sure you will be pleased with the new ones though. I will not be able to make it to the opening. I spent a lot going to N.Y. and caught the flu there. Had it for 3 weeks. Im trying to catch up. The band is playing for the opening of the assemblage show.

Write to me if there is any problem

Thanks
Llyn

P.S. I haven't received money for smaller paintings sold at your gallery. I ran it into someone, who bought one from you, at the opening in N.Y.

[drawing of a painting]

» **John Haberle, page 71**
letter to Sarah "Sadie" Emack Haberle, June 20, 1895
5 pp.; 23 × 15 cm; John Haberle papers

June / 20 1895

Dear Sadie
When I had finished your letter it was about 7-45 P.M. I then had some strawberry shortcake which satisfied my stomach & some Hortons Ice Cream which cooled my fevered brow—I then tried the same old stamp machine with nickel for two stamps but it didn't work = the clerk refunded the nick' & I got two stamps at druggist at regular price. On Wed: I got up at 6 o'c' made breakfast of Bananas & answered a feeling without the aid of a hose—at 8-30 took car for Art Museum in Park but found it did not open until 10 o'c walked from there 82nd St to 59th where the mangerie is—Met a policeman & other people. Saw a young woman changing her kid on a bench—a few squirrels— quite tame—ran about Enjoying the warm Sun & cool shades. I found the animals & surround- ings about the same as when we were here with perhaps a few additions & improvments. The Dromedary had his back up as usual—the Buffalo. Bison & Polar bear were all there the latter brought a piece bread from the water in tank. He looked at me but didn't offer me any—didn't know I guess that I hadn't had a bite yet that day. I felt sorry for the proud old Peacocks that have to drag their long & beautiful trains through the dirt = The sly gray & red fox was there. There was quite a family of them & were very playful = The Alaska dogs were in the same cage but seperated by a partition. There is some resemblance between them = Very interesting are the Prarie dogs with their underground homes. The horned Rhinoceros was munching dry hay when he might have been plowing up 40 to 50 acres of land in No. Madison & living high. The Elephant has the same old "grip as when we met him. He sais he ~~is~~ feel~~sing~~ better with ~~it~~ than without it. I passed the Rhinoceros

again & this time he had his back turned toward—
he didn't excuse himself.

(2)

Either but shook his tail defiantly in my face. it
looked like the tail of a fat turtle. The Axis deer
were the only animals (& they are spotted beau-
ties) in the building containing the two rows of
stalls. I said the only animal I meant the only in
captivity. there were plenty of little mice about.
The Hippopotamus's looked warm & as if they
had just rec'ed a coat of stove polish. There were
signs about these animals that I did not see on
the cages in Lion-house—They read "Dont climb
on the railings" A leopard had two wooden balls
in cage. They were his playthings as he wasn't
allowed to play with children. Lazy Alligators
were basking in the sun. I thought it time to visit
our old friends the mokeys. One of them said
he had heard that I was in town & expected me
in. Asked me how you were—told him you were
taking care of our little one—He wanted to know
what kind of a monkey it was—told him it was like
me in every thing but looks. Well he said then it
doesn't look like a Monkey—just then then the
rum faced keeper rushed in & asked what the
excitement was—we explained. He said I had no
business to insult any one—We then fed the dear
little one on apples & onions. I was now mad &
hungry. after seeing birds I made lunch of a little
neck clam stew at the restaurant near by—while
trying to enjoy these little bivalves my mind
naturely turned to the Darwins & I thought how
much more nature favored the ape than the man.
How much? Why have they not legs as we—armes
& hands as we—Yes & more they have a tail that
can accomplish as much as the arms & legs of
some of us. Had nature added to these Wings I
think the monk would be the most perfect of crea-
tures. Is he not as intellegent as some of us? As I
was soliliquising thusly the waiter ~~tapped~~ whom
I took to be a frenchman asked me in german if I
were a certain duchman—I answered—Nein—&
he charged me 20 cents—Dear Sadie—the supply
of paper is giving out & as it is 10-30 & I must get
lunch & go to museum I will stop & tell you about
my trip to Coney Is. in the P.M. will in the mean
time send you a tin-tipe of myself & write you in
my next why I had it taken = I you care to write

me have letter addressed = J. H. c/o A. Schuessler
77 Elliott St. If you should write my name in full
it might be sent back to you = let me know when
train leaves N.H. that gets me to Madison in time
to go up—with F.Norton. I expect to leave here
tomorrow —

Arriving N.H. at 8 P.M. will leave for No.Madn on
Monday if I hear from you in time. I not as soon
as I do—should you know of any one going in that
would be willing to take me out for 50 cts I will
come with 11 o.c. train any day that you mention =

Your truly
With love
Happy

» **Marsden Hartley, page 73**
letter to Helen and Ernest Stein, December 12, 1936
2 pp.; 28 × 22 cm; Helen Stein papers relating to
Marsden Hartley

Dec 12-36.

Dear Helen & Ernest—
I am back from Canada now—and wonder how you
both are—The summer for me was quite wonder-
ful until Sep 19th—when the two superb sons of
the family with whom I live were drowned—I have
been numb and speechless since that time.

I wonder if you would be good enough to send
the Kidder painting to me at once by Parcel Post
registered—as I would like to show it & it may be
place it awhile and thereby give tribute with fine
ambition of Kidder. I did [illegible] able paint-
ing myself of course & am preparing material
for a book on painting and painters. A splendid
piece of publicity came to me in the Nation of
last Saturday written by Marianne Moore in her
review of the new Caravan Book

2

published by W.W. Norton in which I have an
essay on Ryder & one on Demuth.

This publicity was at most the up to twice but I
am assembling fresh material for a book to follow
Adventures in the arts which I wrote two pub-
lished around 1920—& of which I am always hear-
ing—twice even since I came back ten days ago.
I think the time is probably right for such a book

& I am told in several directives I am the only one capable of doing such a thing —which is of course encouraging. If you come to N.Y. do let me know. The shows are very fine now—the season having opened with a Bang.

Do write & do send me the picture at once and I shall be grateful.

Hope you are both well & happy.

Yours as of old
Marsden.

———

Hartley's essays on painters Charles Demuth (1883–1935) and Albert Pinkham Ryder (1847–1917) were published in The New Caravan, *edited by Alfred Kreymborg, Lewis Mumford, and Paul Rosenfeld (New York: W. W. Norton & Co., 1936)*

» **Marsden Hartley, page 74**
letter to Helen Stein, September 29, 1939
5 pp.; 28 × 21.5 cm.; Helen Stein papers relating to Marsden Hartley

27 Broadway
Bangor
Maine
Sep 29/39.

My dear Helen.
So nice to get your note and I certainl wish I could say yes to your Thanksgiving ideas.—at least I can certainl say yes in the spirit, but it first has a time getting itself across the street, so hampered it is by uncertainties.

I have a real affection for the Gloucester I know—especiall after the season—when the [illegible] get out—rest of the real ones for that matter. I din't need all that—I need nothing really but the awareness—and that I have —

Sometimes I think it would be fun to visit these places that I have known so well—out of season. for example, Ogunquit would be nice now that every one is gone. Provincetown—well some of them live there all the year—but I could brave it.

Gloucester always has a certain something—quelque chose d'autre as Mallarmé says [illegible] is—[illegible]—somehow—and I must so have this one day and you must take me to Wingaersheek

Beach again—God what a sense of infinity there is there—wasn't it nice when you & Seamus and I went there that time. all of the outstanding visions of that beac were so exceedingly well set up but the standing on his hands—with its little swish of sea

2

swishing about him—perfect in build & all so fresh and clean and glowing.

I would love ~~too~~ to go up and say hello to Dogtown too—I really must do all that again & with you.

Bangor here is one of the most engaging towns I ever came across—it is fairly reeking with magnificent history—where it runs all the way down to the sea. Over 30 miles were formed with this & from nearby and the lumber jacks were swarming the place & when they came out of the woods in the spring—the whores were swarming the place to get their gold out of them—

It is extremely handsome as a city—simply buried in huge overhanging elms—and this street Broadway—is the de luxe street of the town—four rows of elms down it—and as for mansions—c/u. never saw anything like them: one mansion—surely 40 rooms—double—doubtless built half for the parents and half for the children—such as Waldo Peirce but he is the offspring of the great traditions here. & the name Peirce here is well at least legion—a not at all bad huge monument of lumber-jacks in bronze in action with their lumber tools—posed high in a block of granite—given by W's uncle. Luther Peirce who also gave a lot of money to this superb library in which I spend so much time—wonderful really.

The towns people so amiable & so good loving—

3.

and take me in as a matter of course because they smell the true Yankee in me.

I feel as if it would be my center for the rest of my life—as from here we go up the coast or into the deep north where bears and more sniff at each other. A friend of mine is up there painting and while he was working on a ledge—out comes a huge bruin and gives him a jolt but he let out a whoop & bruin skiddled away in a hurry. He also writes of beaver—and of course, deer—foxes

raccoons and hedgehogs. I feel as if I shall be living up there myself now. going down for two months to N. Y. so that I can really enjoy it and not be bored to death. I live here in a magnificent chocolate coloured mansion—at one corner of this city Grand Broadway—I have a hall room. must have been the billiard room formerly—but it fair and grand spaces to wander in & I have a brief view down on the town—a 6ft long steam pipe so I shall always be warm.

Next month I go up to Mt. Katahdin to paint the "sacred" mountain as I have wanted to for years—and I must put myself on record as having done it. and as far as I know it has never appeared in art—I have elected myself official portrait painter.

I am now the proud possesser of the local legion d'honneur—the State having written to me for an autograph copy of a house for the State's private collection of Maine authors they having 1000 books now written & [illegible] by

4.

Maine's writers—I also sent them a dozen photos of my Maine painting with a copy of that amazing Index of 20th Century American artists—with two pages and a half all about me. all the shows I had done—all that was even written about me, etc. I know the State Librarian received an official letter giving me full state recognition.

I very much wanted this—and it came as a gesture on their part wholly which I like. There is only Waldo Peirce & myself as outstanding painters from Maine and I really paint Maine & Waldo does not—poor Waldo—such a nice person but not a good artist—one of the best of the not so good ones—or he wouldn't be a failure with [illegible] fully in N.Y. would he? No, he wouldn't. I want to keep out of all that cheap stuff & be as much a mystery is possible—after all, what has our lives myself and you to do with all that.

George Biddle has a book of his life out—So has John Sloan and Jerome Myers—imagine—Waldo is doing his life ordered by Scribner's—so it seems even artists have lives. It makes me feel like giving mine up.

I have lived the life of a 30x40 just a little while ago & you can imagine what sort of victory that

is—Nothing gives me nerves like picture that looks uncertain—bad enough where they look certain—and I loathe it when all my paintings are half done as they are

5

now—but I hope to finish this here—between now & Dec 1st—when I suppose I must go down to N.Y. and when I do—I can take a direct train from here—just down at the end of the street—& it gets me there early the next morning—& saves a lot of bother.

If I were flush I would go via Boston & then I would surely see you. but it doesn't work that way & Boston never really satisfies me.

Anyhow dear Helen—kind of you to ask me for [illegible] & I should visit an evening if as I did the last time—

Love and best wishes always
Marsden.

I must now write a letter to the game warden up Katahdin way—as he knows all that country & has offered to drive me from [illegible] over and up to this Dean Wrty at the Mt. 5.00 a day and for: hunting, camp. but there's no other way & I must get that Mt. for future reasons of fame & success.

» **Martin Johnson Heade, page 77**
letter to Frederic Edwin Church, April 27, May 6, June 16, 1868
6 pp.; 19 × 25 cm

Room 7, Studio building
N.Y. Ap. 27th

Mr. Church
Dear Sir:
I'd like to know why you don't let us have a bit of news from you occasionally.

I was able to pacify the people for a while, but they are beginning to stop me in the streets again! I want to soothe them with a little information. I saw Mr. De Forest a few day ago but he had not heard from you. "nor any other man". The little picture that you daubed for him is in the N.H. Exhibition. The Ex. is rather better than usual. I have one picture in—a storm. I'm having a great run of sales in Chicago, hope it will continue.

Somebody out there wanted one of my salt mead-ows, so I painted one—a sun-rise—near Boston, in-tending to fill up the sky with clouds, but a person who came in was so charmed with the plain sky, that I concluded to take his advice, so I tried the effect of one of Your suns just peeping over the edge of the horizon, with some rays com-ing down from it—as if a man had tears in his eyes! Thats the only touch in which I've imitated you. & that I did not intend—so dont charge me with "stealing your thunder". I wrote you a tiny letter a long time ago, which I presume you got.

The old no.7 study—Jo is still in its neat, old-maidenly condition, & its occupant hasn't been sued for any rent yet! There has been no business, scarcely, done since you left; but I have been lucky in disposing of Everything I've done this winter ditto some old ones.

The Noble Reverend calls often & lunches with me; & the other day he brought another Rev. with him & lunched. & while at it (the other Rev.d name being Aaron) the Rev. Noble got off one of his jokes:—He began in a very jolly way about lunching with such respectable old fellows as Moses & Aaron. I told him I saw the joke as far as Aaron was concerned, but where, O where! was the Moses!

Why, says he—Aint your name Moses? Said I, "not as I knows on—who told you that?" "Why, Church! Confound that fellow! he never seems to be satisfied unless he's getting off some joke or other on me."! The other day he was in. & when I let him out of the door he hoisted his umbrella & started off down stairs!

I have put a lot of camphor in the drawer with your brushes, & caulked it up tight with the following inscription—

"No admittance for moths () on business." Our friend Marshall (he of the Washington & Lincoln fame) has been & gone & made a fool of hisself by making a Grant, & such a Grant!!! If he had got some one else to paint the picture he might have saved his reputation; but he thought he could do it ——& he did

P.S. Why dont you write to somebody?

May 6th. I've just heard that you are in Jerusalem—with Jerome. If so, please bring me a "chunck" of gold from Solomons temple. It may delight you to know that your friend Mr. Chas. Gould has been black-ball'd at the "Union League Club". [[underlined]] Your humble servt. was not [[/underlined]], & is now a "member in good standing". I'm agin clubs in general, but I wanted the use of their Exhibition room.

June 16th. Isn't this keeping a Journal! I had a call from Mr Meeks yesterday, & learned that [inser-tion: you] are about returning to Europe.

I began this letter with the Expectation of getting another from you some day, & then sending it. but I've about given up that hope. & as its written, I send it—to the care of Hottentot & co. Paris. I hav-en't the faintest idea as to whether you recd. the one I sent to Beyruit, or not. Dr. Schench is still in Paris. If you go there before Sept. you can find him through Munroe & co. Bankers.

I'm trying to paint a Spring picture, but it has rained so incessantly that nothing of the land-scape can be seen—only some per-pendicular streaks of water. Cincinnati is waking up again, after a ten years sleep, & is to have a big exhibition in the fall.

Chicago is rushing past everything in the way of the fine arts —Even N.Y. will have to look to its pre-eminence. They have an "Art Journal" there. Robbins has come back, & is now in tribulation because of his having let his room slip out of his hands. He wants me to go to Europe, or some-where else, for a year, & let him have this studio. I told him I'd think about I, which I immediately proceeded to do. I have sold my picture in the exhibition.

As I passed Cyrus Fields last night I found a crowd around the house & found that their "burglar alarm" had been rung & they had the police there; but I did not learn whether they had a successful burglary or a false alarm. As they get so many frights I begin to think it's the work of their ras-cally boys—They are equal to anything in the way of mischief. I asked Beard yesterday how many pictures he'd sold this spring, & he replied— "When I sell another, that will make one." So you see how the arts are flourishing here. The N.H. closes this week—much earlier than usual. I have just seen Tuckerman—sends his love to you—Says

he's much gratified to hear that you've had a good time generally—& wants to know whether you intend going to Athens, as he would like to give you a letter to his brother, who is now minister to that classical court.

This closes my Journal. With regards to Mrs. Church.

Most Sincerely,
M. J. Heade

———

De Forest is landscape painter, architect, and furniture designer Lockwood De Forest (1850–1932); the Noble Reverend is Reverend Louis Legrand Noble (1813–82).

» **Winslow Homer, page 79**
letter to Thomas B. Clarke, January 4, 1901
4 pp.; 20 × 13 cm; Winslow Homer collection

Scarboro Me
Jan 4 1901

my dear Mr Clarke
I send today to M. Knoedler The last of the three pictures that you are to have for the Union League

I consider it

2

the best that I have painted. ~~info~~ Title "~~In~~ West Point Prouts Neck. Me" The western light I get from the Point of Prouts Neck overlooking the bay & Old Orchard—

You will see

3

[drawing of Homer painting]

~~Of Old Orchard~~ on the right hand of ~~the picture~~ I have not put any price on these pictures—M Knoedler will have them for sale, in a week or

4

so—This makes every picture that I have. (but two._ (One at the Cumberland Club. Portland Me— & one in my studio

———————————————

Yours Very Truly
Winslow Homer

Mr. Thomas B Clarke
5—East 34 St New York NY

———

M. Knoedler is Homer's art dealer, M. Knoedler and Company; the Union League Club was a social club in New York City that exhibited the work of numerous artists.

» **Harriet Hosmer, page 81**
letter to "Sir James," August 13, after 1852
4 pp.; 21 × 26 cm; Harriet Goodhue Hosmer letters

Islington August 13

Dear Sir James
Your message, which Lady Marian duly transmitted once, affected me profoundly. Indeed I do not know that I have ever been more startlingly affected save once perhaps when I inadvertently touched the coil of a two horse power Grove's battery.

In further allusion to your message I may admit that I have frequently pondered upon the auspicious suggestiveness of our last meeting. You will remember that it took place in the Felice! But how far more suggestive, under the circumstances, is the site in which I am penning these lines! Destiny and the Engineer have named it Union Square!!!

Verbum Sapienti

There is one point, however, my dear Sir James, upon which it were well to arrive at a speedy understanding. You are aware that the even tenor of my earlier youth has been largely perturbed by what we might call, astronomically speaking, the librations of your sex. I may add that it is not my intention to countenance similar librations in the future, persuaded, as I now am, that they would undermine not only any ordinary constitution that would be sufficient to enfeeble even a Westinghouse brake. I have sustained with considerable fortitude 211 of these moral concussions but the entire Medical Faculty concur with me in the opinion that the 212th might produce, not only paralysis of the heart, but paralogism of the brain, and will kindly furnish me with a certificate to that effect, which I shall enclose to you in a registered letter, along with a Sonnet to "Sympathy" which I have already commenced and dedicated to J.L.

These accidental observations do not call for any written response. I am a woman who prefers deeds to words and awaiting the result of the Certificate and the Sonnet.

I am my dear Sir James very sincerely
H S La — —
(no. that looks premature)
H S Hosmer

Lady Marion Alford (1817–88) was an English artist, writer, and patron.

» Ray Johnson, page 83

letter to Eva Lee, September 15, 1969
1 p.; 21 × 13 cm; Eva Lee Gallery records
© 2016 Estate of Ray Johnson. Courtesy of Richard L. Feigen & Co.

EVA—

HELLO

[drawing of a bunny]

RAY

[written in a different hand: Ray Johnson 9.15.69 left under door of gallery]

» Corita Kent, page 85

to Ben Shahn, ca. 1960
1 p.; 28 × 22 cm; Ben Shahn papers
Reproduced with permission of the Corita Art Center, Immaculate Heart Community, Los Angeles

Greetings to you!
and thank you for your beautiful Christmas card.

We are still trying to figure out how it was printed but a little of the mysterious is probably very healthy. We do want you to know too about all the special kind of de-light you bring to a great number of people by all your books, book jackets and illustrations that pop into view whenever we turn around. Ounce, Dice, Trice was especially good.

I have a completely fantastic request to make of you—please don't hesitate to say no if is too fantastic. My brother and I have both begun an amateur's approach to Hebrew. He has actually begun (lives in N.Y.) I have only started carrying a book around with me. He was the one who thought of asking you to write on some big old piece of paper with a chisel edged pen or two pencils fastened together the Hebrew alphabet.

Or if you haven't time for this perhaps you could suggest a source where we could get some beautifully written ones.

We hope to see you one of these times when we are East—if we get back. We were there just before Christmas but things didn't work out that way.

May you have a wonderful year—Gratefully, Sister Mary Corita, I. H. M.

» Sister Mary Paulita (Helen) Kerrigan, B.V.M., page 87

letter to Charles Alston, August 19, 1962
1 p.; 25 × 16 cm; Charles Henry Alston papers

August 19, 1962

Dear Mr. Alston,
Now that we have reached the quiet little city of Dubuque, I have been looking back with pleasure on the wonderful summer of study at the League! I surely appreciate your excellent criticism and help in painting.

May you have a happy and successful year.

Sincerely,
Sister Mary Paulita,
B.V.M

» Lee Krasner, page 89

letter to Jackson Pollock, July 21, 1956
1 p.; 24 × 32 cm; Jackson Pollock and Lee Krasner papers

Sat—

Dear Jackson—
I'm staying at the Hôtel Quai Voltaire, Quai Voltaire Paris, until Sat the 28 then going to the South of France to visit with the Gimpel's & I hope to get to Venice about the 2nd early part of August—It all seems like a dream—The Jenkins, Paul & Esther were very kind; in fact I don't think I'd have had a chance without them. Thursday nite ended up in a Latin quater dive, with Betty Parsons, David, who works at Sindney's Helen Frankenthaler, The Jenkins, Sidney Giest & I don't remember who else, all dancing like mad— Went to the flea market with John Graham yesterday—saw all the left-bank galleries, met Druin [Drouin] and several other dealers (Tapie, Stadler etc). I am going to do the right bank galleries

next week—& entered the Louvre which is just ~~on~~ across the Seine outside my balcony which opens on it—About the "Louvre" I can say anything—It is over whelming—beyond belief—I miss you & wish you were ~~shari~~ sharing this with me—The roses were the most beautiful deep red—kiss Gyp & Ahab for me—It would be wonderful to get a note from you. Love Lee—

The painting hear is unbelievably bad

(How are you Jackson?)

Krasner stayed with Paul and Esther Jenkins in Paris. Paul (1923–2012) was an Abstract Expressionist; Sidney Geist (1914–2005) was a sculptor and writer; Gyp and Ahab were Pollock and Krasner's dogs.

» Jacob Lawrence, page 91

letter to Edith Halpert, January 1944
4 pp.; 25 × 16 cm; Downtown Gallery records

Jacob Lawrence
St. M. 3/c (1021–097)

Dear Mrs. Halpert,
How are you? I recieved your letter and was very glad to hear that you had made a few sales for me. I recieved the check from the Whitney Museum for the picture "tomestones" which they purchased.

Although I am working steadily it will probably be several months before you receive any work from me. I am doing some drawings on the south. They are being done in pen and ink. I have not decided as yet if I will do them in color or leave them as they are. Although I would like to do some paint-ing's on the Coast Guard, I am afraid I will not

2

be able to do so, as there is no stimulation here ~~for~~ to paint such pictures. I am working in a hotel and, but for the uniforms it could be be a hotel for civilians.

Thanks very much for offering to send me some paint, but as my wife is leaving soon she intends to send me some when she get back to New York.

St. Augustine is a very dead city and really south-ern when it comes to Negroes. There is nothing

beautiful here every thing is ugly and the people are without feeling. As a ~~Ng~~ Negro I feel a tense-ness on the streets and in the Hotel where I am working—in fact; every where. In the North one ~~heres~~ hears much talk of Democracy

3

and the four Freedoms, down here you realize that there are a very small percentage of people who try to practice democracy. Negroes need not be told what Facism is like, because in the south they know nothing else. All of this I am trying to get into my ~~wk~~ work. It is ~~a~~ quite a job, as it cannot be done in a realistic manner. I have to use symbols and symbols are very difficult to create, that is good strong ones. It takes me much longer to do a drawing than it took me to do a painting. And my drawings are very simple.

So this is what I am doing a series of drawing on "How a Negro

4

sees the South". If they are good I would like to have them published. I will not send them to you, one and two at a time, but when you do see them there will be many, as I am working steadily. Please tell Lawrence Hello for me and that ~~I in~~ I intend to write him soon.

Sincerely Yours
Jacob Lawrence

» Louis Lozowick, page 93

letter to Adele Lozowick, July 15, 1932
6 pp.; 27 × 19 cm; Louis Lozowick papers

Triuna Island,
Bolton Landing,
Lake George, N.Y.
July 15, 1932

Precious:
Your second letter brought me a little bit of yourself (Oh. such a wee wee bit) and made me happy to know your time passes so pleasantly in Provincetown. I think the combination of blue eyes and a dark bobbed head will make some one adopt you in Provincetown for the Season (at least).

By now my letter has probably reached you. I am getting used to the place even during nights. Of

course, in general, it is a wonderful spot, really ideal for a summer's rest, or work or recreation. Never hot, never dusty; sunlight or shadow a choice, step right into the water any time

2

You want a bath; mountains, sky, lake all around. The other day there were two rainbows in a row astride across the mountains in a complete semi-circle–a beautiful sight. All I miss is really you ~~especially~~. The moon is on the lake this week and the whole world looks unreal, enchanted.

Of an evening to ~~I~~ make things gay ~~er~~ and keep the nightly visitors out I start a fire. The flames crackle and light up the place like one of those popular prints at Macy's. And I myself look like one of the moon-struck actors in The Moon-light Sonata (Every piano teacher has a print). I generally wander or read (most of my reading material is gone already. I shall have to get a new supply).

4

Here is one of my companions of the evening [drawing of a bat]. Clever little bastard (or is he?—bastard, I mean); and likes to tease. Brushes by past you just about touching you Then whiz! Off like a bullet. I think I'll tame one and adopt it as a pet. Perhaps I ought to train a few of them for a circus. That would be novel and might even help fill the pot in these days of depression.

Which reminds me. Since next winter looks at best rather uncertain I hope to turn out enough work here so that I can ~~e~~ take time off next winter to hustle for the wherewithal. And that's another reason why my stay here is import—

4

ant I am at work on several things, some of them very ambitious (heavy artillery). Some rather light by contrast. I pass from one to the other and am working pretty steadily.

I walk across two bridges for my meals + I am making a drawing of one of the bridges at the bottom of the page + The bridge looks rather elaborate. The lower part serves as a passage between the islands. The upper part has rooms.

[drawing of a bridge]

5

though none of them ~~are~~ is at present occupied.

The kitchen has accomodations for every kind of meal and the couple take full advantage of that. But my own meals are very simple: salads, eggs, chops in rotation. Naturally, I can vary the rotation and start with eggs or chops. When the diet gets monotonous I shall call upon the American benefactor Cambell for assistance.

Otherwise nothing ever happens as the smart doctor say in Grand Hotel. There was a lone visitor here from Saratoga (Yaddo) ~~la~~ last week; believe me we gave him a glad hand. I also noticed a couple of rabbits on the island. I wonder how they ever got here. In any case if they are of different sexes the islands

will soon be overpopulated.

I did not get the Kaplan's letter. If you send me their address I shall write to them anyway.

A bientôt
No end of kisses.
Your Louis

Regards to everybody

» **Grandma Moses, page 95**
Christmas card to Frances Greer, ca. 1950
Frances and Mary Virginia Greer papers related to Grandma Moses

Grandma Moses

» **Grandma Moses, page 95**
letter to Frances and Mary Virginia Greer,
December 26, 1953
4 pp.; 10 × 12 cm; Frances and Mary Virginia Greer papers related to Grandma Moses

Dear ones, this is late, owing to a busy time, I wanted so to come and see you all this pass summer But Brother Fred has passed on so now I will have to depend on Loyed, in hopes to if you can't come this way.

How nice it would be to all get to geather once more, You remember Ealnor Robertson. She

maried Kineth Potter they have 2 Boys all most men now,

May you don't remember Hugh wife Dorothy, Edward is thir son they had three children, Jean she married Howard Harrington, they have five children Lindy susan Hugh, Pet and mark, you remember Bettie Forrest daughter she has four Bruce Glenda Blenda Jacken me carts

EgleBridge. Dec 26, 1953. all is well here and I trust my Frends are elce where, where, ever they are. We were over with Forrest and Mary yesterday. Had a lovely Christmass dinner, The were 12 of us at the table, a happy lot, you see now my Famaly have scattred out and each goes with his wives people, some day I will try to send you a picture of them, that is some of them.

It has been a warm winter here. Picked a dandelion in the yard yesterday, no snow here on the river as yet. Oma is here came home from Calforna 2-1/2 years ago with some chin chillays from thir ranch, to see how they would do in this climate, they have did fine, has now ove 80. here,

Mrs Cook has come here from the ranch and will take back some of them for sale after the first of the year, I will miss her she is such good company. may be you don't know where we are livin now, you remember where Mary and Forrest lived, well now they live in a new house just across there garden. they have sold the old house, Geral, you remember thir oldest Boy, he and his wife and 2 Boys, live just acrost the Oil Kill, in a new house, and Carol and his wife and 3 little giarls live in a new house just across the road from jearls.

and my new House is in the same field about 1/4 mile from Carls' and about 1/4 from the old Home that you Knew, down across the me a dow where we picked charries. Edward and his wife and four children and his mother and sister five in the Home stead, I'm down here with Ona,

So I can see them all every week, and most everyday. Loyed and alice and thir three Boys are down on thir same farm, mrs Cook will go back to Calforna the 7 and intends to come back the first of march, they are to buy a ranch over in Vermont and live there, the Califorana ranch is up near the Donor pass, so far from every where, now I must say Good by, for this time

Love and best wishes to all, Grandma Moses

» **Robert Motherwell, page 97**
letter to Joseph Cornell, February 18, 1950
3 pp.; 21 × 16 cm; Joseph Cornell papers
Reproduced with permission of the Dedalus Foundation

c/o Chareau
215 E. 57
18 Feb 50

Dear Joe: For a long time I wanted to write you about the marvelous "box" that you made for me– but when I contem-plate it, + think of the grace of your gesture, I am moved on a much deeper level than those for which I have words, + ire irritated at my inadequacy.

2.

I will have to make you something wordless, though it may originate in something verbal, perhaps Un Coup de Dès—but you know how long it takes for a complete conception to develop, I know you know because you are the only complete artist this country has, + it fills me with rage to read the triviality with which your radiant show was reviewed. But the effect of it on other artists was

3.

deep + permanent. The past confronts the present in your work—to the enhancement of both–with love + perfection. I know guess what it has cost you, but work of that felt quality could not have come easily.

Give my best regards to Robert.

Your friend + admirer
Bob M.

The red faded, can I have a sample of the original hue? I want to make it permanent.

» **Isamu Noguchi, page 99**
letter to Andrée Ruellan, April 12, 1924
2 pp.; 24 × 16 cm; John W. Taylor and Andrée Ruellan papers
Reproduced with permission of the Isamu Noguchi Foundation and Garden Museum, New York

Dear Andree
I'm so happy to have heard from you—but don't know what to write—I want to speak to you to no one else—at supper the orchestra was playing

"Why do I love you" and you will surely not object to our becoming sentimentally reminiscent at this distance It really exasperates me to think that you are so far away—a part of me seems closed to me and I am almost another person.

I suppose you are happy. I am happy too—in a way—but it does not make me happy to be happy so.

New Yorks great and I'm all enthused ~~and~~ gorgiously amazed and amused.

<u>Isamu</u>

» **Jim Nutt, page 101**
letter to Don and Alice Baum, May 1, 1969
2 pp.; 28 × 22 cm; Don Baum papers

Dear Don + Alice,

[drawing of a woman speaking] such foliage!

Enclosed is another appraisal of your [drawing of a foot]. Did you talk with wonder boy Frankenstein or did he doo it on his OWN. Hope Whitny Halsted as fortunate in getting photos from cooperative Jan. People out here are not sure what to make of it. W. Boy has been thoroughly successful in keeping [blocked word] people from thinking about show by having them think about him

[drawing of a woman speaking]
"Whats dat boy up to n o w ?"

Dars something terribly similar (in effect) about frank— + franz. Tanks for your note about stuff in lover level. I sent note to Karen Rosenberg immediately (can't wait to hear from her). Sending one to D. Adrian to check on that end. was disappointed to hear Low du didshe did not buy (he must be Italian after all) we wait axniously for your letter telling <u>ALL</u>. We have yet to hear from the bird of paradise falconer—hope he has found a mother lode for film—what he described to me was very discooraging-(of all the people to go out asking for money!) We are truly tinking bout cuming back to Chicago. But don't know four sure yet. Probably move back to safe sanctuary Evanston and all that it has to offer.

Hope you liked wash. Show (we aim to please) working with Hopps was fun.

I met doty in San f.—a nice person—not to much to talk about other than details—He will go to wash which is good (I think). The lunch he bought me was down on pier (not fishin man warf). Waitress "…he called <u>me</u> a greaseball!! Da nerve…." (she <u>was</u> big + nice + fat face) smiling she says to me "I always sign my sandwichs"

[blocked word] pickle gloria musturd

What a lunch
Jim

———

Whitny Halsted is art historian and artist Whitney Halstead (1926–79); D. Adrian is art historian and critic Dennis Adrian (b. 1937); "Low du didshe" is Chicago art gallery owner Ciprian "Joe" LoGiudice (?–2008); Hopps is Walter Hopps (1932–2005), who at the time was director of the Washington Gallery of Modern Art; doty is art historian and curator Robert Doty (1933–92).

» **Georgia O'Keeffe, page 103**
letter to Cady Wells, spring 1939
6 pp.; 24 × 16 cm; Cady Wells papers

Dear Cady:
Your check slid under my door one day last week.

I will try to collect my wits and cash the check tomorrow and give the painting to the packing man. I feel you don't really like the painting so it is difficult for me to get myself to do anything about it.

Maybe I will try to make you another painting. If I do and you like it better I guess you will be willing to exchange it—

I guess we will have to let it go at that.

I would really have liked to have you take the deers head—it is for me very perfect in a delicate kind of detail that I think you would have liked very much to live with—subtle and to me lightly sad and gay at the same time—it is of our country there without any of the feeling imposed by peoples who have lived there—

You might not see it that way at all—

It is also one of my paintings that I least wish to

give up—However —I feel it would satisfy your exacting demands more than any of the four you thought about—and I oddly wish to please you—However—for the present lets call it settled—I merely wanted to say what I have honestly thought about it myself—as I thought of it since I saw you—

Easter has come and gone—it is warm like real spring today—I had intended to write you yesterday morning—Sunday—but I had a terrible quarrel Saturday night—really an awful quarrel—with an old friend—He said horrid things about an older friend who was here and left early—He left very angry with others who had been here for supper and I got into bed—then some one else telephoned and four more people came—I staying in bed— after they left I read till after three—reading some old letters that I wrote in my twenties that had been in a drawer waiting to be read since they were brought to me about a month ago. Letters written where I was first beginning to see and work in my own way—I waked yesterday morning at 7:30 and read on with the letters till about eleven—

It was a queer experience.

My excitement over the outdoors and just being alive—my working and working and always seeming to think that maybe it was foolish—but I kept at it a bit <u>madly</u> because it was the only thing I wanted to do—it was like one way to speak—and the drawing and painting made me

feel much more truly articulate than the word. I must laugh at the things I read at that time and do not remember at all

There are many boats going up and down the river—many rusty looking freighters—There seems to be one every few minutes of the day and night—Many horns and whistles- -many English boats.

It seems so terrible to have such a quarrel with any one you have spent hours and hours and hours with for some seventeen years.

It is two days now and wrath still seems to knock around the room hitting the walls like

I've seen billiard balls hitting the cushions again—and again and again—

or maybe that is too gentle

I hope things are going well with you Cady—or shall I say better.

I will write your sister when the box goes off to her——

—Fondly
Georgia—.

Monday night—.

» **Claes Oldenburg, page 105**
letter to Ellen H. Johnson, 1971
6 pp.; 34 × 22 cm; Ellen H. Johnson papers

Marmont Hotel
8221 Sunset
OL6–1010 until Aug 9

no typewriter

1. It is made of odds + ends and only measures about 3". I had a real drum set when I was about 14 + enjoyed playing it, along with jazz records. I also tried playing piano + guitar but liked the drums best tho I hadnt the patience or whatever to learn it very well. I eventually sold the set.

Music was later an inspiration to modern form. I mean I got out of the the Wagner hole my Mother favored via Stra-vinsky + Ravel—which wasnt very modern in 1954 but modern to me. Stravinsky whom I then collected had an influence on my attitude and style, expressed in drawing. I also admired his discipline and read his prose and aquired his prejudices fx liking the "out" Tchaikovsky. Ravels detachment while producing emo-tion fascinated me, also his parodies which were still art in the best sense.

I was fond of blues way back and all rhythmic music. Walter de Maria who is a good drummer seemed to take my soft Drum sit [insertion: as a] personal attack via magic. He and Pat were seeing each other then and felt a bond a-gainst—the icy monster. All that is rumor. Music means a lot to me + it translates for me into art. We could discuss this.

3. It appears now, due to prohibitive transporta- tion costs and the complex engineering of the Ice Bag, that it will not travel to Osaka but be built here (LA) by Gemini Ltd, in edition [insertion: of

five] + perhaps shown at MOMA or during tour of my show. The six foot model here is very promising, it moves too. Size projected is 24 ft diam. and 11 ft high.

2

4. The Elephant Mask was shown on top of a sculpture of scrap wood pieces nailed to a coat rack —"flying" planes, painted white + drawn on w. casein black. Photo exists.

I also showed a piece of "Street" with rough figures in glued paper, with drawn shadows, some other masks and objects and drawings of the street from above with figures and elaborate "shadows." Also figure drawings in crayon of Pat. All objects were white. White came from the effect of bright sun on the street, which I observed from Cooper Union in PMs. I equated it with [illegible] the white of paper. The show was about objects and light. Shadows were present every-where.

I have a list of what was shown somewhere in the files.

6. Billy Klüver introduced me to Norman Browns first book. However, it is in the line of neo-freudian readings which for me seems built on D.H. Lawrence's Studies in Classical American Lit., so gershon Legmans studies (f ex "Love and Death"—about mass media in USA) which I read in college, and Leslie Fiedler. Neofreudian analysis of American tradition is reflected in Injun—the pamphlet, and much of the R-G Theater, esp. Fotodeath.

The title comes from an account of a mass murderer who always photographed his victims in the desert before killing them—equated with Death by light—the H-bomb. I dont know Kubler.

Browns rereading of Swift interested me especially. Swift is a favorite.

3

7. There is no doubt Focillons book was one of my major influences + important discoveries in college. Not applied systematically of course but a great sti-mulus to fantasy.

8. I am working on the Punching Bag Noses now. They are very strange to me [illegible] and

occurred really as a byproduct of the Notes at gemini in 1968. They are not especially formal—closer to a fetish objects. The logic of them seems to be, I mean their explanation in relation to other work—as an unwatched development, a souvenir of fantasies going on beside the main work at the time–the Notes—run thru sophisticated technology. Tyler took them up as an edition—I had only half intended them as that. At gemini almost anything one toys with goes into Editions.

9. Drum set miniature is still far from ready.

11. Yes, I'd like to do that. I think it should be offered to a journal of writing or language, not an art mag. The [checkmark] means used by someone. In the 63 notes, by Max Kozloff for his gathering of notes in 66(?) for Art Forum. The [drawing of a screw top] is a hamburger (or a screw-top), made by Kaspar Koenig in suggesting selections for the 66 Moderna Museet catalog.

12. Im glad you like it. I do too. I will consider it.

4

13. The lipstick like so many pieces functions on contrast—here between a peaceful object—the lipstick and a warlike object—the bullet or rocket. also between female function + male function, soft + hard. It also works on the principle of contrast in relation to its size: Simple, primitive, metallic, contemporary vs. the stone tradition, highly sophisticated, which surrounds it. Color vs. colorlessness, vs. Puritan fear of color + sex. Its anti—in this way—it looks forward to an environment more suited to fantasy + modern reality than the white elephant imposed by Harkness gift to the University—he insisted on these heavy forms which are awful to live in. Also, levity. vs. solemnity. The monument is meant to translate desires for change into form.

In its forcible placement it is more an invitation to struggle than a pacifist monument. It deliberately incorporates the diagonal rising line of Tatlins monument for Red Square and strangely also suggests the tank parades that Moscow likes to stage now. It is subject to several interpretations but really goes back to private fantasy in the studio—the use or adaptation of a favorite subject—the red column. The tank treads were suggested by the look of corrugated cardboard.

The "use" of a sculpture is often more precise than its origin. One cant escape that by stating what its for. I try for a general formulation, simple formally, which will adapt itself to a number of unpredictable "uses."

5

14. The work is all on the side of life. It is about how it feels to be alive. Conditions of natural existence, imitated, reenacted, celebrated. Abstract Thought is treated lightly, sometimes, as an amusing irrelevance to physical existence—hence the impression I give of not being "serious" enough. Violence is a condition of Nature. The con-flict between the non morality of nature and the morality of speculation is a subject—wish fulfillment vs. nature. The work seeks always to be alive + the artist to create life.

Concept is anti-life. The bedroom ensemble is a tomb because it expresses an obsession with geometry, idealism vs. the true function of the bedroom. Death in the work is the presence of a natural condition. It is always present—its occurrence is unpredictable, its nature incomprehensible. The presence of death defines life. Many of the objects symbolize death in order to keep death away. My thinking is primitive + superstitious, something I dont find at odds with contemporaneousness.

Death is both threatening and desirable. All life is infatuated with its own destruction, consumption—that is the conceptualization of natural fact. Death is metamorphosis, change, reconstitution. No work that leaves out Death is about Nature. I often say—the subject of my work is Death, which is the same as saying the subject of my work is life.

I suppose I am against living—rationalism (which is anti- the organic growth of fantasy), repression, or any form of obstacle to nature (con-di-tioned by a strong sense of what's practical). Basically romantic. Natural death is idealized, as in Böcklin, Death is a sublime concept—or, the brooding on the in-finite.

6

Many contradictions here—romanticism vs. pragmatism. My interest in Death a good subject for discussion. My personal techniques of self-destruction.

Art, ie. an ideal occupation, was the basic alternative in 1953, to suicide.

Back to the icebag—

Love—
CO.

[illegible]

Oldenburg + ice bag = ice berg.

Iceberg = Oldenburg

Ice cream cone = prince of death, or, his habitation.

Interesting series of ads, billboards, just now here in L.A., tries to sell Forest Lawn cemetery by Luscious representations of life—eating, loving, captions being—dont hurry our services. They mean—<u>do</u> hurry our services, by all means, do live, so you can die the quicker.

» **Claes Oldenburg, pages 106–107**
postcard to Ellen H. Johnson, August 17, 1974
1 p.; 10 × 16 cm; Ellen H. Johnson papers

Dear Ellen. 8/17

Sitting in LA on my terrace at Marmont Chateau. Came here direct from NYC. Hope to visit Akron day after Labor Day. Maybe see you on Labor Day?

» **Walter Pach, page 109**
letter to Arthur B. Davies, August 4, 1912
4 pp.; 10 × 14 cm; Macbeth Gallery records

Arezzo, ~~July~~ Aug. 4th, 1912;

address: 3 bis rue des Beaux-Arts, Paris (That is my old studio; I expect to be in a hotel almost next door about the end of this month,—will send you a card to make sure, when I am settled; they will keep mail there).

Dear Mr. Davies,
You will quite surely have had my card from Florence whither I went immediately after receiving the check from Mr. Macbeth. I did everything that it was possible to attend to then, and came back to my work here. Since, I have had a note from Mr. Loeser, who is kindly acting for me,

to say that the lawyer of Count Costa's estate is away from town, but that he will see to it that the matter is expedited immediately on the lawyer's return I wrote this to Mr. Macbeth. The lawyer has the picture, ~~and~~ also his signature as the "seller" is needed to the consular certificate. On that document I took the liberty of placing your name as the buyer, judging from Mr. Macbeth's note that it was not he and therefore thinking it better to use another name. I do not imagine that this makes any difference at all, but I will apprise Mr. Macbeth of the fact and all other details when I get the duplicate invoice which I have asked them to send to me so that I may know that everything is in order. Mr. Loeser thinks the picture was painted about 1875; we both signed the certificate (I am now an "expert on the work of Cézanne") to the effect that it dates from before 1880. Mr. Loeser—as a friend of the Costa family (or of mine)—framed the painting in some quattrocento moulding he had and which he says suits it admirably. My only expenses were for my trip to Florence—about $2.50; since I still owe you $1.78, Mr. Macbeth can refund you the $2.50 and then I can enjoy the luxury of having you my debtor for the balance (beside the fun of my day ~~and~~ a half in Florence). Oh—the consul said he would write a note to the customs house saying that Mr Loeser's opinion about the date and mine was valid. There are many fine Cézannes still to be had in Paris but they keep getting dearer. Two years ago I wanted to get one of the two lithographs he did (the smaller one) but hung fire when I found the price had skipped from 20 fr. to 40 fr. Later on it went to 50 fr. and this spring I screwed my courage to the sticking point and determined to have it any how. It was 75 fr.—I got it anyhow and have had more pleasure from it ~~ever~~ since than I have ever had from a possession before. I will write Mr. Macbeth about Kent's photos.

I get quite a number of newspaper clippings about art in America and am, of course, tremendously interested in the new Society. From what I hear we should have a really great show. I have written (short) notes about it twice for "L'Art et les Artistes"—one still to appear. You remember?— you suggested my affiliating with them. I found Armand Dayot a fine big enthusiast; he has given me full swing on American art and I could write on the European men too if I want,—in fact they have asked for one such paper. I have an article on Sloan with them with lots of illustrations—don't know when it will appear. I don't think I can reach any of the American papers for an article at present. But I do hope you will let me of service if I can, when you come to Paris. I know Matisse fairly well (he thought he would be away in the fall but I think the Steins might help you) and I know Picasso, Maurice Denis, Roussel and Vallotton slightly. I could reach most everyone else I think. Do let me know as soon as you come or, rather, before I go to Germany in about ten days for a visit with my parents before their return to America. In all probability I shall be coming back myself after two or three months in Paris.

In the matter of quantity I am disappointed in my work here—I had meant to do such piles of pictures and find I have to go over them again and again instead of letting 'em go after one sitting as I used to. I feel I have done my best here though and—wonder of wonders—have painted one thing that is a total break from my old humdrum stuff. It had hardly changed in years. (The Autumn Salon is from Oct. 1st to Nov. 8th).

Hoping you and your family are all very well, I am

Cordially yours
Walter Pach

———

Mr. Macbeth is dealer William Macbeth (1851–1917); Mr. Loeser is art historian and collector Charles Loeser (1864–1928).

» **Maxfield Parrish, page 111**
letter to Martin Birnbaum, December 4, 1918
1 p.; 28 × 22 cm; Martin Birnbaum papers

December 4th '18.

My dear Birnbaum:
Alas, I wish I had, but I have not a single thing for that lovely rich lady. When last in New York I fell in with a bad crowd and got all tied up with some work for the Red Cross, so I'm working day + night on some very bad things for their Christmas shindig. But—early this spring I am going to do some things for myself, and have refused all

orders until next fall. Those beautiful panels are above my head getting themselves all nice and dry.

I wish people wouldn't ask for blue, for its the one thing to stop me using it. As soon as the bells were ringing up here for the end of the war I thought of you, as how you would'nt have to go. I hated to think of you in mortal combat = you would sure to have been thoughtless in bayonet work + neglect to warm it before using. I'll be down around the 10th. I think, + will stop in for a moment.

Hastily: sincerely:
Maxfield Parrish:

» **Guy Pène du Bois, page 113**
letter to John Kraushaar, January 12, 1927
3 pp.; 21 × 33 cm; Kraushaar Galleries records

4 rue Bruller, Paris XIV
January 12 27

Dear John,
I saw Galanis the other day who asked me to call you that he was sending his prints on to you. The seven pictures left on the Rochambeau today—mine I mean. The others I shall keep a while longer. These are in a some what different vein from those to which we are better accustomed and I should rather be sure of them before sending them on.

The three hundred dollars you cabled arrived the day before yesterday. Thanks. I do sure think that Dale and you are right about the big pictures even from your own point of view. Here is what I have found: Every time I meet any body they remember having seen the Jeanne Eagles Marion Levy or Neely McCoy (girl with accordion) or the Miss Bishop. These pictures, from my experience have contributed more to making my name known among lay men more than any thing I've done. They do not sell now. They may later. But in either case in making my name known they must certainly help in selling the small canvases, and in this way, even if it is indirect, are of tremendous financial importance to both of us.

Another thing I wanted to ask is would it be too much trouble for you to pay for the shipments at your end? I've just had the bill for the last one. It

amounts to something over twenty-five dollars which is more than I like to take out of the small funds which I have on hand. I always try to keep some sort of balance at the bank here in case of need. The hole made in that balance in the case of larger pictures is greater than this one. I send those things to you through de la Rauchange & Cie (formerly Kimbel) who have sent many things to you, they say, and are willing to wait for payment at the other end. I hope you had a good new year's day and have a good year beyond all your expectations.

Everything is going fairly well here. But the Doctor's have now decided to try the xray treatment as Floy for two or three time and if this does not show a marked improvement they will have to operate. I hope they do not have to do the latter.

Affectionately yours.
Guy Pène du Bois.

—————

Galanis is Greek artist Demetrois Galanis (1879–1966); Jeanne Eagels (1890–1929) was an actress painted by Pène du Bois; "girl with accordion" is likely the painting Woman Playing Accordion *(1924) by Pène du Bois; Miss Bishop is painter Isabel Bishop (1902–88), who studied with Pène du Bois; De La Rauschange & Cie was a French shipping firm formerly known as Kimbel & Cie; Floy is Florence Sherman Duncan, Pène du Bois's wife.*

» **Jackson Pollock, page 115**
letter to Louis Bunce, June 2, 1946
3 pp.; 25 × 21 cm; Louis Bunce papers

Dear Lou, —
It was good to get your letter. I hardly know what to advise—the housing shortage in N.Y. (as every place is) is terrific—don't think there is any thing to be had—possibly a cold water flat on the lower East side.

We are about 100 miles out on Long Island three hours on the train. Have been here thru the winter and we like it. We have 5 acres a house and a barn which I'm having moved and will convert into a studio. The work is endless—and a little depressing at times.—but I'm glad to get away from 57th Street for a while. We are paying

$5000 for the place. Springs is about 5 miles out of East Hampton (a very swanky wealthy summer place).—and there are a few artists—writer etc. out during the summer. There are a few places around here at about the same price.

As you already know I have been able to paint all thru the war—and am very grateful for the opportunity and tried to make the most of it. Have had fairly good responses from the public (interested in my kind of painting) and from a critical point of view. Moving out here I found difficult—change of light and space—and so damned much to be done around ~~the ho~~ the place, but feel I'll be down to work soon.

—Bernie Schardt is in silkscreen printing (cosmetics) on a big skale. Steff is in silk screen business—Sande worked in defense in a small town in Conn. and has opened a silkscreen shop there—just getting by at the moment. Joe Meest is in Ny. and getting some painting done between jobs—Some exciting stuff, abstractions with a personal ~~iz~~ touch. Mr. Brooks (who has part of my old studio at 46) is back from the army and, painting abstractions, and getting reajusted to the knew life again.

Baziotes', I think is the most interesting of the painters you mentioned—Gorky has taken a new turn for the better—from Picasso thru Miro—Kandisky and Matta. Gottlieb and Rothko are doing some interesting stuff—also Pousette-Dart. The Pacific Islands show at the Museum of Modern Art—tops every thing that has come this way in the past four years.

Spivak is working toward abstraction, Byron Brown continues along at the same slick pace. N.Y. seems to be the only place in America where painting (in the real sense) can come thru. Tobey and Graves seem to be an exception—are they ~~ann~~ around your your part of Oregon? Austin has fallen to repeating a formula—and of course his stuff gets weaker instead of growing.

I hope the hell you can get back into painting Lou as you know I liked your stuff—and am sure you can get into a gallery—and not Pearls?–(remember)? Every one is going or gone to Paris. With the old shit (that you can't paint in America) have an idea they will all be back—.

There is an intellgent attack on Benton in this months ~~magazine~~ magazine of art. —it's something I have felt for years. He began coming around before I moved out here. Said he liked my stuff but you know how much meaning that has.

Best to Ede and John—and let us hear further on your plans here!

Jack.

———

Gottlieb is Abstract Expressionist Adolph Gottlieb (1903–74); Spivak is muralist Max Spivak (1906–81); Painters Mark Tobey (1890–1976) and Morris Graves (1910–2001) both lived in the Pacific Northwest; Benton is painter Thomas Heart Benton (1889–1975), who mentored Pollock in the late 1930s; Ede is Bunce's wife, Eda; John is Bunce's son.

» **Abraham Rattner, page 117**
letter to William Kienbusch, 1944
3 pp.; 28 × 22 cm; William Kienbusch papers
Courtesy of SPC Foundation, Inc. and Leepa-Rattner Museum of Art

Dear Bill:
Your kind note and xmas card just came. It is good to hear from you and many thanks.

Anything can happen in the army. One can never say definitely the how or what, the where, the when or the ins or outs of anything while in uniform—especially during a war time. This new work you are in should be very interesting—and falls in line with your camouflage insight, which ought to make you a valuable man in the new field. There is a series of two interesting articles on the map technique in Harpers Magazine of August, and September 1944 by C. Lester Walker (a freelance journalist)

Lucius Crowell—you know him I think—friend of the Poor's—and a painter—is somewhere at Ft. Belvoir doing something in the map making field. (address Pvt Lucius Crowell 2765th EBPC Ft. Belvoir, VA.) we had aperatif with him, Percilla and Emmy Swan since we saw you.

Saw Annie Poor's show—candidly she has made a big jump in conforming herself in the direction she has chosen to follow for the time being (—unless the time will be elected to be longer)

Because of her sensitivity it is felt and delivered convincing—honestly—and compares with such reporting done by those conceded to be professionally of the first rank. suggested that she investigate the creative possibilities of this subject and occuppy herself in a searching to find the essential plastic forces involved in this expression—, particularly now that she seems convinced the army is unwilling to encourage her in this work so far achieved.

Saw Barry Stavis at her show—a top sergeant—signal corps—nerve broken from strenuous exertion to achieve results—now returning again to the army hospital.

So take it easy Bill.

I am flat on my back—again the last war devastation—my constant side kick, literally—too intense an effort brings out his kick—so—I say to you try to be careful. I always was a wild guy. God gave me a busted back to try to make me sensible—and every once in a while I forget—go mad—and then God stretches me out. In some ways a great blessing. otherwise would have probably done myself in completely long ago.

Hope you do have the chance to see your folks during the Holiday Season.

Youve been a great traveler these past days—a great experience.

Well Bill someday you'll put all these things you are going thru into some form of expressive beauty. Out of such deep experiences—new symphonies new structures of monumental Beauty can be created. All you have to do is to let the seed take root and then keep watering the plant. With Best wishes—and again

Merry Xmas & a Happy New Year
Abe Rattner
Bettina [in a different hand]

———

Henry Varnum Poor (1887–1970) was a muralist, ceramist, and designer, and his daughter Anne Poor (1918–2002) was also an artist; Bettina is Bettina Bedwell, Rattner's wife and a fashion journalist.

» **Ad Reinhardt, page 119**
postcard to Samuel J. Wagstaff, July 23, 1964
1 p.; 9 × 14 cm; Samuel Wagstaff papers

Dear Sam Wagstaff, I guess you must have thought I was kidding when you asked me if I saw any interesting English painters and I answered "Bridget Bardot and she's a nice girl too"? I meant to answer "Bridget Riley and she's a nice girl too."

Ad

» **Ad Reinhardt, page 119**
postcard to Samuel J. Wagstaff, August 12, 1965
2 pp.; 9 × 14 cm; Samuel Wagstaff papers

Sam, Monday I was in and out all day, Sun-day I was floored into painting a ceilin-g, Tuesday I got trapped into a studio ro-utine, Wednesday I received a letter fr-om Old Lyme, Thursday I went to a fu-neral service, Friday I write this card so you should get it then to tell you sorry that I missed you and write that I'll be in town all summer long during the doldrum-days to the dog-days, days in and days out, about the November portfolio and Christmas business I'm not sure, and about October things are not very definite, who can be certain about Se-ptember?

Ad

» **M. C. Richards, pages 121–122**
letter to Francis Sumner Merritt, August 22, 1974
2 pp.; 28 × 22 cm; Francis Sumner Merritt papers

August 22, 1974

Dear Francis,
Thank you for your letter. I am sorry to hear of Ralph Thompson's death. He was a good man—and a memorable proxy! Long live his memory, as you say. He is very vivid in my mind's eye.

I loved the week with you at Haystack—and left feeling unusually refreshed and renewed. There's something about blackfolks that suits me mightily.

The one moment that still hangs in my memory like a question is the departure of the Africans,

with much ado, swooped off by the 2 young
guides & guardians from the state department,
as if it were an honor to be black in America!
I'm still wondering how that scene struck our
black American friends, who are more likely to
be arrested than fêted for their appearance and
ancestry, right? Ah me, the paradoxes…

I finally got home this Monday—took the Volvo
in for inspection on Tuesday, & it didn't pass!
So now I'm carless till it gets fixed—mostly body
work, king pins & the like. Mine didn't win the
prize—another, 1951, 270000 miles!

—over—

(I think that's what the feller said)

Raja seems glad to be home—no more collar &
leash! There's lots to be done: garden & house &
mail & neighbors—you know what it's like to come
home after 9 weeks away in summertime! Rabbits
& chipmunks making merry with the vegs., etc.

I'm wondering how Black Session II went. And
already looking forward to 1976 Indian's of the
Americas ZOWEE.

Did Tucker ever get the pot shop cleaned up? &
the Raku kiln fixed?

Take care of yourself, dear Fran—you are a trea-
sure—and long live Haystack & the beautiful light
of Maine—

Much love to you + Pris,
Mary Caroline

———

Pris is Priscilla Merritt (1913–2006), Merritt's wife.

» **Eero Saarinen, pages 125–126**
letter to Aline Saarinen, April 10–11, 1953
10 pp.; 28 × 22 cm; Aline and Eero Saarinen papers

April 10

I

ALINE
This will not be written with scalpel like objec-
tivity it is just going to be small talke ----- and
than the phone rang and I heard your very nice
voice and also all the very nice things you said ---
of wich the very nicest was "I love you so much
darling" ---- while I was drawing your letter on
the plane I had a fellow next to me of the type that

just gets on planes to strike up conversations—he
wanted to know what I was doing because he was
curious which apparently was sufficient excuse in
his mind [insertion: to aske]--I told him it was a
dream --- and continued—the thing I liked most
about the monument was that it was a beautiful
result of you & I being close together---the funny
thing about it is that it proves your point in your
article soo much—that I translate everything into
architecture ---- you could now say "He eaven
sees his closest friends as stone and concrete" –or
"he looks at this reporters and" ---- and so on—

Now—just talke about things the office the Drake
"Bible School" It is a tiny little class room build-
ing with a tiny chapel—near it is to be a bigger
chapel—I think it is going to be O.K. Now.—It is
located next to the science and pharmacy building
we did and not far from dormitories now under
construction—the whole thing really becomes a
campus & when these are built Drake will really
have quite a good group of new buildings.—If
plans are accepted (Wedsday) than it will look like
this.

[Captions on drawing, page II]

Dormitories

Mall

Future chapel

Lake in ravine with bridges across to stimulate
romanticism in girls

Future mall

Bible school

Wall because ground slopes

Existing

Court I think will be nice.

Main future chapel—we may get in trouble on this
one later combining circle and rectangle may be
degenerate.

Central table (altar) with light above wall of slabs
of brick with slits (6") between.

Very simple class room building with all columns
disengaged from walls.

This drawings & design stinks compared to → but
this is only small talke.

All interior walls off columns (Kump did this in school once.)

Page III

Next—a site plan we are doing for U. of M.—it is a triangular piece of ground and everything conspires to making triangular lots possible—Jay Barr invented this one and I like it very well.

I can't remember how it goes but I think it would be fun. [caption for small triangular sketch.]

Next problem—Milwaukee Cultural Center—I have been scared to look at it for the last week because my mind has been so filled up but to-morrow at 2 p.m. I am going into it—I think our part now is good—I don't think you saw it.—It consists of a veterans building + art museum + theater for 3000—the site is magnificent but has peculiar problems too long to explain.—if art museum goes ahead it will be very peculiar—Vatican is entered from below—this will be entered from above

[Captions on drawing]

City

RR Tracks

Existing

Express Parkway

Lake Michigan

Veterans Bldg on stilts—enter from city under it decend to sculpture court—enter museum galleries below court—sculpture court wil museum court will be mingling area for all activities—vet building to go ahead only until they collect more money

Page IV

Styling Auditorium is an other one I am scared to look at but will have to Sunday 11 AM—really get into it!—

Columbus Bank—I am going thru it carefully now and having terrible trouble with stairway while trouble stems from a bit of confused thinking in the beginning and when that is inherant there is no end of trouble that one may never get completely logical.

M.I.T.—Working with Bruce & Joe on revisions her to cut down cost. 10 AM Sat.

MIT Chapel—Bruce & I have to start on a new version of iron works above—we intend to put lights there are well as the bell—same as what Aalto did over dining—it will make people conscious when chapel is in use—will also remedy objection of starkness—I think it will be better this I have to get to SOON—Monday or Tuesday

Michigan (U of M) is way behind will have to start soon on it including design of large music school (4,000,000)

Stevens Chapel—should look into soon to see what can be done to reduce cost—I don't like this job but we have to do it.

Motorola intends to build new laboratory (4,000,000) in Chicago but and is considering us & others—I am supposed to go to Chicago the 22nd to appear & "sell" myself but job is not interesting and to-morrow I will tell them we don't want to be considered—that always impresses people!

--------------Anyway this is roughly what does on in my mind about work and I just wanted to tell you about it but I will stop talking about work now because I get all nervous thinking of all the things I should concentrate on—thank I am glad that I decided not to go to New Haven———- now from all this talke about work I shall the subject so much that I need to start an other page -----

Page V

My mind wanders to the beautiful complete time we had in Boston. It wanders very often—and it is very hard for me to believe that it is all true and that it exists in tow minds—a nice thing you said in one letter and also to-nite on the phone—was— "long term"—something—this is a thing I hope for also—I think this way → she seems so very nice—but remember Eero you have not known her very long—but the more I know of her and the more time I spend with her the more I just like to be with her --- but remember Eero if she is as nice as all that it is much much better to learn to really know her slowly—slowly --- also remember Eero you have been a very confused little boy this last year your confusion is not over yet time is what you need right now—you really should clear things up and get a perspective before your get overenthusiastic—but when I saw that she is nice I really mean it an if I broke it up in its component

parts I would say—like her spirit & enthusiasm, I like that combined with the clear sharp brain. I like her looks-eyes-smile-figure. Humor, energy, generosity—and as a proof that I love her I know how I feel with her and I also know how my mind wanders to her—and than there are the very nice dreams --- yes yes Eero I agree with all that but hold your feelings and thoughts back at this time—that is much better in the long run for so many reason—to learn really to know a person is somewhat like digging up a very fine treasure.

Page VI

You go about it (with scalpel like objectivity) carefully slowly and lovingly—you treasure every part you find and you weigh carefully what parts are not there --- gradually than the whole person becomes a picture before you --- that is the very nicest way of knowing a person—and you have to remember Eero that you are very slow in really knowing people --- yes I know but I think I have seen enough of this treasure to have an overall picture of this wonderful girl but I will admit that the finer the treasure seems the slower one should proceed, but you mentioned that there were ~~many~~ reason—yes Eero the thing I mentioned before you became very enthusiastic and very much in love in Europe—that creates many reasons why you should think very slowly—that has created certain repercussions at home which have to be thought out. They can only be thought out slowly---are you sure that you have thought thru everything in Europe—you think so now but give that also a little time.—and besides Eero are you not talking to God damn much right now—I don't know—Perhaps.—Eero I like that dream you had the one about the round chapels and the ~~one you~~ temporary one you and A. where going to dig foundations for———it expressed the possibility of temporary but it also clearly said that one never knows one may strike rock—and than one could build a cathedral on the same footings

Page VII

Now for instance can I tell her that I really love her from the bottom of my heart—yes Eero that you can do because you really seem to do that.

LOVE
EERO

Friday nite, 1 a.m. ♥

Page VIII

April 11

Sat. nite 9:30—Eero the cencor held up the letter of last nite until now to read it because it dealt with rather delicate things—he decided that it was OK to send if Aline reads it and rememberes with every word that I love you very very much—I don't know exactly how I have come to love you so much considering the very stormy period I have just come out of—I guess that is what it all dealt with ---------------- your letter arrived the one including bath tub poetry—I received it in a meeting and it was very difficult to wait thru the whole meeting to read it.—It was a very very beautiful warm—open arms letter 0 it expressed above all a yearning to expand our togetherness and also an eagerness to convery to me your life—that is why I loved it. ----- Darling I am terribly eager to just talke about you and my witch doctor to whom I have planned to say many many things travels so much as I do & therefore we never get together and I really look foreward to seeing him.------- Merl Armitage (Look Art Director) was here for dinner with last world in new wife a French girl who seemed very nice.—He is an old friend from the war days.—Do you know him—he is very loud and opinionated but has a good heart.

I am looking foreward so much to coming east—seeing you—we could figure it out many ways—would you have a car?—I could easily rent one but it won't be a convertible—we stayed somewhere and than see Bertoias things and than drive on—I once drive ~~th~~ thru that part of the country with George Nelson—years ago—the barns are very beautiful—I think.

Page IX

Or at least I though the best in American Aboriginal or unconscious architecture—we can also ~~do~~ figure it out many other ways the main thing is that we spend as much time as possible together—darling—I love you.

E.

P.S. If your son will be away it might be very much nicer not to drive away until Sat. AM because it would be wonderful to be with you in your own bed --- I would love that.

P.S. Now I have to stop because I have to read your letter.

Page X

P.P.S.

Darling

I don't really like this letter—I would like to write you a much finer one—but I don't know how—yours is much finer—it is absolutely marvelous.

There are so many things that you said that I would like to turn around and tell you also—inward worlds—outward worlds—darling—I love you.

<u>E</u>.

» **Eero Saarinen, page 127**
letter to Aline Saarinen, 1953
2 pp.; 28 × 22 cm; Aline and Eero Saarinen papers

'A'
Now a few words about divorce so that I don't have to waste the time on the phone with that. This will be a summary and bring you up to date.

Monday noon we will send down to the lawers a whole bunch of things.

a. Conclusive proof that G. M. will <u>not</u> go on for 3 or so more years which is his impression.

b. Chart showing office and my income curve since '47 also showing tremendous effect a very favorable G.M. contract made on this curve to prove that G.M. is a unique ~~experi~~ situation.

c. Compilation (by Joe) of all our other work than G. M. showing that we made a farily low (19%) profit on all work except GM and a mighty high (?) on G.M

d. My personal bookkeeping since 1948 showing that the myth that Lily has paid most household expenses is absolutely untrue—instead that I have paid thru my nose.

e. Income Tax showing that I have paid 90% of Lilys taxes since '48 an amount that exceeds what she has paid in home expenses.

f. Present & projected future income—

—Armed with this he will (Ben Jayne) give his counter proposal. which is 250 per month per child + tuitions until 18 and 200 per month +

tuition thru college. + (if it works as a tax deductible—this still has to be checked 20,000 the 1st year 15 the second 10 the 3rd 6 the fourth and then it goes on with 6 until she marries. + layers fee. His pocket he has my authority to use this proposal with a lump sum payment of 20.000. — Meeting on this will probably be held Tuesday.

—I do not blame Lily for the high request—I would say that it was worked out by Harry & Paul Hammond—Lily understands very little about money.

[Notes in margins by Saarinen]

[upside down at top of the page] You beast! I was just about to send you flowers—for the first time than you wrote about flowers—now you will have to wait—a bit.

[along right side of page] "Mrs" to Vassar was so as not to get you confused with the inmates.

What you said about Brandeis was very interesting—I want to tell you the sad story about why our work there stinks but if you trust me that can wait 2 yeas. I also want to talk more about Brandeis & the Chapel but with you.

[upside down along right side of page] Should California project into first days of August—2 or 3 is that very bad for you? —Just in case something comes up here that delays departure.

[upside down at bottom of the page] The envelope has a line above mason Dixon belt history but never mind.

[along left side of page] I talked with Hans on phone—he wants to ask you for lunch & will probably call you. I hope you do it if you can. Lets see if he will persuade you to persuade me to design some furniture.

But It is quite possible that all these bargening negotiations will drag out because it is ~~impt~~ important that we don't hurry.—Therfore it might be that no conclusion will be reached by the 15th of July—If not it might be reached by 10 of August and if not then early September.—The significant thing is however that the thing is now moving—Lily is facing more specific problems—when to tell people and such things. The Layers advise me not to move out of house until September.—Roy Dahlberg is trying to work up a case for Lily

not staying in the house on and on—that will be dangerous because she will take forever to move out.—That is however a secondary consideration.—We have too little bargening power on the 1st to worry now about 2 many stuff.—I am writing all this in detail to you not because it is really necessary for you to know all the intermediate steps but it might be interesting to follow.

—Did I ever tell you about how the French pay taxes?

In Cairo I once bargined down the price of a mummyfied hand from 62 piasters (or whatever it is) to 7 and then said I didn't want it because it was too expensive.—and that was done in a day and 1/2.—Harrys offer is admittedly a first offer—all this is in answer to yor nice sympathetic letter written thursday nite.

Last nite Bruce and I spent on Cleveland.— First notes on the Wurster-Belluschi—Aalto—Scandinavian etc. group. "Composed of in a group of individuals who search for their own form thru a greater responsi responsiveness to the particular demands imposed upon the problem by local conditions or traditions 'etc etc"

Should something on July 17 is Friday 18 is Saturday—I How would leaving Friday the 17th be? We can talk about that

Arms are wide open and I love you very very dearly wonderfull girl—I love you so much and I miss you so much that I am almost bursting

love E

[Notes in margins by Saarinen]

[along right side of page] Can I move in with bag & all on 27th?—It will be wonderfull I lounge soo much for the moment we are in each others arms.—Marvelous girl.

[upside down at bottom center of page] To morrow nite that is Sunday will call you and than it will be 12 an 7/8 days untill we are together—I am angry about having to leave A.M. the 30th. But I have to go! Love & kisses.

[along left side of page. First three words obscured by crease.] ...to have a slide projector—if not dont bather borrowing one—we can use viewer.—I will bring slides along of various things.

» **John Singer Sargent, page 129**
letter to Henry Mills Alden, January 19, 1887
1 p.; 27 × 19 cm.; John Singer Sargent papers

Jan. 19th

Mr John S. Sargent sends to Mr Alden a photograph of himself, as requested by Mr Henry James for the purposes of his article in Harper's magazine.

» **John Sloan, page 131**
letter to Mary Fanton Roberts, December 16, 1909
1 p.; 28 × 22 cm; Mary Fanton Roberts papers

My dear Mrs Roberts:—
I enclose my permit for your photographer to copy the "Chinese Restaurant, Tenth Ave," painting

That you found it in the N.A.D. Exhibition—speaks well for your eyesight—or did your foresight prompt you to tour the show with a ladder?

At any rate I thank you for considering it for "The Craftsman" article on The Ex.

Mrs. Sloan has flitted to Philadelphia to see her medicine man—there I join her toward the end of next week and when Xmas has passed we will return to N.Y. and drop in on The Roberts's during the week perhaps.

With regards and compliments of the season

Yours
John Sloan

» **Robert Smithson, page 133**
draft of a letter to Enno Develing, September 6, 1971
5 pp.; 28 × 22 cm; Robert Smithson and Nancy Holt papers

Dear Enno,
I just returned from Utah. I'm happy to hear you enjoyed my work in Emmen. But hope they will not destroy it. It seems that John Weber did [insertion: not] find time to visit my work—that is unfortunate, because I have so few photos of the work. Both Beeren + Zijlstra have yet to let me know whats going on. So, I really appreciate

your serious concern and interest in the project. For one thing, the project is outside the limits of the "museum show". There are a few curators who understand this. As Jennifer Licht says, "art is less and less about objects you can place in a museum". [insertion: Yet,] the ruling classes are still intent on turning their Picassos into capital. Museums of Modern Art are more ~~like~~ and more banks for the super-rich.

2

But the strike at MOMA is a good indication that the old museum order is crumbling. Why should art be controled by people who have not dedicated their lives to art? Art that turns away from physical production to abstract consumption, strikes me as reactionary. Museums are too much about "collecting" objects and not enough about developing the resources of substanial art. Art should be an ongoing development that reaches all classes. As it is now artists are treated like colonials, who are systematically ripped off. Of course, there are artists who support this reactionary condition by making abstract paintings and sculpture that can be converted into an exchange currency by the ruling powers. ~~that~~

3

By making portable abstractions, the middle class artist plays right into the hands of ~~the~~ mercantilist ~~control~~ domination. Money itself is a figurative respresentation reduced to the widest ~~possible~~ exchange. Portable abstract art is a non-figurative representation reduced to a narrow exchange. [?] The portrait of a being as a ~~presdient~~ president on money together with acane symbols and signs is for the many. The strips and grids on an abstract painting is for the few. Both currencies are ex-changable, but only for those that control the mysteries of wealth. Mysteries replace precious metals as a value standard.

4.

Conceptual art, therefore becomes a cheap currency below the value of ~~abstraction~~ representation. Both abstraction and conceptualism form substitutes for natural resources as physical development, ~~therefore~~, enabling the collector [insertion: to] casts off the artist from his own [?] production. Conceptual art is like a credit card

that has nothing to back it up. Abstract painting is like money that has nothing to back it up. That's why so—many galleries are going bank rupt. The over consumption of modern museums have made them insolvent.

Having said this, I now

5.

return to my project in Emmen. I must maintain <u>Broken Circle</u> and <u>Spiral Hill</u> by keeping on grip on its physical developments. The show is not over, as far as I'm concerned. Although I [insertion: have film footage] ~~the film remains to be made~~ of the construction of the work, I have yet to get aerial shots of the work. Still shots from carefully planned angles have yet to be shot. I would love to return to Holland to work on the project. I hope Sjouke Zijlstra realizes the importance of this project, and will keep it from being destroyed. I don't know yet, if I will able to get to Prospect. Hello to Trudie

Bob

Broken Circle / Spiral Hill *is an earthwork executed in 1971 in Emmen, Holland. Wim Beeren (1928–2000) was a Dutch museum director who contacted geographer and local art center director Sjouke Zijlstra to help identify possible sites for* Broken Circle / Spiral Hill.

» **Saul Steinberg, page 135**
remarks prepared for a luncheon given in his honor at the Smithsonian Institution on February 27, 1967
2 pp.; 27 × 21 cm

[Text is purposefully illegible]

» **Alfred Stieglitz, page 137**
letter to Elizabeth McCausland, Jan. 22, 1932
3 pp.; 28 × 22 cm; Elizabeth McCausland papers

<u>Jan 22/32</u>

My dear Elizabeth McCausland: I have just wired you.—Had to. Your work—Marin article—the O'Keeffe rotogra-vure—so perfect and I wanted

you know at once my feeling.—And how badly I needed what you gave me—just this morning. Your work in the Republican—its spirit—the work of an artist—real integrity in these days of ever increasing sloppiness & lack of all that's really fine. Together with your gift—for gift it is—comes a letter from Brett—Taos snowbound—a grand letter clean as the snow—enclosing a few of Laurence's last

2/

poems. Poems about Death And I yesterday about ready to cave in—Tired beyond death—a long impossible story—and here I am early as usual at the Place—with your gift & Brett's—Lawrence's—many thanks to you all—

the true workers in Life &

in Death—

They give one the

courage to go on—

So once more a million thanks for everything—The reproductions are

fine. My photograph better than the print! Marin will be delighted. He is so tired too of the usual

3/

Twaddle written about him—& here finally is something solid & truly alive—

Cordial greetings
Stieglitz

———

Marin is painter John Marin (1870–1953); Brett is painter Dorothy Brett (1883–1977); Lawrence is novelist D. H. Lawrence (1885–1930). Brett was living at the D. H. Lawrence Ranch in Taos, New Mexico, with Lawrence's widow, Frieda (1879–1956).

» **Henry Ossawa Tanner, page 139**
draft of a letter to Eunice Tietjens, May 25, 1914
5 pp.; 18 × 28 cm; Henry Ossawa Tanner papers

May 25—1914

Dear Mrs Tietjens—
Your good note & very appreciative article to hand I have read it & except it is more than I deserve, it is exceptionally good. What you say, is what I am

trying to do—in a smaller way doing. (I hope.)

The only thing I take exception to is the inference given in your last paragraph—& while I know it is the dictum in the States, it is not any more true for that reason—

You say "In his personal life Mr T. has had many things to con-tend with. Ill health, poverty, race prejudice, always strong against a negro"—Now am I a Negro? Does not the 3/4 of English blood in my veins, which when it flowed in "pure" Anglo-Saxon veins which has done in the past, effective

2

& distinguished work in U.S.—does not this count for any thing? Does the 1/4 or 1/8 of "pure" Negro blood in my veins count for all? I believe if (the Negro blood) counts & counts to my advantage—though it has caused me at times a life of great humliation & sorrow—unlimited "kicks" & "cuffs"— but that it is the source of all my talents, (if I have any) I do not believe, any more than I believe it all comes from my English ancestors.

I suppose according to the distorted way things are seen in the States my ~~eurly~~ blond curly headed little boy would also be a "negro"

True, this condition has driven me out of the country but, still the best friends I have are "white" Americans & while I cannot sing our National Hyme, "Land of Liberty" etc. etc.

3

still deep down in my heart I love it, & am some times very sad that I cannot live where my heart is—You know many of us have still animal qualities strongly developed.

I had a chicken yard once with 20 or 30 hens & cocks, when we bought a new hen she was chased around the yard & abused for 3 or 4 days, & then finally taken in the circle & herself became a tormentor to all new comers. One day I thought I would buy a turkey or two—now certainly a turkey is as worthy a bird as a chicken, but, no—my 30 chickens refused to divide the yard with turkeys. They were chased from corner to corner, & back again, not for a week, but for months, finally one became ill & refused to eat &

-4-

to end their torture I gave them away.

Please dont imagine, that any of this criticism of American ways applies in the least to you or yours—it absolutely does not, there are many others also. But the last paragraph made me want to tell you what I think of myself, that I am glad I am what I am, for the same reason than a Swede hates to be called a Norwegian, a Scotchman to be called & Dane to be called a Swede a Scotchman to be called an Englishman &c &c—He is no better than the other, but, sometimes he thinks he is, as my chickens thought the earth was made for chickens & not for turkeys—Of course I shall not write Mr. Lane but, should the article be accepted if you would recommend that you

It might be like what happened when my "Lazarus" was bought by the French Government. It was telegraphed to the States "A Negro sells picture to French Government." Now a paper in Baltimore wanted a photo of this "Negro" of course they had none, so out they go & photograph the first dock hand they came across & it looked like maybe some of my distant ancestors when they were cuss out from Africa.

———

Tanner's acclaimed painting The Resurrection of Lazarus *(1896) was awarded a third class medal at the Paris Salon where it was purchased by the French government.*

» **Lenore Tawney, page 141**
postcard to Maryette Charlton, February 15, 1969
1 p.; 10 × 14 cm; Maryette Charlton papers
© Lenore G. Tawney Foundation

Kyoto
Feb. 15, 1969

I had a beautiful visit today with Kobori ed, Ryoko-in. I took a Japanese friend with me & she also enjoyed it very much. It is so calm, so peaceful, so perfect in its age. We stayed almost two hours. And he said you & Ruth are coming back in April! Tomorrow he is going with us to two antique shops near by to see tea ceremony things, pottery. We saw some of his beautiful old things. We were so happy in the little tea room, where it was a little warmer, & we had tea.

Love
T.

» **Lenore Tawney, pages 142–143**
letter to Maryette Charlton, January 27, 1970
2 p.; 20 × 19 cm; Maryette Charlton papers
© Lenore G. Tawney Foundation

1-27-70
Dear Charlton,
A year ago I was in Kyoto. From my notebook:

The day before I had visited Kobori at Ryoko-in, an incredibly beautiful ancient Japanese building with tiny old gardens. He gave me a small pottery jar & a square of calligraphy, with line characters.

The first—meaning "nothingness"

The second—meaning "event" or "making happen"

The third meaning "this or that"

The fourth, a double character, meaning "noble man"

"Doing nothing, one is a noble man"

or

"Not changing anything, one is a noble man"

Then Kobori spoke of the being of the plum blossom in its vase, of the tea kettle, of the tea bowls, of the fire, of the big pottery piece, of ourselves. I was suddenly aware of these things as being, & of myself as the same. Kobori said, the plum blossom is a flower, but inside it, it does not know that it is a flower. It simply is. The same with us. When we are drawing a line, it is a part of our being. Only after it is done, can someone look at it & say, It is a line.

L T

» **Cy Twombly, page 145**
letter to Leo Castelli, ca. 1963
2 pp.; 25 × 16 cm; Leo Castelli Gallery records
Reproduced with permission of the Cy Twombly Foundation

Dear Leo, Have your series finished—9 in all and 1 separate piece if u need it. They are shaped this way [vertical rectangle] + can go 2 on the facing wall 3 on each side + 1 on the small inner wall making the total 9—

I am really terribly happy over them & think that you will be pleased by them—Now they must have

some time to dry—will have them stretched but very good dry wood (if possible)—Plinio wants to do all 9 in color for a small book as soon as they are able to be stretched. Any way if you would like to make plans as to the time—Maybe in March as we talked of because they can certainly be sent by the middle of Feb—What else? Did you want drawings and how many do you think of—? Thank you so much for giving the check on the Commodo. I lost my head for it, but it inspired this series so maybe it is good to loose my head, + gain a new—My fond regards to your nice new family—& also thank Ivan for his always kind help.

love—Cy

———

Plinio is Italian art dealer and photographer Plinio De Martis (1920–2004); Ivan is Ivan Karp (1926–2012), who was the associate director of the Leo Castelli Gallery at the time of this letter.

» **Max Weber, page 147**
letter to Forbes Watson, April 2, 1941
1 p.; 27 × 19 cm; Max Weber papers

April 2. 1941

Dear Forbes:
Enclosed you will please find the article I promised to write before I left Washington. I hope you will find it printable. If you do, please do not hesitate to change [insertion: or leave out] a word or phrase as you see fit, for you know that writing is just a little side issue with me. The art of writing is immense and that is why I shrink [insertion: and freeze up] when called upon to do so.

And if you think the article is apt to ~~arouse harsh criticism and~~ create ill feeling ~~and antagonism~~, please do not hesitate to discard it. I will understand perfectly. it is an honest expression of my feeling about the Gallery. ~~In case~~ Should you find it "fit to print", and if it does [insertion: subsequently] raise a little dust ~~subsequently~~, I know you will intervene in my behalf by persuading the authorites not to deport me.

With kindest regards to [insertion: you and] Mrs. Watson from Frances and the children,
Max

If the article is published two or three of the titles might accompany the text

———

Frances is Weber's wife.

» **H. C. Westermann, page 149**
letter to Clayton and Betty Bailey, November 17, 1963
1 p.; 30 × 22.5 cm; Clayton Bailey papers

P.S. And I think that paint job your wife did was an herculean task + a damn good green job.

11/17/63

[drawing of a sun] DAY

"A RAY OF HOPE" FOR EVERBODY

I HOPE!!

Dear "Bill Bailey" + WIFE,
YA know → it was sort of dirty to drink up [insertion: OH, BOY] all your [drawing of can labeled Shlitz Milwaukee] [insertion: THE BEST] like that + then bug out after it was all gone. But my little wife [insertion: HI FOLKS] + I sure had a fine time + certainly enjoyed the many fine conversations we had with so many of you people!! AND you people were all so sweet to us. THANKS!!

Sincerely,
H. C. Westermann

» **Edward Weston, page 151**
letter to Holger Cahill, March 5, 1936
4 pp.; 28 × 22 cm; Holger Cahill papers

3-5-'36
446 Mesa Rd
Santa Monica
Calif

Dear Mr. Cahill—
The idea, or ideal, back of the WPA art project is of such great importance that I hesitate to comment. At the time of the PWAP, which gave me the first opportunity of my life to do work that I wished to do and get paid for it, I intended to write Mr. Bruce. But again the subject was so big, had such extensive connotations that I kept postponing.

That a democracy should at last recognize the cultural value, even necessity of the artist to society, is almost unbelievable. But alas it was not the "people" who recognized the artist, it was a handful of intelligent individuals. And now who are the artists this democracy is to choose?

Your program is vital, but who is to say who are the artists to carry it out? Under given conditions compromise is inevitable. Artists coming from relief, perhaps 90% are artists only by a great stretch of the imagination,—self-labelled artists.

As a member of the local committee I have found myself compromising when a work came up for vote of acceptance. If the work was not actually bad I voted "yes" because if I did not, and the others lived up to my standard, nothing or very little, would be accepted. On the other hand if the kind of work I like was given preference, the "public" would rise in rebellion. I recall years ago overhearing an irate tax payer at the L. A. Museum in violent protest over some "modern" exhibition. She would refuse to pay taxes, etc.

But you know all this. You asked me to comment on the WPA program. I think it is important, comprehensive. My only concern is in its practical execution to that end which would achieve something significant.

I suppose that if several great works come out of this project, and a handful of important artists developed or given a chance to work, (and large number of lesser lights get their bellies filled) then the effort will not have been in vain.

Be assured of my sincere interest.

Cordially
Edward Weston

Mr. Bruce is painter Edward Bruce (1879–1943), who was Director of the US Treasury Department's Section of Fine Arts.

» **James McNeill Whistler, pages 153–154**
*letter to Charles Bowen Bigelow, October 5, 1891
3 pp.; 20 × 16 cm; James McNeill Whistler Collection*

Dear Mr. Bigelow—You tell me that your friend Mr. Fred. Allen, of New York, upon the

representations of Sheridan Ford, sent over the sum of one hundred pounds, to be paid by him to me—as an inducement to close with him, accepting his proposal to lecture, paint and generally "tour" in America, under the management of a syndicate in which Mr. Allen was interested—

You were good enough to say that you would convey to Mr. Allen my answer to his enquiry as to whether I had ever received the hundred pounds in question—I therefore, beg that you will kindly write and inform him that I never received from the man Ford any sum on any occasion whatever—

The Sheridan Ford proposals were so preposterous that my solicitor, Mr. George Lewis, to whom I had referred him, sent him about his business, and advised me to have nothing whatever to do with him— + there the matter ended.

I never knew, until you told me, of the Ford's obtaining money under this false pretence; —and now I beg Mr. Allen to be good enough to forward a simple declaration of the fact to me—This is all important, as on the 26th of this month, Sheridan Ford is cited before the court of Antwerp (Police Correctionalle) on a charge of Piracy—and I am subpœnaed to appear as a witness—

As it will be such a near shave in the matter of time, please ask Mr. Allen to send his statement directed to me, "aux soins de

Maitre A. Maeterlinck. [insertion: (Avocat)]

No.1. Rue des Dominicaines. Anvers. Belgique.

Pray offer my apologies to Mr. Allen for the trouble I am giving him, and accept my best thanks for your kind courtesy—

Very faithfully yours
J McNeill Whistler

Oct. 5. 1891.

» **James McNeill Whistler, page 155**
*letter to Frederick H. Allen, June 6, 1893
2 pp.; 20 × 16 cm; James McNeill Whistler collection*

110 Rue du Bac, Paris
June 6.

Dear Mr Allen, Sheridan Ford left in the City of Paris for New York under an assumed name and

Mr Alexander cabled to you immediately. This most desirably fast.

Since then I have waited for the news of his arrest—surely you have not allowed

This shocking scoundrel to escape! To think that when we despaired of even getting hold of him—because, as you pointed out, of the difficulties of extradition—he should of his own accord run right into your arms is amazing!—

It would be unpardonable if by any chance this time he were to slip through the very clever fingers of the New York Police.

I am most anxious to hear. Do let me have one word by cable to say that Sheridan

Ford is properly in "Sing Sing"—or "the Tombs" or wherever it is that scamps tramps & jailbirds do so aspire, are safely sequestered!

With hearty congratulations upon such excellent work.

believe me dear Mr Alexander

Always Sincerely
Jms McNeil Whistler

» **Grant Wood, page 157**
to Zenobia Ness, October 28, 1930
4 pp.; 21 × 31 cm; Grant Wood collection

Cedar Rapids Ia Oct 28-1930

Hurray!

<u>Two</u> paintings of mine in the American Show—"Stone City" and "American Gothic"!

Two is the maximum and only a few make it each year

I am having photos of the two made in the Art Institute and will get them when I go in next week. Intend to have newspaper matrixes made of the best photo and have an article written about it by a professional press agent I know in Chicago. In it the credit for my luck will be put just where it belongs—with you and the State Fair.

Will have her (the press agent) bombard the State papers with it (especially the Des Moines Register and the Davenport, where they are holding the "All Iowa" show) If I discover that other Iowa

people got in I will, of course, have them played up, too, in the write up. Am holding off on the Corey letter till this is published so that I can include a clipping.

Am enclosing a page torn from the Art section of the Chicago post which includes a write up of the Colorado State Fair awards. If they get mentioned, why cant we? I think it would be very nice for all concerned if you could get something in.

Did you know that Cedar Falls art teacher at the N.E.I.T.A. convention here railroaded Ed Rowan in as head of this section—electing him over Ed Bruns who was also nominated. Rowan is not, of course, a public school art teacher and the local teachers are very indignant. We are all hoping that there is something in the constitution which will block this new move of his. If there is anything you can do please do it.

The Iowa Artists Club was very insistent that I send in this year—even elected me to an active membership without my having sent them any paintings. But as long as Rowan dominates the jury again, I refused. Will enclose my letter to Miss Orwig. When you write me again please tell me the cost of getting an out-of-the-state judge to come.

Am delighted over the idea of your coming here for a visit. By all means let me know in advance.

Sincerely,
Grant Wood

———

N.E.I.T.A. is the National Excellence in Teaching Awards. Ed Rowan (1898–1946) was the founder and director of The Little Gallery, Cedar Rapids, Iowa (1928–34).

Acknowledgments

This project required the expertise and support of many people. My colleagues at the Archives of American Art committed their time and enthusiasm to this project, particularly deputy director Liza Kirwin, who oversaw our partnership with Princeton Architectural Press and provided shrewd guidance at key moments; director Kate Haw, whose thoughtful leadership was invaluable; head of digital operations Karen Weiss, whose brilliant observation led to this book; and registrar Susan Cary, who oversaw the care of the letters. I thank my colleagues Hunter Drohojowska-Philp, Annette Leddy, Kelly Quinn, Jennifer Snyder, and Jason Stieber, who offered helpful recommendations and feedback. I am indebted to the work of imaging specialist Martin Hoffmeier, digital asset manager Robin Holladay Peak, digital projects librarian Bettina Smith, digital experience manager Michelle Herman, rights and reproductions coordinator Elizabeth Willson Christopher, archives aide Kathryn Donahue, and advancement specialist Kira Neal. I am also grateful for enthusiasm shared by all staff members for this project, namely Elizabeth Botten, Jenifer Dismukes, Jayna Josefson, and Erin Kinhart, who each uncovered many exquisite handwritten letters in our collections as the exhibition and book took shape. Moreover, a fantastic team of interns worked on this project from its beginning to the very last stages: Brandon Eng, Emma Fallone, Sheridan Sayles, Annie Schweikert, and Cecelia Vetter. Likewise, volunteer Sally Mills scrupulously helped to review and edit the transcriptions.

At the Smithsonian Transcription Center, I am grateful to Meghan Ferriter and the many "volunpeers" from around the world who enthusiastically transcribed the letters in this book, sometimes in mere minutes. Along similar lines, thanks to the Smithsonian's public affairs specialist Sara Sulick for promoting our endeavors.

I thank all the writers who penned the clever and insightful essays for this book. Many authors and supporters of the project helped provide crucial information and granted permission to publish letters: Paulus Berensohn, Graham Boettcher, Ashley Burke, Tim Clifford, Heidi Coleman, Julia Connor, Robert Cozzolino, Cynthia Crane, Patricia Cronin, Susan Breuer Dam, Katherine Degn, Nicola Del Roscio, Eleonora Di Erasmo, Betsy Fahlman, Jack Flam, Ruth Flynn, Llyn Foulkes, Lee Glazer, Stacey Gershon, Amelia Goerlitz, Felix Krebs, Ronald Kurtz, Lindsay Hightower Kathleen Nugent Mangan, Musa Mayer, David McCarthy, Asma Naeem, Jim Nutt, Claes Oldenburg, Jennifer Stettler Parsons, Corinne M. Pierog, Scott Propeak, Ron Protas, Akela Reason, Christina Roman, Sheila Schwartz, Richard Shiff, Ray Smith, Leslie Squyres, Leslie Umberger, Lynne Warren, Cécile Whiting, and Elaine Yau.

And special thanks to Princeton Architectural Press, notably senior editor Sara Stemen for her keen editing and impressive management of the many elements of this book, as well as the clever designer Benjamin English, acquisitions director Jennifer Lippert, production director Janet Behning, digital prepress coordinator Valerie Kamen, and publicist Jaime Nelson Noven.

Credits

Collections cited are those of the Smithsonian's Archives of American Art
unless otherwise noted.

page 2 Thomas Eakins letter to Frances Eakins, March 26, 1869. Thomas Eakins letters.

page 24 Berenice Abbott, ca. 1968–69. Photograph by Arnold Crane. Arnold Crane portfolio of photographs. Reproduced with permission of Cynthia Crane.

page 28 Ivan Albright painting *That Which I Should Have Done I Did Not Do (The Door)*, 1931/41, in his studio, ca. 1940. Photograph by Helen Balfour Morrison. Miscellaneous photographs collection. Reproduced with permission of The Morrison-Shearer Foundation.

page 33 Oscar Bluemner, notes in the catalog *Exhibition of Early Chinese Paintings & Sculptures*, 1922, at the Bourgeois Galleries, ca. 1922–33. Oscar Bluemner papers.

page 34 Charles Burchfield, *In a Deserted House*, 1918–39. Watercolor, black ink, black crayon over pencil on paper, 56.5 × 74.0 cm. Detroit Institute of Arts, USA / Bridgeman Images. Reproduced with permission of the Charles E. Burchfield Foundation.

page 36 Alexander Calder's studio at 14 rue de la Colonie, Paris, 1933. Photograph by Marc Vaux. All works by Alexander Calder ©2014 Calder Foundation, New York / Artists Rights Society (ARS), New York.

page 38 Mary Cassatt, *Young Women Picking Fruit*, 1891. Oil on canvas, 131.44 × 90.17 cm. Carnegie Museum of Art, Pittsburgh: Patrons Art Fund, 22.8.

page 42 George Catlin, *View of the Junction of the Red River and the False Washita, in Texas*, 1834–35. Oil on canvas, 49.7 × 70.0 cm. Smithsonian American Art Museum: Gift of Mrs. Joseph Harrison, Jr., 1985.66.345.

page 44 Frederic Edwin Church, ca. 1865–67. Photograph by George Gardner Rockwood. Artists' portraits from Henry Tuckerman's *Book of the Artists*.

page 46 Joseph Cornell, 1933. Photograph by Lee Miller. Katherine Segava Sznycer papers. © Lee Miller Archives, England 2016. All rights reserved. www.leemiller.co.uk.

page 50 Large studio desk, house of Hanne Darboven, Hamburg. Foto © Felix Krebs.

page 52 Willem de Kooning, ca. 1946. Photograph by Harry Bowden. Harry Bowden papers.

page 54 Beauford Delaney (second from left) and Lawrence Calcagno (third from left) at a cafe in Paris, 1953. Photographer unknown. Lawrence Calcagno papers.

page 56 Arthur Dove, *The Bessie of New York*, 1932. Oil on canvas, 71.1 × 101.6 cm. The Baltimore Museum of Art: Edward Joseph Gallagher III Memorial Collection, BMA 1953.5. ©The Estate of Arthur G. Dove, courtesy of Terry Dintenfass, Inc.

page 58 Marcel Duchamp, 1950. Photograph by Robert Bruce Inverarity. Robert Bruce Inverarity papers.

page 62 Thomas Eakins, ca. 1870. Photographer unknown. Walter Pach papers.

page 64 Reverend Howard Finster in Paradise Garden, Pennville, Georgia, April 1985. Photograph by Liza Kirwin. Photographs and video of self-taught artists.

page 66 Installation view of *Untitled* (1966) by Dan Flavin in the *10* exhibition in Los Angeles, May 2–27, 1967. Photograph by Virginia Dwan. Dwan Gallery (Los Angeles, Calif. and New York, N.Y.) records

page 68 The Rubber Band, 1974. From left to right: Mike Baird, John Forsha, Llyn Foulkes, Paul Woltz, Alan McGill and Vetza Escobar. Photograph by William Erickson, courtesy of Llyn Foulkes.

page 70 John Haberle, *The Slate*, ca. 1895. Oil on canvas, 30.48 × 23.81 cm. Museum of Fine Arts, Boston: Henry H. and Zoe Oliver Sherman Fund, 1984.163.

page 72 Marsden Hartley, *Canuck Yankee Lumberjack at Old Orchard Beach, Maine*, 1940–41. Oil on fiberboard, 101.9 × 76.2 cm. Photograph by Cathy Carver. Hirshhorn Museum and Sculpture Garden, Smithsonian Institution: Gift of Joseph H. Hirshhorn, 66.2384.

page 76 Martin Johnson Heade, *Cattleya Orchid and Three Brazilian Hummingbirds*, 1871. Oil on wood, 34.8 × 45.6 cm. National Gallery of Art, Washington, D.C.: Gift of the Morris and Gwendolyn Cafritz Foundation, 1982.73.1.

page 78 Winslow Homer, *West Point, Prout's Neck*, 1900. Oil on canvas, 76.4 × 122.2 cm. Sterling and Francine Clark Art Institute, Williamstown, Massachusetts, USA / Bridgeman Images. Reproduced with permission of the Charles E. Burchfield Foundation.

page 80 Patricia Cronin, *Harriet Hosmer, Frontispiece*, from *Harriet Hosmer: Lost and Found, A Catalogue Raisonné*, courtesy of the artist.

page 82 Ray Johnson, mail art sent to John Held, April 7, 1981, announcing the *Ray Johnson Dollar Bill Show* exhibit at the Feigen Gallery, April 3–May 5, 1981. John Held papers relating to Mail Art. © The Ray Johnson Estate, courtesy of Richard L Feigen & Co.

page 84 Corita Kent, *that they may have life*, 1964; mailed to Ben Shahn, March 1965. Serigraph silkscreen. Ben Shahn papers. Reproduced with permission of the Corita Art Center, Immaculate Heart Community, Los Angeles.

page 86 "Rainy Day Course," newspaper clipping enclosed in the letter from Sister Mary Paulita Kerrigan to Charles Henry Alston, August 19, 1962. Charles Henry Alston papers.

page 88 Lee Krasner, ca. 1942. Photograph by Maurice Berezov. © A.E. Artworks, LLC.

page 90 Jacob Lawrence in a US Coast Guard uniform, 1944. Photograph by Arnold Newman. Downtown Gallery records. © Estate of Arnold Newman/Getty Images.

page 92 Louis Lozowick, ca. 1928. Photographer unknown. Louis Lozowick papers.

page 94 Grandma Moses painting at her kitchen table, 1952. Photograph by Ifor Thomas. © 1973 Grandma Moses Properties, Co., New York.

page 96 Robert Motherwell writing in Amagansett, New York, June 1944. Photographer unknown. Joseph Cornell papers.

page 98 Isamu Noguchi, 1924. Photographer unknown, courtesy of the Isamu Noguchi Foundation and Garden Museum, New York.

page 100 Jim Nutt, *More More*, 1986 (back view). Acrylic on Masonite and wood frame, 67.3 × 53.7 cm. Photograph by Nathan Keay. ©MCA Chicago.

page 102 Georgia O'Keeffe, ca. 1920. Photograph by Alfred Stieglitz. Miscellaneous photographs collection. © 2016 Georgia O'Keeffe Museum / Artists Rights Society (ARS), New York.

page 104 Claes Oldenburg, 1969. Photograph by Jack Mitchell. Jack Mitchell photographs of artists. © Jack Mitchell

page 108 Walter Pach, ca. 1909. Photograph by Pach Brothers. Walter Pach papers.

page 110 Kenyon Cox, *Maxfield Parrish*, 1905. Oil on canvas, 30 × 25 in. National Academy Museum, New York.

page 112 Guy Pène du Bois's passport, April 16, 1929. Guy Pène du Bois papers.

page 114 Jackson Pollock's high school portrait at Manual Arts High School in Los Angeles, 1928. Photographer unknown. Jackson Pollock and Lee Krasner papers.

page 116 Abraham Rattner, *Procession*, 1944. Oil on linen, 95.4 × 92.4 cm. Photograph by Ricardo Blanc. Hirshhorn Museum and Sculpture Garden, Smithsonian Institution: Gift of the Joseph H. Hirshhorn Foundation, 1966.

page 118 Ad Reinhardt in his studio, 1955. Photograph by Walter Rosenblum. Thomas Hess papers. © Rosenblum Photography Archive.

page 120 M. C. Richards in her Stony Point pottery studio, 1956. Photograph by Valenti Chasin. Mary Caroline Richards papers, Getty Research Institute, Los Angeles (960036 ADD2).

page 124 Aline and Eero Saarinen, ca. 1954. Photographer unknown. Aline and Eero Saarinen papers.

page 128 Painter John Singer Sargent in his studio in Paris with the painting *Madame X*, ca. 1884. Photographer unknown. Photographs of artists in their Paris studios.

page 130 John Sloan, ca. 1903. Photographer unknown. Charles Scribner's Sons Art Reference Dept. records.

page 132 Robert Smithson, *Broken Circle*, ca. 1971. Photograph by Stedelijk Museum. Robert Smithson and Nancy Holt papers. © Holt-Smithson Foundation/Licensed by VAGA, New York, NY.

page 134 Saul Steinberg, artist's statement for "Fourteen Americans," 1946. Ink on paper, 9.5 × 20 cm. Private collection. © The Saul Steinberg Foundation/Artists Rights Society (ARS), New York.

page 136 Alfred Stieglitz, 1924. Photograph by Arnold Rönnebeck. Arnold Rönnebeck and Louise Emerson Rönnebeck papers.

page 138 Henry Ossawa Tanner, 1907. Photograph by Frederick Gutekunst. Henry Ossawa Tanner papers.

page 140 Lenore Tawney, 1966. Photograph by Clayton J. Price, courtesy of Lenore G. Tawney Foundation.

page 144 Installation view of *Discourse on Commodus* by Cy Twombly at the Leo Castelli Gallery, March 1964. Leo Castelli Gallery records.

page 146 Max Weber, ca. 1940. Photograph by Alfredo Valente. Alfredo Valente papers.

page 148 H. C. Westermann, envelope to Clayton Bailey, November 1963. Clayton Bailey papers. © Dumbarton Arts, LLC/Licensed by VAGA, New York, NY.

page 150 *Untitled (Portrait of Edward Weston)*, 1940. Photograph by Brett Weston. ©The Brett Weston Archive, brettwestonarchive.com.

page 152 James McNeill Whistler in his studio at 86 rue Notre Dame des Champs, 1890s. Photograph by M. Dormac. Charles Lang Freer papers, Freer Gallery of Art / Arthur M. Sackler Archives.

page 156 Grant Wood in his studio at 5 Turner Alley, Cedar Rapids, Iowa, standing in front of the unfinished *The Midnight Ride of Paul Revere*. Photograph by John W. Barry. Grant Wood collection.

Published by
Princeton Architectural Press
A McEvoy Group company
37 East 7th Street
New York, New York 10003
www.papress.com

Editor: Sara Stemen Designer: Benjamin English

Special thanks to: Nicola Bednarek Brower,
Janet Behning, Erin Cain, Tom Cho, Barbara Darko,
Jenny Florence, Jan Cigliano Hartman,
Jan Haux, Lia Hunt, Mia Johnson, Valerie Kamen,
Simone Kaplan-Senchak, Stephanie Leke,
Diane Levinson, Jennifer Lippert, Sara McKay,
Jaime Nelson Noven, Rob Shaeffer,
Paul Wagner, Joseph Weston, and Janet Wong
of Princeton Architectural Press
— Kevin C. Lippert, publisher

Library of Congress Cataloging-in-Publication Data:
Archives of American Art, author.
Pen to paper : artists' handwritten letters from
the Smithsonian's Archives of American
Art / edited by Mary Savig. — First [edition].
pages cm
Includes bibliographical references.
ISBN 978-1-61689-462-7 (paperback)
1. Artists—United States—Autographs—Catalogs.
2. Letters—Catalogs. 3. Archives of American
Art—Catalogs. I. Savig, Mary, editor. II. Title.
N45.A73 2016
700.92—dc23 2015034201